THE BFP BOOK OF
FREELANCE
PHOTOGRAPHY

British Library Cataloguing in Publication Data
The bfp book of freelance photography.
 1. Freelance photography - Manuals
 I. Wade, John, *1945-*
770'.28

ISBN 0-907297-18-8

Design and editorial production by
Wordpower Publishing
PO Box 303, Welwyn, Hertfordshire, AL6 9AG.

Published by BFP Books
Focus House, 497 Green Lanes, London, N13 4BP.

Printed in Great Britain by
Butler & Tanner Ltd., Frome.

THE BFP BOOK OF
FREELANCE
PHOTOGRAPHY

Edited by John Wade

BFP BOOKS London

CONTENTS

PART THREE: TIPS FROM THE TOP

How can you lose with a shot like this - a winning picture in the freelance section of the Canon/UK Press Gazette 'Images of Life' competition.

Introduction

ONCE UPON A TIME, as all good books start, there was a photographer whose name wasn't Fred, but that's what I'll call him because this is a true story and I have no wish to hear from his lawyers. Fred worked freelance for a local newspaper on which I served as a junior reporter at that time. One day, in the middle of summer, there was a cloudburst of such staggering proportions that the town was flooded in fifteen minutes flat. Drains exploded. Cellars flooded. Cars floated down the high street. So the editor rang Fred and asked him to get out quickly and get some pictures. *'What, in this weather?'* came the startled reply.

On another occasion, Fred was asked to cover the local carnival, due to take place on a Saturday, but he fancied going away for the weekend instead. So he printed a set of pictures taken at the previous year's event, full of bright smiling faces, parachutists dropping out of a clear blue sky, pretty girls in summer dresses - all the usual paraphernalia of a town carnival - then he headed for the coast. He returned in the early hours of Monday and delivered his pictures to the editor as soon as the office opened. That was the first he heard of the freak storm that had wiped out the carnival, cancelled the parachutists and drenched the floats.

Fred didn't work for our paper after that.

The thing is, Fred was a good photographer. He knew how to take the kind of pictures that local newspaper editors want - but he didn't have the commitment or the perseverance to succeed in a big way.

Against this, let me tell you another true story, this time about a man whose name wasn't Bill.

Bill arrived in my office when I was editor of *Photography* magazine with a portfolio of quite nice pictures and a feature about his silver anniversary in photography. It started with how he had been given his first camera by his auntie twenty-five years ago and how he had progressed ever since, mentioning on the way various family weddings, holidays and outings over the years and the cars he was driving at the time. All very interesting to members of his family, but of no interest at all to the readers of a national photographic magazine.

I told him so, in the nicest possible way, but added that I liked the pictures. Use them as a basis to write me a feature on picture composition instead, I suggested.

Bill returned a week later with some different pictures and a feature on how they had all been taken on a twenty-year-old camera that was no longer available. Interesting in its own way, I said, but not relevant to readers who want to hear about the latest technology. Why not use the pictures to illustrate a feature on the use of light? That way, it doesn't matter that they were

taken on an out-dated camera; the information you'll be putting across will apply to any photographer, whatever the camera he or she is using.

He returned with a feature that was essentially a test report on a camera that had been available for the past five years and which we had covered in depth at the time of its launch.

Bill, you see, had both commitment and perseverance. What he *didn't* have was a willingness to match his work to the market. He wanted editors to accept what *he* wanted to produce, not what *they* wanted to buy.

Those stories illustrate two very important aspects of freelance photography. First, you must have the commitment. You must really want to be successful. It shouldn't just be an idle whim. You need to accept right from the start that you're going to have to change the way you think about your photography. Very often you're going to have to take the kind of pictures that don't necessarily interest you. There will be times when you're going to have to work with film that you wouldn't otherwise use, with cameras and accessories that are far from convenient to carry around, at times of the day when more sensible people are either out enjoying themselves or tucked up safely in bed. And you'll do all this because you love it. Because nothing, but *nothing* beats the thrill the first time you see your work in print - and you'll still be getting the same thrill the hundredth time as well.

The second point that the stories about Fred and Bill illustrates is the real importance of knowing your market, and then sticking to giving that market what it needs, rather than what you think it ought to have. This is the basic fundamental of freelancing. Most beginners have little difficulty understanding it, but they do seem to have difficulty in accepting it and complying with it.

Which is what this book is all about. There have been books before on freelancing and there will doubtless be others in the future, but as editor of this book, I'm going to stick my neck way out and say that this is the Big One.

Most books on freelancing are written by one person. If that person is already a successful freelance, he or she will inevitably be a specialist in some field or another. So the book immediately becomes biased in one direction, with the author going heavily into detail on his or her own specialist subjects, to the exclusion of other, quite important, areas. That hasn't happened with this book, quite simply because it has been written by many different writers and photographers, each one a specialist in a particular field and each under the guidance of an editor who has had his share of experience in selling pictures as a freelance, buying them as a magazine editor and analysing them as a photographic tutor. It has also been divided up and laid out in such a way as to make everything as clear as possible, with frequent pauses to consider the most important aspects of each area and simply-explained conclusions at the end of chapters.

Put a combination like that together and we can't fail to have produced what is, in my humble opinion, the definitive book on how to sell your pictures. If it doesn't put you on the path to successful freelancing, I'll eat my tripod.

John Wade

THINKING LIKE A FREELANCE

FIRST THOUGHTS BEFORE YOU BEGIN: Equipment needs, starting a business, understanding the laws of photography, getting to know the market, making contact, adopting the right philosophy and looking at where you might go wrong.

A basic 35mm single lens reflex with the addition of a few lenses, from wideangle to medium telephoto gives you all you need to make a start as a freelance photographer.

Choosing equipment

BY JOHN WILMOTT

THE DETERMINED FREELANCE photographer has a more bewildering task of equipment selection than he or she ever did as a pure amateur. To get together a system to do the job properly takes a great deal of forethought and careful budgeting. Not only must the photographer select an appropriate camera, lenses and accessories, but he or she must also make an initial choice on whether to stick with 35mm, move up to medium format, or run both systems.

The choice of format will, to some extent, depend on the most likely market for the results. If colour transparency is to be the medium, many agencies prefer to use only medium format. If one or two agencies have been earmarked, it is worth checking their requirements at an early stage.

Weddings and portraiture demand a large negative simply to maintain the highest quality. For most general purpose and editorial photography, 35mm is fine provided the film stock is of the best quality.

If medium format gear were as versatile and inexpensive as 35mm equipment, it would be the automatic choice, as one could then guarantee the finest results. However, a 35mm SLR is far more suitable for many applications - sport, for example, where a bulky rollfilm camera would be too cumbersome.

Start with the body

Linchpin of the 35mm system is, of course, the camera body. It is important to emphasise 'body' as the 50mm standard lens may not be the best choice, or even required at all.

It is wise to let the head rule the heart when selecting a body. Autofocus cameras have plenty of glamour appeal but note that they are not always the first choice of professionals. Although today's AF systems are excellent, when results mean money, the tendency is to rely on personal judgement and experience. The hand can still make fine adjustments to the lens in a fraction of a second, and a

By today's standards a twin lens reflex looks old fashioned and can be cumbersome to use. Yet cameras like this are inexpensive to buy second-hand and can help you make sales in markets that prefer medium format to 35mm colour.

manual lens can be prefocused at any distance for action or depth of field shots. The other drawback is that many AF cameras are complex and not easy to become familiar with, something that's essential to take advantage of every opportunity.

A good choice is an auto-manual which is well made and has a very clear control layout, where the switches and dials all fall easily to the fingertips. Comprehensive and clear viewfinder information is an advantage. Remember it's the lens that produces the goods not a proliferation of electronic features.

For the more creative freelance, handy features to have include a multiple exposure device, depth of field preview and memory lock. A built-in winder helps make sure the camera is always ready for the next shot.

Although some of the less well known SLR makers offer more features per pound, they may not offer such an extensive system or service network as one of the big names. If the photographer decides to specialise in the future, he must have access to the appropriate accessories.

A second body is very worthwhile expenditure.

Ideally, it should be of the same model as the prime camera with which the user will become familiar. If not, it should most certainly be of the same make as the basic handling may well be similar. A second body can be loaded with alternative film stock so if the light changes, or if both black and white and colour are required, a changeover can be made quickly without reloading the film.

Unless the freelance intends to become a full-time photographer, in which case he may well invest in something like a Hasselblad, it is worth taking a look at the 6 x 4.5 cm cameras available. Most models are much cheaper than their 6 x 6 cm or 6 x 7 cm brothers and are smaller and lighter, too. The 645 format is still significantly bigger than 35mm to make a noticeable quality difference on enlargements. There isn't a huge choice but budget models are good enough if a little basic.

If the freelance is willing to tackle any assignment, he or she will need a good selection of lenses in different focal lengths. Even if money is no problem, a careful choice must be made in order that a comprehensive system can be carried around without undue stress.

There are many different permutations of focal length. A typical general purpose outfit may consist of a 24mm, 50mm, 85mm and 200mm. The 24mm is a good compromise between the dramatic ultra-wide and the popular 28mm, the 50mm with its wide aperture is useful for low light work, the 85mm is for portraits and the 200mm for sports. Of course, this simple combination can be easily adapted if the photographer has a preference for a particular subject. Landscapes, for example, would benefit from a 20mm, 28mm, 35mm and 85mm.

Zoom lenses

Note that zooms have not been mentioned in the above examples. A zoom can take the place of a number of fixed lenses and takes up less room and weight in the gadget bag. Although the optical quality of zooms is on the whole very good, some of the cheaper examples can be prone to flare or glare which, even in small doses, can reduce the contrast of an image. Therefore, choose only the superior quality zooms and don't be over-ambitious on the focal length range. The long range examples also suffer from a modest maximum aperture and close focusing distance, and a gloomy viewfinder image.

Camera manufacturers often offer the same lens with different maximum apertures. The wider the aperture, the more expensive. Unless it's for a

Points to remember

- **Consider medium formats as well as 35mm.**

- **Go for useful features, not gimmicks.**

- **Buy a second body when you can afford it.**

- **Match lenses to your speciality subjects.**

- **Be careful of budget-priced zooms.**

- **Buy a flashgun that can be separated from the camera.**

- **Don't overlook the importance of a tripod.**

- **Buy useful filters before you buy special effect types.**

specialist use, an f/2 wideangle or f/1.4 standard isn't really necessary. However, an extra stop on a portrait lens or a telephoto can make a real difference. An 85mm used wide open at f/1.4 will completely throw the background out of focus. An f/2.8 200mm gives a much brighter viewfinder image and smaller depth of field for crisp focusing, as well as coping better with floodlit sports. They are worth considering, but at a price.

Don't bother with teleconverters unless they are specially produced for a particular lens. The quality simply suffers too much, as well as losing lens speed.

The next most important piece of equipment is a tripod. Tripods are undoubtedly a nuisance - heavy, cumbersome and taking time to set up correctly. Yet

they are worth the trouble if the light is anything but bright, especially when using slow films or telephoto lenses. Often a tripod is the only way to achieve a sharp picture without loading a faster and grainier film. A cheap tripod is not likely to be stable enough for a camera with telephoto attached, so pay the most you can afford for a good, stable model. A high quality cable release also makes a difference as cheap ones can be inflexible and insensitive.

Winders and motordrives, if not built in, can have more than just showroom appeal. For the serious sportsman, a two or three frames per second winder just won't be fast enough to capture action sequences. A four or five frames per second motordrive is the expensive essential.

Even if the photographer finds he is not doing much after-dark work, a decent flashgun is vital. Correctly used, fill-in flash can make a great deal of difference to a daylight picture and this is a technique well worth getting to grips with. Many of the latest cameras offer automation of flash exposures that take the worry out of fill-in techniques.

Dedicated flash

The lightweight, hot-shoe mounted flashgun is next to useless for the freelance. The light source is too close to the camera, causing red-eye and glare, and probably not powerful enough. The best type is the hammer style flash, used on a bracket or held in the hand. A reasonable alternative is a powerful hot-shoe flash mounted on a bracket. Choose one with a bounce head and a number of auto aperture settings to avoid complex exposure calculations. Dedication is a boon, leaving the photographer free to concentrate on the subject, but do buy one which has a connecting cord for off-camera dedicated flash.

Accessory choice will depend on whether the freelance has any particular speciality. For example, a ringflash for nature work or a remote release for wildlife. Filters are useful for many aspects of photography and it is easy to build up quite a collection.

For black and white photography, the most essential filter is a pale yellow for boosting contrast a little. Orange and red give a more dramatic enhancement of contrast but are less realistic. Filters for colour photography should be used carefully. Apart from photographic magazines, there is little demand for pictures taken with trick filters. A polariser is handy for enriching blue seas and skies and for a little extra colour saturation. A warm-tone (81A) filter will give a more pleasing appearance to pictures taken on overcast days, while a pale blue filter (80A) is the one for using daylight film under artificial light. Graduated filters can add interest to a sky and the grey and tobacco versions are popular.

Bits and pieces which all come in useful from time to time include a slave unit for using supplementary flash, bean bag for supporting the camera when a tripod isn't available and a transparent container for film cassettes. Spare batteries and a lenshood for each lens are vital.

A gadget bag has to serve a number of purposes. It should be capacious enough to carry as much gear as will be needed for a shoot, plus plenty of film. It must be tough to protect the equipment but it must also be comfortable to carry all day. A large, soft bag with plenty of interior dividers, padded pockets and a wide, padded strap is ideal.

Get yourself a good quality camera bag, one that's easy to carry and which holds your equipment safely as well.

CONCLUSIONS

You can sell pictures with almost any camera. The serious freelance photographer, however, should start with a good basic 35mm body and build up a system of lenses and accessories that will be genuinely useful, rather than buying just for the sake of the latest gimmick or piece of electronic wizardry. Once you have the basics needed in a 35mm outfit, it's also well worth considering adding a medium format camera to your kit.

Setting up a darkroom

BY JOHN WILMOTT

ONE OF THE hardest lessons that a newcomer to freelancing has to learn is the importance, even in today's colourful world, of black and white photography. Reluctantly, then, the photographer who must comply with the needs of the market, shoots a roll of black and white film and then sends it out to a photo lab to be developed and printed. Because the majority of trade processing houses are set up more for colour than black and white, the results are often disappointing - low in quality and high in price.

The answer to the problem is to simply set up your own black and white darkroom - a project that needn't be expensive and which isn't nearly as complicated as most newcomers seem to think.

The basic hardware is a means of projecting the negative or slide onto a piece of sensitised paper, plus a couple of trays in which to develop the print. But to make the darkroom an efficient, comfortable and ultimately profitable work area, you need to give careful thought to the choice of equipment.

First find a room

A suitable room has to be found, blacked out, ideally equipped with shelves and benches and well ventilated. But a permanent room is by no means a necessity. Providing you comply with the basic rules of electrical safety, there is no reason why you shouldn't set up a temporary darkroom in the kitchen or bathroom. But do use common sense over the electrics. Remember - water and electricity just don't mix!

A darkroom doesn't always have to be dark. It must be jet-black and light-tight for handling film, but printing is carried out under a safelight. When you choose one, go for a yellowish-orange type of filter over the light source rather than a red one. It makes judging the appearance of a print in the developer that much easier.

The enlarger is the most expensive item. It boils down to a straight choice between a model designed for colour work and one designed for black and white. The colour model will have dial-in filters for colour correction, the black and white version will have a filter drawer in case you decide to print colour at a later date.

Colour printing from negatives is not really practical for the freelance unless he or she has found a steady market for the results. It takes a lot of practice and expense and even then it's difficult to get the reliable results achieved by a laboratory's automatic equipment.

Black and white is comparatively easy, but that doesn't necessarily rule out a colour enlarger. The dial-in filters can be used to print Multigrade variable contrast papers and are useful if you want to have a go at the relatively easy Cibachrome colour process. The softer, diffused light box of the colour machine as against the direct light of the condenser black and white enlarger gives less contrast and longer exposure times but it doesn't make that much difference in practice.

Flimsy enlargers tend to vibrate, so buy one with a thick, rigid column and preferably a geared drive for moving the head up and down. You should be able to make fine height and focusing adjustments without the head slipping. The baseboard should be at least as large as the largest print you intend to make.

An important feature is the negative carrier. Glass ones hold the film flat but tend to attract dust; glassless holders avoid dust but may not flatten the negative. Ideally, you should be able to slide the negative strip in and out without having to constantly remove the carrier. Watch that the carrier frame doesn't crop the negative area; some have adjustable masks.

The lens is the vital link between good negatives and equally good prints. It is a waste of time to use expensive camera equipment to get sharp negs and then degrade the image by skimping on the enlarger

Everything you need to start you off as a darkroom worker can be bought in a kit. Alternatively, it's easy to pick up second-hand equipment through advertisements in the photo press.

lens. Fortunately, all except the cheapest tend to be optically sound as they are quite simple lenses.

Another item which can be either a joy or a nuisance in the darkroom is the frame in which the printing paper is placed on the baseboard. It's well

Points to remember

■ **A basic darkroom is neither complicated nor expensive.**

■ **Stick to black and white processing for freelance purposes.**

■ **Don't stint on enlarging lenses.**

■ **Don't buy what you don't need.**

■ **Improvise where you can on equipment and techniques, but don't allow indifferent technique to affect print quality.**

worth paying out for a quality model which gives accurate adjustable borders or no borders and holds the paper down firmly. Quite a few of the budget versions give uneven borders and do not even hold the paper straight.

Don't waste money on a test print frame, a piece of thick card moved along at timed intervals is equally good. Likewise, a contact print frame - a pane of glass does the job just as well.

A developing tank is needed to process the films before they even get to the printing stage. There are many types available and the two main priorities are that it should be easy to load the spiral and should be leakproof. Some models do tend to leak a little or spurt chemicals when the lid is opened. The most expensive isn't necessarily the best, so look at a few before going for one which appears to be well designed with a tight fitting lid. One which takes two spirals saves on time and chemicals. Of course, the same developing tank can be used for processing colour slides which use the E6 process.

The right timing

Some form of enlarger timer is needed, especially if more than one print from a negative is being made. A timer which also acts as the on-off switch is perfect. Some also have the facility to switch on the lamp independently for focusing. The other form of timer is for developing films and prints. Here a stopwatch can be used, but only if easily readable in the dark. There are various forms of programmable timer available

which work well, but are not essential. For prints, the experienced eye is still the best way of telling whether a print is ready to come out of the developer and into the fix. Timers are more useful for colour developing with drums.

Meters can be bought for making enlargements and they work in a similar way as a camera meter. Again, they are not vital but one with spot metering is useful for working out the exposure variations when printing a difficult negative.

For developing prints, open trays are still the best choice. It doesn't matter what they look like as long as they are about half as large again as the print. The better ones can be rocked with the fingertip for agitation, but any kind of shallow dish will work as well.

Temperature control

Developers need to be kept at the right temperature. This is most important for colour work; black and white is quite flexible in its attitude to temperature but to get the best results, consistency is important. For film developing, the developer can be placed in a washing up bowl of warm water until it reaches the correct temperature, then the processing can begin.

As development takes place, the tank can be held in the bowl for a few seconds every now and then if the room temperature is below the required developing temperature. Heated shelves can be purchased to keep the developer in trays at a thermostatically controlled temperature, handy if the darkroom has no form of heating. For all purposes, a decent mercury thermometer is essential, plus a spare as they break easily.

Washing films and prints has always been rather trying for those who do not have running water in the darkroom. Compromises can be made, for example leaving fixed prints in a bowl of clean water until the end of the session, but ideally films and prints should be properly washed as soon as possible after processing. It is therefore well worthwhile plumbing the darkroom and incorporating a sink.

The enlarger is your single most expensive item of darkroom equipment.

Then comes the greater problem of drying. Unless dried properly, films end up with drying marks and prints curl or become ragged around the edges. As presentation is so important to the freelance, the drier market should be investigated. Hanging type film driers and simple print driers can be picked up at reasonable cost. Plenty of film clips, tongs, squeegees and a sponge help considerably.

The less time it takes to make a print, the more profitable the enterprise. Therefore, don't be afraid to improvise as long as the finished quality doesn't suffer. Some of the best darkroom items on the market were born out of the idea of a frustrated photographer who decided to adapt his equipment to his needs.

CONCLUSIONS

To the uninitiated, the idea of setting up a darkroom to process black and white might seem daunting. But it's really very simple, relatively inexpensive... and will certainly enhance your chances of freelance success.

Where to start

BY JOHN WADE

JUST BECAUSE EVERYONE says your pictures are great, don't fall into the trap of immediately thinking that they will sell. If they're good and suit the market, then you stand a good chance of making sales. But if they don't suit the market, not even the most beautifully-composed, exquisitely lit, technically perfect picture will stand a chance.

What all this comes down to is learning how to look at a market in advance, to analyse and understand its needs and then to decide how best you can fill those needs. Not with pictures that you think the market should buy just because you like them, but with pictures for which they have a genuine need.

Now, it's perfectly true that there are freelances who seem to take pictures at random and then look round for a place to sell them. The reason they can work this way is because, although they might not have a firm market in mind at the time they take each shot, they do know in general terms what is and what is not a marketable product. They can look at a subject and know instinctively that there will be a place for it. That's because they are looking at that subject, not in terms of its colour, its composition, or the way the light falls, but as a saleable commodity. And they have learnt exactly what kind of picture sells and what doesn't.

For the beginner, with less experience in the marketplace, it's a lot more difficult to judge the sales potential of a certain subject, and very easy to be over-influenced by all the wrong criteria. But don't despair. There is a way to learn the ropes and to get the kind of experience that will lead you to eventually knowing instinctively what you should and what you should not shoot.

Put in its simplest terms, your task is not to shoot pictures first and then to look for somewhere to sell them, but instead to start with the market and then go out to shoot pictures specifically for that market and that market alone.

The big difficulty many find is knowing just where to start. The answer is to begin by looking at your own type of photography and how it might be associated with the market in general. Do you take landscapes, for instance? If so, think about a magazine that illustrates the national or local countryside. Then consider other possibilities. Ramblers like to see interesting places to walk, so they will be interested in landscapes of the right sort. How about caravanners, campers, tourists? They all want to look at landscapes.

You enjoy taking people? How about photographing pretty girls for covers of women's magazines or photo magazines? Or local craftsmen for craft magazines. How about people in the news for local newspapers or anyone who has an interesting story to tell for any number of different publications, depending on what the story happens to be.

Animals? Look at domestic pet and wildlife publications. Cars? The shops are full of motoring magazines. Seascapes, rivers, canals? There are magazines for people who enjoy boating in all these areas.

A common trap

So it isn't difficult to find the type of magazine that might be interested in your kind of photography. But having found that type, you are just at the beginning of your quest for a market. This is the point where it's all too easy to fall into a very common trap. You take a picture of a boat on a canal, for instance, and immediately think it will sell to a canal magazine. It might, of course, but only if it has a point to make, if it has a sense of purpose and if it genuinely has something to tell the reader.

That reader won't want to look at a picture of a boat on a canal without a reason. But give him a reason and things might change. Perhaps you are illustrating a particular patch of countryside that's worth visiting and about which you can wax eloquent.

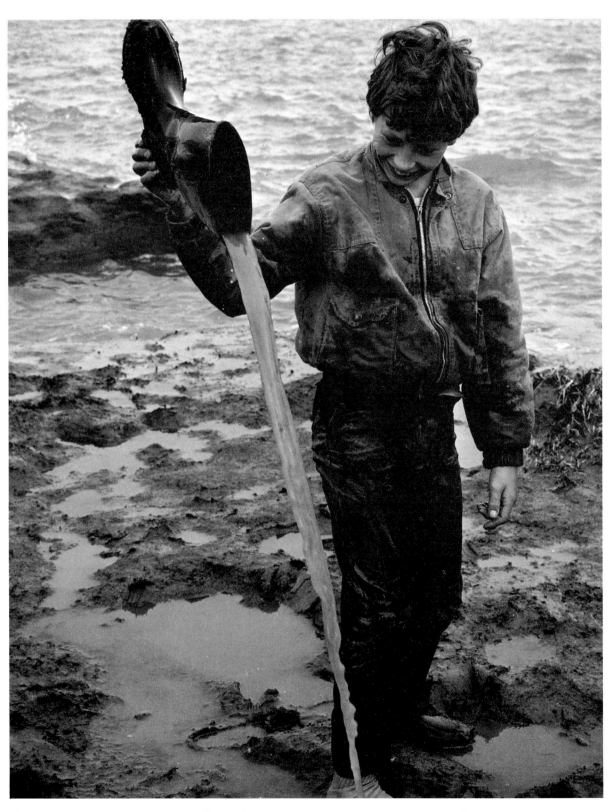

Before you even start to think about selling, make sure your pictures have a strong sense of purpose.

Maybe your picture is a close-up of the paintwork of the boat and can be used to illustrate a feature on canal art. Is there a chance that your picture shows the reader the right way to navigate a lock, or the way a certain piece of equipment is used on a canal boat? If so, once again, you stand a better chance of success than you would by simply showing a picture of a boat on a stretch of water for no reason.

That's what's meant by giving your picture a sense of purpose and it's a purpose that you should have sorted out before you took the picture, when you first looked at your chosen magazine to see what kind of pictures they might be interested in.

We're not talking here in general terms, anymore, we're moving now to looking at one or two specific markets. So, having decided what kind of publication you might best work for, go out and buy a few copies of actual magazines that deal with your chosen market. Take them home and look at them carefully from cover to cover. Look at them in ways that you might never before have looked at a magazine as a mere reader.

Start with the contents page. That's where you'll usually find a list of staff. The obvious first step is to see if the magazine has a staff photographer. A few do, but the vast majority of national magazines - unlike national or local newspapers - don't have a permanent photographer on the full-time staff.

Where you come in

So, in most magazines, the majority of the pictures will have come from outside sources. What you have to sort out now is what those sources were, why the magazine chose the pictures it did and how you can muscle in on the act!

Look first at something very basic: the ratio of colour to black and white. There are still a lot of markets around that have no use for colour, except perhaps on the cover. Once inside the magazine, every illustration is black and white. There are others that have just a little use for colour in the editorial pages, but concentrate mostly on black and white illustrations. And, of course, there are magazines that use more colour than mono.

Whatever the style, that's the one you have to follow. If the magazine uses only black and white, then don't send colour. If they have a little colour, but mostly monochrome, then stick with black and white wherever possible. And, of course, if the magazine is predominantly colour, then that's what you send. The important thing is not to send colour to a mostly monochrome magazine merely because it's conven-ient to you. Always remember the needs of the magazine come first.

Another couple of points to remember here. Firstly, when you analyse the magazine, ignore the adver-tisement pages. You might find a magazine that, at first sight, seems to take a fair amount of colour but which, on closer examination, uses the colour only for advertisements. Those pages are being paid for by advertisers, which is why they can afford to print them in full-colour. The rest of the editorial, which is open to you, might be exclusively black and white.

The second trap to steer clear of is one which many first-time freelances fall into. They send colour to monochrome markets because they know it's possible to translate one to the other. It is, but it's not terribly practical. It's more expensive than making monochrome repro from black and white prints and the final quality isn't as good. So, given the choice, the editor won't want to do it. The moral, as always,

Points to remember

- Find a market that uses the kind of subjects you are good at taking.

- Give your pictures a sense of purpose.

- Recognise the importance of separating colour from black and white.

- Analyse your market carefully before shooting.

- Don't try to invent markets that aren't really available.

- Give the editor what he or she wants, not what's most con-venient for you.

is to give the editor what he wants in the first place.

Your next task is to sort out the format used. Were the pictures taken on 35mm or medium format? This doesn't matter a great deal in black and white because the average 35mm black and white negative will yield a print that's perfectly adequate for reproduction up to the size of most magazine pages. It might be a different matter in colour.

A 35mm slide will give adequate reproduction quality, especially if you use a quality slow-speed film like Kodachrome 25, but the fact is that however good the quality of a 35mm picture, a medium format original will be better - and a few magazines ban 35mm completely on account of it.

The easiest way of sorting out what format your magazine prefers is simply to ring and ask. Failing that, you can usually tell by looking critically at the picture quality. If it really is superb, with lots of full-page illustrations, there is a good chance that medium format has been used. In any case, most magazines still prefer medium format on the cover, even if they handle 35mm inside.

Three basic questions

Your next task is to ascertain why and how the magazine is using pictures. To do that, ask yourself three questions:-

1. Are the pictures one-offs, used for their own sakes, merely to show the pictorial content?

2. Are they associated with articles, but not necessarily tied in inextricably with the words?

3. Are they clearly associated with a specific article, emphasizing the points being made in the copy?

If they fall into the first category, you stand a good chance of selling the kind of pictures that many amateurs take for club competitions - well-composed, nicely-lit, colourful landscapes. Into this first category also fall one-off pictures which tell a complete story in a brief caption, or which sell on their humorous content. The subjects of these pictures will be extremely varied, but they will all have a strong connection with the specialist interest of the magazine in question - women's interest to women's magazines, motoring interest to motor magazines, etc.

The second category comes from stock pictures that you can supply for the magazine's files, the sort of thing that can be used to illustrate articles supplied by freelance writers or staff members. These are pictures which sum up the various themes of the magazine in general terms, but not specifically to an actual article. So you might sell pictures of children involved in typical day-to-day activities to the women's press, photographic technique pictures to the photo press, general stable shots to the horse magazines.

The point to remember here, however, is to make sure your pictures have a genuine point to make. A picture of a little boy, looking at the camera in a family snapshot type of pose has no reason to find its way onto the files of a woman's magazine; the same little boy, playing cricket, building sand castles or having a bath could be used to illustrate an article on different aspects of bringing up children.

Our third picture category is actually one of the easiest to sell to, providing you feel at home adding words to your pictures, or if you are prepared to work with a freelance writer. That's because the pictures will have been supplied as part of a package, together with the words. The trap which many freelances fall into is to take a picture and then invent a mythical feature to support it, assuming that that is enough to make a sale. The chances of the magazine actually preparing that very feature at the moment when it's most convenient to you to supply the picture is, of course, a million to one. So, for this category, you're going to have to come up with the idea for words and pictures, and then supply both at the same time.

It's worth remembering that editors meet a lot of photographers who can't write and a great many writers who can't take pictures. The person who can do both will always be in demand.

CONCLUSIONS

Once you start to look at a magazine - or any other market - in an analytical way, you'll soon start to see the big difference between the kind of pictures that you take for your own amusement and those which stand a good chance of selling. Stick to the rules, be totally honest with yourself, don't try to convince yourself that a picture is right for a market when it isn't, always match your way of working to the needs of your target market, and you'll be well on your way to selling your pictures.

The business side

BY GRAHAM JONES

ANYONE WHO TAKES photographs and earns money from selling them is 'in business'. No matter how few pictures you sell you need to remember that you are running a business operation, and as a result you need to organise your business affairs properly if you are to derive profit from your endeavours.

The first step in any organisation is to open a separate business bank account. You will use this to purchase all the film and equipment you need as well as to pay in those welcome cheques from editors! A separate bank account for your freelance activities enables you to keep an accurate check on the costs of your work, and is of major assistance when it comes to dealing with financial authorities, like the Inland Revenue, which will almost certainly want a slice of your freelance income.

Without a separate bank account your payments for films and processing will be muddled up with all sorts of 'personal' expenditure. Consequently it is difficult for you to see how much you are actually spending on your freelance work and how much you are earning from it.

If you are doing a great deal of freelance work, or if you intend earning your entire income from freelance activities, it is a good idea to shop around the banks to find out which offers the best service. Some banks will charge their business customers more than others, so in order to keep your costs to a minimum, and thus enhance profits, it is wise firstly to assess what is on offer from the various banks.

At the outset of your freelance business career, it is also advisable to consider the services of an accountant. Accountants are extremely helpful for anyone in business since they understand the intricacies of tax law and enable you to derive the maximum profit from your work whilst minimising your tax bill. If you are going into a freelance business full-time, an accountant will be vital.

The service will cost only a few hundred pounds each year for the production of your annual profit and loss account and the negotiation of your tax liability with the Inland Revenue. An accountant will also advise you about such important items as Value Added Tax (VAT).

When you start your freelance business you should consider VAT. If you think that you could earn over a Government determined amount of money each year, you are legally obliged to register as a VAT trader. If you do not register, and HM Customs and Excise can show that you had reasonable grounds to believe that your sales would achieve this level, then they can make you pay all of the VAT that you should have charged on your work. They can also do this if in any three-month period you earn over a set level.

Registering for VAT has advantages, and even if you do not think that your freelance business will have a turnover approaching the pre-set figures you can still register voluntarily. Registration as a VAT trader is easy. You need to contact your local HM Customs and Excise office, which is listed in the telephone book under 'Customs'. You will be sent a booklet explaining VAT together with various leaflets and a registration form.

How you charge

Once your registration has been accepted by the authorities you will have to charge Value Added Tax on all of the work you do which is subject to this form of tax. At the time of writing, VAT is charged at a rate of 15%, so if you do some work for £100, you charge £115 including the VAT. Some types of work do not attract this 15% rate of VAT, but the rules are thoroughly explained by HM Customs and Excise.

Charging VAT on your sales has two advantages. Firstly, it raises your business status, making you appear more professional. Secondly it provides you with extra money which you can place in a high interest deposit account to earn you more money. Eventually the VAT you collect has to be passed on

to HM Customs and Excise, but you can get it to work for you by earning interest in the meantime.

Another advantage of registering for VAT is that you can reclaim the VAT you spend on purchasing items for your business. For example you could reclaim all of the VAT you get charged on film, processing and so on. This has the effect of reducing your business expenditure by 15%. If you are not registered for VAT you would have to bear the full cost of processing including the VAT, thus making your business running costs greater than someone who is a VAT trader.

Once you have registered for VAT, you will need to inform a number of authorities about your freelance work. The first organisation to be sure to tell is the Inland Revenue. If you have hired the services of an accountant he or she will do this for you. You will also need to tell the local DHSS office as your work may attract additional charges for National Insurance. If you are working full-time on your freelance business you will certainly need to pay your own National Insurance contributions so that you can have access to the NHS etc. If you are self-employed you will not benefit from sick pay, or unemployment benefit, but you will still have to pay National Insurance contributions.

Working from home

Another aspect of running a freelance business which needs to be considered at the start relates to the use of your home. Many homes have specific regulations which forbid their use for any kind of business purpose. You will need to investigate the legality of using your home for freelance work if you are to avoid clashes with the law. The first problem to be considered relates to the deeds of your house. These may have 'restrictive covenants' attached to them which state that the home in which you live may not be used for any business or trade. This is a common occurrence and is designed to ensure that domestic properties retain their value by remaining primarily residential.

If you only intend using a spare bedroom as a study then you are unlikely to be in breach of any covenant. However, if you set up a studio, or a darkroom, you could be contravening the regulations. Anyone could then complain about your use of residential property for business purposes and get the courts to produce an injunction forcing you to stop.

There is also the problem of planning permission to consider. The planning authorities are obliged to

Points to remember

- ■ **Open a separate bank account for your business.**

- ■ **Shop around for the best bank.**

- ■ **Get yourself a good accountant.**

- ■ **Consider the advantages of VAT registration.**

- ■ **Think about how you use your home.**

- ■ **Don't stint on stationery.**

- ■ **Invest in a telephone answering machine.**

- ■ **Type or word-process your correspondence.**

- ■ **Have samples of your work and business cards always readily available.**

separate as far as possible those areas which are residential from those designed for commerce and industry. By running a business from your home, as any freelance photographer would be doing, you could be contravening planning permission. The photographer most at risk would be someone who has a studio or darkroom at home, or who has converted the garage into an office! However, it is wise to consult an independent planning consultant (listed under 'Town Planning' in Yellow Pages) about your proposed business activity to check that you are not likely to upset the local planning authority.

Other officials to contact are your mortgage com-

pany, or landlord. Ordinary residential mortgages are not designed for business use and most mortgage companies will have clauses in the lending agreement forbidding you to use the money to buy property which will be used for business. Your lease or rental agreement may have similar clauses. You should check the likely ramifications of using your home for business purposes with your landlord, or your mortgage consultant. If you go ahead without checking you may find that you are forced to stop freelancing, or that your loan is revoked, or worse still, that you are thrown out of your rented accommodation!

If you are happy that you can proceed in using your home as a base for freelancing then you should take the next step in the organisation of your business. Get some printed stationery produced.

Looking more professional

Image is very important to anyone running a business. If your letters, invoices, and so on are just on tatty slips of paper you will be viewed as less professional by potential customers and will therefore be less likely to get work. In order to ensure that you gain a good reputation you will need to have professionally produced letterheads and business cards. You can get these designed and produced quite cheaply at local copy shops — the costs will be a tax deductible expense and if you are VAT registered you get the 15% VAT back.

Be sure also to look into buying a telephone answering machine. If you are out all day editors will have difficulty in contacting you to commission you for work. By using a simple inexpensive answering machine, you will be able to keep in touch with your customers and therefore gain more work. The cost of the machine is tax deductible and you can even claim its depreciation in value against your tax liability over a five-year period, further reducing your tax bill.

Another item to buy and offset against tax is a good electric typewriter, or better still a word processor.

You will fare much better against the competition if your letters are typed clearly. If you buy a word processor you will have the added benefit that you will not have to re-type standard letters, and you will be able to keep a file of names and addresses of customers on the machine. If you do keep a list of names and addresses on a computer you will need to register under the Data Protection Act. (Contact the Data Protection Registrar.)

You will also need to buy an efficient filing system and a supply of other general office items. If the administration of your business is not efficient at the outset you will be working at a serious disadvantage and will not be as effective as your organised competitors. You will also waste time and effort. This will cut down the amount of time you have for work, and will therefore reduce your earnings.

If you are doing a great deal of work as a freelance it can be economically advisable to employ your partner to do the administration. Providing this person is not earning any other money, you can pay them up to their tax threshold and claim tax relief on the payment whilst giving them a tax-free income!

Once you feel you are organised and your business financial situation is arranged you can start on your freelance career. As you will read from other chapters in this book, proper market research is vital, and it's also tax deductible. Any costs incurred in research can be claimed as a legitimate business expense in your annual accounts, thus reducing your tax bill.

Another important aspect of running a freelance business is promotion. Never be afraid to hand out your business cards. Perhaps you could get a simple leaflet produced which outlines your work. You should also have a small portfolio of your work available at all times to show editors and other potential customers. Without such promotional efforts you will not be able to convince people that they should buy your work, and you will also not be able to inform possible customers of your existence.

CONCLUSIONS

Getting your business off on the right footing is every bit as important as learning to take the right kind of pictures. So, if you are serious about freelancing, think carefully about how you present yourself, avoid problems with how and where you run your business... and don't try to dodge the taxman. Certain aspects of tax - such as VAT registration - can actually work very much in your favour.

Looking at the law
BY DON CASSELL

THERE IS NO body of law which has been framed purely for photographers, be they professional or amateurs. Laws which affect photographers are to be found in many Acts of Parliament and what follows will be a summary of the many laws of particular relevance to photographers.

The question of copyright

Quite obviously one of the greatest concerns for photographers is the question of copyright. Who owns the copyright in a photograph? What rights does copyright grant and what can a photographer do with those rights?

In 1989, the Copyright, Designs and Patents Act 1988 came into force and with it what might be described with some justice as a new deal for photographers as far as copyright is concerned.

Now, unless the contrary is agreed, copyright in a photograph belongs to the photographer, even if the photograph was commissioned by another person. The only exception is if the photographer takes a picture in the course of his employment, in which case the copyright for *all* purposes belongs to his employer unless the contrary is agreed.

To take a realistic view about this, it would be necessary for such a contrary agreement to be reached for it to be included in the photographer's contract of service. It would be an impossible situation if, before going out on any photographic assignment, the photographer had to ask his employer if he or she could have the copyright in the picture about to be taken.

Needless to say, although there is no copyright in news, copyright does exist in a news picture. So freelance photographers should always be certain, if they assign their copyright to a newspaper, magazine or similar publication, to establish the limits of such assignment of copyright.

Copyright now lasts for fifty years *after* the death

of the photographer, and when selling or assigning copyright, there are many facets to take into account. These, of course, apply to all photographers whether or not they take photographs for the media.

For instance, if copyright is sold or assigned, is it going to be for fifty years after the death of the photographer or, for example, ten years from the date it was taken? And is copyright to be sold or assigned just for the United Kingdom, or worldwide, or somewhere in between?

This is not as academic as it seems. An exceptional photograph or one that captures a world-shattering event can be in demand around the world, and the photographer who wishes to capitalise on his work must be very certain of the copyright situation.

Although the copyright of a commissioned photograph belongs to the photographer or his employer, this does not mean that it can be published or exhibited without the consent of the person who commissioned the work. In most instances this is unlikely to affect a photographer, but if for some reason the subjects of the photograph become newsworthy, the photographer, even though he owns the copyright, can't sell the picture to a newspaper without the consent of the person who commissioned it.

Similarly, a commercial photographer can't exhibit a commissioned photograph in his shop window or studio without such consent.

The latest legislation has also introduced the concept of moral right. One important right is for the photographer to have his work acknowledged when published, although this right does not apply where the photographer is employed and the photograph is taken as part of his employment or where it is published in a newspaper, magazine or similar periodical or an encyclopaedia, dictionary, yearbook or other collective work of reference.

Another moral right is the right not to have work falsely attributed to him while another is not to have his work 'doctored' unless a disclaimer is made

disassociating the photographer from the treatment of his work. This right, however, does not apply to photographs taken for the media of news and current events.

It must be remembered that copyright is considered a property right and, as such, the owner cannot only, as has been mentioned previously, sell or assign it; he can also bequeath the copyright in his will.

Naturally, where the law grants such a right as copyright, it also affords the means for such rights to be enforced and a number of remedies are available, the objects of which are to ensure that an infringer of copyright does not gain and the copyright owner lose, from an infringement.

Because these remedies are varied, they are not gone into here, for this is not a section for do-it-yourself lawyers. Remember, there is no substitute for expert professional advice.

The laws of libel

It is said that the camera cannot lie, and indeed this is the truth. But a photograph can often be the unwitting vehicle for a costly libel action. There are four definitions of what constitutes a defamatory statement, that is a libel. They are a statement or statements which:-

1. Expose a person to hatred, ridicule or contempt
2. Cause him to be shunned or avoided
3. Lower him in the estimation of right thinking members of society generally
4. Disparage him in his office, trade or profession.

It is also necessary, to found a successful libel action, to prove either one or more of the above, that the statements referred to the plaintiff and they were published to a third person.

So how can a photograph be the basis of a libel action? Strictly speaking it can't unless it is doctored, but libel actions, which have involved photographs, have invariably resulted from the caption.

To caption a well known tee-totaller who may be photographed in a group with a glass in his hand under the broad statement, '....a group seen to be enjoying a drink' may sound harmless enough. In reality, however, to use the expression 'enjoying a drink' to the ordinary man or woman infers the taking of alcohol and the tee-totaller labelled thus is branded as a hypocrite and may well have grounds for a libel action.

It seems a harmless enough picture, but call everyone in the picture a drinker when, in fact, one of them might be a tee-totaller and you could find yourself facing a libel charge.

Care must also be taken with location shots, as there was a case which was settled out of court which involved a nude model posing on a motor launch. Nothing wrong in that, but for the fact that the owner had not given permission for the launch to be used and its name was clearly visible in the shot.

As a result, the owner of the boat was able to claim that people who knew him from his boat would believe he was in the habit of allowing nude girls to use it.

This was a typical *nudge nudge, wink wink* situation, and it is interesting to speculate what, if such a case went to court today, the decision of a jury would be.

Finally, there is the question of retouching a photograph by use of an airbrush or even a montage. There is a story, which may or may not be apocryphal, of a newspaper which painted out that part of a prize

If you find yourself shooting a hot news story, take special care not to obstruct the emergency services.

bull's anatomy which would make the animal in great demand for breeding purposes.

The story has it that the owner of the bull took legal action by claiming that he had been made to look ridiculous as a breeder by the emasculation with an airbrush of his prize bull!

So it can be seen that even the most innocent of photographs can be potentially dangerous if the wrong caption is used or it is doctored.

Photographic services

It is unfortunate that most amateur photographers may, at some time or another, put films in for developing and printing, during which they are lost or damaged.

This leads to bitter disputes as it is usual for the developing and printing firm to offer to replace only the cost of the film. The lost film, of course, may have contained photographs which cost the photographer time and money to take, or might be of particular sentimental value, such as a family wedding or Christening.

Under the Supply of Goods and Services Act 1982 there are three main points which must be observed by those who supply services. The work must be carried out with reasonable care and skill, within a reasonable time unless the contrary is agreed and at a reasonable charge.

Obviously, a developing and printing firm which either loses or destroys a negative cannot be said to be exercising reasonable care and skill but the problem for the photographer is how to seek redress.

Some firms will seek to hide behind an exclusion clause which will restrict liability to the replacement of the film and the processing charge. Under the Unfair Contract Terms Act 1977, such exclusion clauses will only be upheld by the courts if they are fair and reasonable in all the circumstances.

But the main problem facing a photographer is how to quantify damage. How much, for example, is the loss of photographs of an event special to the photographer worth? If they are holiday snaps, he can't in all honesty claim that his holiday was ruined by the subsequent loss because at the time he was on holiday the loss had not occurred.

It is much easier for the photographer who can prove that he went to a certain event or place just to take photographs. In cases such as these, the actual expense can be quantified. And if he had been commissioned to take such photographs, then there is a further financial loss involved.

Many developing and printing firms do, these days, realise that there is a risk to the type of photographic work described above and offer what can be called a premium service at an additional charge.

Problems with equipment

Some photographic equipment can cost many hundreds of pounds, while some is comparatively inexpensive. Nevertheless, when equipment is purchased from a seller who is in business, the buyer is entitled to expect that the goods are of merchantable quality, free from defects and fit for the normal purpose for which it was bought.

This protection is given by The Sale of Goods Act 1893 and the photographer is entitled to his money back providing he claims his right to a refund as soon as reasonably possible after the defect has been noticed.

It is worth remembering that the claim lies not against the manufacturer - unless purchased directly from such a source - but against the shop which sold the equipment.

Normally the shop will offer to replace the article with another one, but it's worth remembering that it does not have to do so and the buyer has no right to insist on this. All the buyer is entitled to is the refund of the purchase price.

The correct behaviour

Many photographers - especially professionals working in the media - can often fall foul of the criminal law when photographing major disasters.

Failure to move on when asked to do so by a policeman may lead to an arrest for causing an obstruction, while a photographer who gets in the way of rescue services or causes an offence, can be arrested for behaviour likely to cause a breach of the peace.

Quite often, in the circumstances mentioned above, an over-zealous police officer will try to seize a

Points to remember

■ **Copyright belongs to the photographer, unless it was taken in the course of his or her employment.**

■ **Copyright lasts 50 years after the death of the photographer.**

■ **Take every care to avoid possible libel when captioning photographs.**

■ **If you are seeking a refund on faulty equipment, complain as soon as possible after a defect has been found.**

■ **Remember it is easy to fall foul of the law when photographing certain types of news story.**

photographer's camera with the intention of destroying the film.

In so doing, he is exceeding his rights and can be sued by the photographer for interference with goods and or damage and if, in seizing the camera, he manhandles the photographer, there are grounds for a further action in a civil court for trespass to the person.

CONCLUSIONS

The above is only a brief digest of just some of the law which affects photographers. I've tried to deal with some of the more common questions raised by photographers, but remember, if in doubt, on any point of law, it is wise to consult professional advice.

A picture like this, while very pretty in its own right, doesn't have a great sense of purpose on its own. But add some words, tell the reader the story behind the pictures, and its sales potential immediately increases.

Adding the words

BY REGINALD FRANCIS

SUCCESSFUL WRITERS ARE clever and industrious; successful editors, like all successful men, are clever and lazy. The writer who says to himself, 'That's not right but the editor will sort it out', is deluding himself. Editors are not like that. They require an article about the right subject with the right preparation at the right time.

Choosing the right subject is not difficult. My own field of writing is primarily for the country press, but the advice I'm about to give you is mostly true of any market, once you recognise the importance of matching your way of working to the precise requirements of your chosen publication.

I started writing when I first moved into my area. At that time there was much development in progress; *The Changing Face of...* was the obvious title, which I was able to follow some months later with *The Changed Face of...*. Everywhere I went there seemed to be suitable subjects for treatment: from the persistent moorhen who kept rebuilding her nest after the storm had swept it away to the baronet and his lady who lived in a stately home, a subject most acceptable to the kind of county magazine that has up-market pretensions.

Finding subjects

Talking one day to a graduate in hotel management, who had given up his well-paid job as deputy manager of a large hotel to cultivate and sell miniature trees, known as Bonsai, I wondered how many others had made similar radical changes in their lives. I discovered there were many: a famous sculptor who had once been an adagio dancer; the teacher who spent the first two years of her married life sailing round the world in a brigantine; the manager of a London branch of Austin Reed who resigned to go to Art College to learn to design and make exquisite objets d'art in glass; another London businessman, tiring of the rat race, is now a successful master

thatcher; and many others. The source seems inexhaustible. To highlight the connecting theme, I called this series *First Person Singular*.

Later I became interested in the variety of ways in which people spend their free time and started a new series, *Leisure and Pleasure in....* visiting a variety of clubs from Public Speaking to Sailing and from Olde Tyme Dancing to Weight Watching and Body Building. Currently I am working on my latest series, *People and Places,* which I find a useful, flexible heading which, nevertheless, gives shape and a kind of discipline to my writing.

Of course, it is not essential to group articles under theme headings - many successful writers eschew any kind of linking idea - but I find the method suits my particular style.

Care in the selection of subjects is important if you want to ensure a sale. For example, an expert in the Suzuki method of teaching music has been pressing me to write about his activities. As his work is with young children, I am not sure that it is of sufficient interest to the adult, middle to upper class readership of a county magazine.

Then again there is the question of photographs - an important part of the project. One needs to assess the potential. In this instance, I doubt if my editor would publish a photograph of tiny tots playing violins any more than he was willing to publish my excellent pictures of the lively - but rather elderly - Olde Tyme Dancers. On the other hand, my photographs of the attractive black-and-white scraper-board work of a young artist were all published, probably because the subject was particularly suitable for black-and-white photography, but even more probably because the artist was not only young but also very beautiful.

Beauty is not, however, essential: my article about weight-watching was illustrated by a picture of a very large lady in a very tight leotard heaving up dumb bells in her efforts to fight the flab: the pictures of the gentlemen in the sauna were not published! Machin-

ery, by itself, is of doubtful interest but in conjunction with the human subject can make a useful illustration. For example, writing about an expert in early gramophones I photographed him working an original hand-cranked phonograph.

Selecting the right subject with the right photographic potential and the right appeal to the readership is not enough: it must also be right for the writer. I cannot write about a subject that does not interest me.

Having chosen my subject, I write or telephone to introduce myself, make an appointment and take along my photographic equipment and my tape recorder, a portable model that can pick up normal conversation from several yards away. Politely requesting permission to use the recorder - never yet refused - I place it between us, reassuring my interviewee that I will send nothing for publication until he or she has seen my draft. This, I find, creates a pleasantly relaxed atmosphere. It is certainly much more effective in this respect than scribbling in a notebook - even if you are a shorthand expert.

After the interview I take the photographs which must include a close-up - the 'mug-shot'. Before I leave, I ask if there is any relevant literature which I could borrow. In this way I have obtained some very useful quotable material.

Interviewing technique

Back in my study I play back the tape and listen. The first time I used this method I had a nasty shock: there was more of my voice on it than the voice of the person I was interviewing. This was a salutary lesson, which did wonders for my interviewing technique.

I listen to the tape, take notes, and copy down those passages which I can quote verbatim. Some kind of shape starts to form in my mind. Then I turn to the ancillary material - books, magazines, leaflets, anything that might be relevant. In this respect I find the staff of my local library particularly helpful; they know what I am doing and follow my work with interest.

I always feel impatient at this stage, yearning to get down to it, anxious to get the job done and in the post. I know from experience, however, that I cannot afford to skimp my research. I must, also, spend some time thinking about it: in bed, lying in the bath, walking the dog. For me, sitting down and working out a plan on paper does not work: the plan must be in my head.

I like to start with the title - something to stir the curiosity of the reader: *The Stationary Engineers;*

Points to remember

- ■ There are subjects everywhere, once you make the effort to look for them.

- ■ Set yourself a theme.

- ■ Write about what you enjoy.

- ■ Listen to yourself on tape and learn by your mistakes.

- ■ Don't skimp on your research.

- ■ Use a title to give inspiration.

- ■ Intrigue your readers and make them want to read on.

- ■ Use long and short sentences together to retain interest.

- ■ Note the importance of the final paragraph.

- ■ Respect the wishes of your subject.

David and His Stroke of Luck; The Metamorphosis of Anne Jacob; Pulling Together - Backwards; The Flower Shop and the Very Adaptable Person; The Wide, Wide World of Jane Seligman. I have in my mind's eye the typical reader flipping through the pages. I aim to make him pause and ask himself: Why were the engineers stationary? What did Anne change into? Who is the adaptable person in the flower shop?

To reinforce the stopping power of the title, I sometimes place a quotation as a sub-heading. Under the title, *The Wide, Wide World of Jane Seligman,* for

example, I quoted the verse spoken by the Pilgrims from Hassan: 'We are the pilgrims, Master, we shall go always a little further'.

The title chosen and the quotation selected, I sit down to my typewriter and begin. In composing the opening sentence the aim is the same as for the title and quotation, that is to stop the reader from turning the page and to persuade him to read on. For this, I have a number of different ploys. For example, I use a provocative idea as at the beginning of this chapter, or a hint of mystery: *I stood in the shadow of the house, unobserved.*

Plunging straight into dialogue can be effective: *I was born in China and my husband found me under a gooseberry bush.* Sometimes I go straight for the subject, as in my opening paragraph about the master thatcher: *It was when I was taking photographs of the newly-thatched Coach and Horses that passers-by paused and, with beaming faces, exclaimed, 'Isn't it beautiful!'*

Keeping in mind the old saying about beginning, middle and end, I try for a simple, logical development and resist the temptation to 'sound off'. I include a number of quotations from the tape, sometimes in report form but more often in direct speech. This is important.

Getting the emphasis

Variation in the length of paragraphs and sentences is also important: it helps to retain the interest of the reader. One must not be afraid to use a short sentence, especially when emphasis is required - as at the end of the previous paragraph. Variation, too, in sentence construction is worth studying; I find the use of the participle - as at the beginning of the previous paragraph, and the colon, semi-colon, and dash most useful tools in this respect.

Constantly correcting, revising and re-shaping, I come at last to the challenge of the final paragraph. Wherever possible I return to the ideas expressed in the opening, bringing the process full circle with a definite point to make in a winding-up statement.

Some pictures seem to demand words, to tell you more about the subjects.

I state to the nearest 50 the number of words, making sure that the number is within the bracket stated and, on the last sheet of my manuscript, I add my name, address and telephone number, just in case my covering letter is mislaid.

I send a copy of the article to the subject, asking for it to be annotated and returned as soon as possible. The manuscript usually comes back bearing a few minor comments and requests for additions or omissions. I respect the subject's wishes and amend my script accordingly. I do not argue: it is not worth the hassle. I make a final check of the manuscript, re-typing wherever necessary.

Quotes from the article make useful captions for the photographs, to which I attach labels bearing the title of the article, the caption and the name of the photographer. Making sure that I beat the deadline, I place the package in a secure envelope and send it off by first class post.

When the article is published, I compare it with my copy. I note carefully any alterations and try to discover the reason for them. Sometimes my text is published exactly as I submitted it. When that happens I congratulate myself that I have submitted an article about the right subject with the right preparation at the right time and my happiness is in no way lessened by the suspicion that my clever editor might be lazy!

CONCLUSIONS

Writing is not difficult once you get yourself organised and stick to the rules. Even if you have never attempted article writing before, it's worth a try. Undoubtedly, words sell pictures and the freelance who can give an editor a complete package of both will always be welcome.

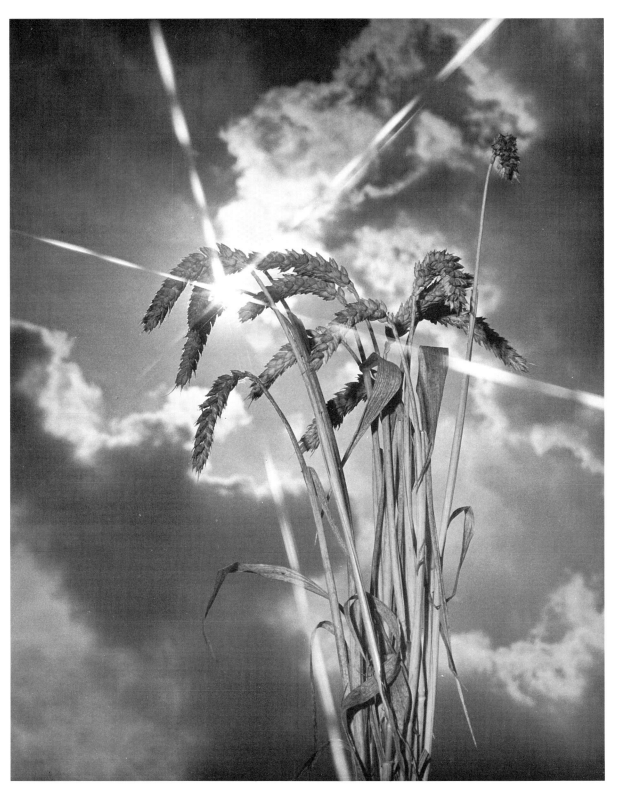

When you make initial contact with a new market, make sure your pictures are of the highest quality. An editor who hasn't met you before will not be impressed by inferior work.

Making contact

BY JOHN WADE

THERE IS A commonly-held belief that editors are somehow different from mere mortals. They live in ivory towers and speak only to a select few freelances who somehow have managed to find the magic key to the castle. Getting one on the end of a telephone is second only to ringing your favourite film star for a chat. In fact, nothing could be further from the truth.

Editors are ordinary people like you and me, doing a job and - in many cases - relying on the likes of us to help them do it. If you are good at your work, they need you a darn sight more than you need them. They are, however, extremely busy people who will object strongly to having their time wasted. But if you are confident that you have something worthwhile to show to an editor, then he or she will welcome you with open arms and be glad to look at your work, even if you are completely unknown to them.

So what is the correct way to present your work and make contact?

Be prepared

Stage one is to get yourself well prepared. Before you lift a phone, put pen to paper or paper to typewriter, make sure that the work you are about to offer really does suit the requirements of your chosen editor. Editors are in business to produce magazines for their publishers. They are not there to wet-nurse you through the intricacies of freelancing. If the work you show them is not quite up to standard but it is felt that a little encouragement and a few suggestions are all that's needed to make it saleable, then there's every chance that an editor, or one of the publication's other members of staff, will offer some helpful and constructive criticism.

But if the work is totally wrong for the market, you won't even get that. Chances are, you'll either get a straight rejection slip, or you'll get a polite but standard letter that might appear encouraging at first, but which is just another way of rejecting your work.

So start off by being totally honest with yourself. Make sure you at least think you know what's required before you make that initial contact.

The two obvious ways of getting into contact with a magazine, or any other market for that matter, is by telephone or by letter. If you have done your homework correctly, you'll have a copy of the magazine in front of you, so begin by finding out exactly who you want to speak to and what their name is.

A surprisingly high percentage of magazines are run with a very small in-house staff, some with literally no more than an editor and a shared secretary. Others might be run by an editor and assistant, while quite a number will have deputy or assistant editors in charge of different departments. A photographic magazine, for instance, might have a technical editor and a features editor under the main editor; a woman's magazine might have a beauty editor, fashion editor and cookery editor. The vast majority of magazines list these people on their contents pages and you should have no difficulty in ascertaining their names.

So, if the magazine at which you are aiming is one of those that runs on a shoestring with a very small in-house staff, prepare to address yourself straight to the editor. If, on the other hand, the magazine is larger with a number of different departments, run by different people, work out which one is best for your idea and approach the editor of that department.

Let's start by making a telephone call. The number you want will usually be listed in the magazine's imprint on the contents page, along with the staff list. If there are several different numbers, make sure you get the right one, which will be listed for the editor or the editorial department in general. Don't confuse that with other numbers for advertisement departments or even the printer.

Make your call and ask for the person you want by name. You'll probably find yourself speaking initially to a secretary who is there to filter out the time wasters. So, once again, say who you want to speak

Points to remember

■ Editors are approachable. but...

■ Don't waste their time.

■ Identify the person you need to contact by name.

■ Be brief and to the point.

■ Don't try to justify your pictures - let them speak for themselves.

■ As a newcomer, don't state the fee you require - accept the publication's standard rate.

■ Pack your pictures simply but securely.

to and, if she asks what it's concerning, be brief and to the point...

'My name is Joe Bloggs, I'm a freelance photographer and I have some work I'd like to offer.'

Simple as that. Don't go into a long preamble about the work or yourself. If the secretary asks you to put things in writing along with some examples of your work, don't argue. That's the way things are handled on that magazine and you won't change them. But, assuming you get through to the editor, keep three things in mind: Be positive, be informative and be brief.

A good positive telephone manner is one of your greatest assets. When you speak to the editor, he doesn't know who you are and if you are going to be of any use to him. You have to establish your professionalism within the first thirty seconds if you want to get anywhere. So don't mumble. Plan what you are going to say in advance, even make a few notes if you think it will help, speak clearly and with authority.

When it comes to information, tell the editor exactly what you've got and, just as importantly, why you think it would be right for his publication. Let him see that you've done your research and you'll win his heart.

And don't talk too much. Listen to what he has to say and, if he sounds encouraging, keep talking. But if it's clear that he wants to draw the conversation to an end, sum things up, find out what he wants you to do with your pictures and get off the phone.

If you are confident about your work and you genuinely feel that it will be of strong interest to an editor, rather than just a passing interest, the phone is undoubtedly your best line of approach. But if the work you are offering is weaker, or you are doubtful about your own powers of communication, then write a letter.

Once again, remember that you are out to impress, that you have to gain the editor's attention within a few seconds of the envelope being opened. So, whenever possible, type your letter or use a word processor. If you have any headed notepaper, so much the better. If not, it really is worth having some printed with 'Freelance Photographer' incorporated into your name and address at the top. Any high street printer will be able to produce what you need.

Put it in writing

There are two methods of approach now. You can write either a preliminary letter of enquiry, or you can send off a complete package of pictures - and maybe words as well - on spec. The letter of enquiry should be handled in much the same way as the telephone call. Address the editor or department editor by name, tell him or her who you are, what you have to offer and why you think it would appeal to this market. Enclose a stamped addressed envelope and say that you look forward to hearing from them in due course. Say no more and no less than you need to. Generally speaking, if an initial letter like this covers more than one page, then you've written too much.

If you are going to send your pictures on spec at this stage, then the covering letter should be even briefer. There's no need now to tell the editor why you think your work will appeal. The editor can see that for himself by looking at your pictures. Their sales potential should stand or fall by their content, not by anything you feel impelled to say about them. If you really feel you need to say more, then do so, but having said it, look through what you've just written and ask yourself one simple question: Am I adding something positive to the pictures with what I've

written, or am I making excuses designed to persuade the editor to accept something that might not be quite right for him in the first place. If you find yourself answering 'yes' to the second part of the question, you're work is probably doomed to rejection anyway.

Most letters that you write to editors along with picture submissions should be as simple, as straightforward and as brief as this one...

JOHN BROWN
FREELANCE PHOTOGRAPHER
32 Black Road, Yellowtown, Wessex. Tel: 0987 65431

\

Fred Smith,
Editor,
Practical Cat Keeping,
12-14 Green Street,
Anytown,
Wessex, SM1 4QQ.

Dear Mr. Smith,

I enclose a set of pictures that I hope you will consider for publication in Practical Cat Keeping at your normal rates. I also enclose a stamped addressed envelope for the return of my work should it not prove suitable and look forward to hearing from you in due course.

Yours sincerely,

J.T.Brown

John Brown

The picture, or pictures, you want to sell should speak for themselves. Don't try to justify something which is obviously uncommercial.

Note a couple of points here. First, you are offering your work at normal rates. This shows the editor that you are familiar with freelance practice, that you actually do require a fee (necessary in some markets) and that you are prepared to accept what is offered. In fact, you don't have much option here. As a newcomer, you won't be in a position to negotiate the rate, unless you have a world-beating photograph that's impossible for anyone else to duplicate and which the publication simply can't live without. The other point to note is the reference to a stamped addressed envelope. It's common politeness to include one with every submission you make.

Finally, a word about presentation. Always make it easy for an editor or any other picture buyer to look at your pictures with the minimum of fuss. Send prints well packed in a stiffened envelope. Put slides into multi-pocket plastic filing wallets that can be easily laid on a lightbox and viewed straightaway. Don't send glass-mounted slides. Complicated packing or anything that makes your pictures difficult to get to will put the editor in the wrong frame of mind even before he looks at the actual pictures. And anything you can do to keep him sweet, while showing him you know your business, will increase your sales potential.

CONCLUSIONS

It's not difficult to contact and speak to an editor. Be confident in your approach, but don't make contact until you are sure of your work. And always remember than an editor is a very busy person. If you think he really needs your pictures, make a call or write a letter. If all you want is advice, ask elsewhere.

What went wrong?

BY JOHN WADE

AS SENIOR TUTOR with the BFP School of Photography, I regularly see a lot of work from aspiring freelance photographers. As the editor of a national photographic magazine during seven years, I saw a lot of work from photographers who were dying to see their work in print.

Because of my contacts in the publishing world, I hear regular stories about the kind of work that is being submitted to editors every day of the week, every week of the year. All of which puts me in the best position to tell you one hard fact. It's this...

The vast majority of people who try to sell their pictures for publication fail.

Having started on that rather negative note, let's now try to be a little more positive. The second, more encouraging, fact is that probably the same percentage of aspiring freelance photographers, *could* sell their work.

Technically, there is rarely much wrong with it; aesthetically, it's fine; picture composition, subject matter, the use of the right equipment, all leave little to complain about. So why do so many fail to make the grade?

Quite simply, because they don't pay enough heed to the real needs of the various markets. Initially, most make one, or all, of the same three basic errors:-

1. They try to sell the obvious.

2. They expect a publication to accept what the photographer wants to sell, rather than what the editor actually needs.

3. They invent markets for pictures that aren't there in the first place.

Let's look at those various problems in greater detail.

Selling the obvious

'I've taken a lovely picture of a sailing boat, and I'm sure it will sell to a boating magazine.'

Really, why?

'Because it's a nice picture, against the light and, well, it's a boat, isn't it?'

What sort of boat?

'A sailing boat.'

So what's different about this sailing boat as opposed to any other? What does it show a reader who already knows something about sailing? Is there something newsworthy about this particular boat? Is the person sailing it a well-known personality who has an interesting story to tell? Is the boat itself of an unusual design? Is the location an unusual one for sailing or one that has something new to offer readers? What make of boat is this anyway? Does the designer or maker have a story to tell, and if so does this picture illustrate that story?'

'Well, I don't know. I don't actually know much about sailing to tell the truth. But it is a nice picture isn't it?'

Yes it is. But it doesn't have a reason to sell.

That hypothetical conversation is one that you can apply to all sorts of pictures. A landscape might not sell purely on its pictorial merit, but it might sell as an illustration to an article on rambling - if the picture was taken in good walking country. A picture of a dog won't have much success outside the family circle - unless the dog is an unusual breed or perhaps did something newsworthy, like rescuing his master from a river, let's say. A picture of a three-year-old grinning at the camera might please proud parents, but it says little to the reader of a mother and baby publication. The same three-year old, playing tennis or diving off the top board of a swimming pool, however, is a different matter. Suddenly, there's a story to tell and a reason for the picture being bought.

What all of this comes down to is giving your pictures a sense of purpose. A magazine is in business to inform, to entertain and even to educate its readers and the photographer who helps an editor achieve those ends by use of his or her pictures is on the way to success.

Give them what they want

'I took this beautiful landscape in Scotland. I reckon it's ideal for a greetings card.'

The subject is absolutely right, but the trouble is you've taken it in overcast weather conditions which make the picture rather dull and lifeless. You need bright sunlight and clear blue skies if you want to sell this kind of subject to that kind of market. Also, because the light level is low, you've obviously had to use a wide aperture and a slow shutter speed. Together, they've resulted in camera shake and a very narrow depth of field. A picture like this really should be sharp all the way from those tree branches in the foreground, right through to the mountains in the distance. Also, that particular market tends to reject 35mm on principle, demanding medium and large format original transparencies.

'That's all very well, but it just so happens that it never stopped raining on that holiday. This is the best I could do in the circumstances, and there's no way I can go back again when the sun shines. And do you know how much a medium format camera costs? There's no way I can afford one at the moment.'

Which is a pity, because it really was a smashing picture as far as the subject was concerned. But put yourself in the shoes of the editor or picture buyer. In front of him, he has two pictures - one taken on large format with plenty of sunshine and sharpness all the way through the image, the other taken on 35mm, slightly out of focus and in dull weather conditions. Which one would you buy?

The point is to remember that the editors don't buy excuses; they buy the pictures they want and need.

The invisible market

'I took this great picture of a busker in Covent Garden. I reckon it would sell to a magazine that specialises in street musicians.'

Name one.

'Name one what?'

A magazine that specialises in street musicians.

'Well I don't know the name of an actual magazine, but there must be one out there somewhere. Anyway, what about this picture of a church with a weird spire? It must sell to a magazine that specialises in religious architecture.'

Name one.

'This picture of a polar bear for a magazine that caters for zoos?'

Points to remember

■ **Give the editor what he or she wants.**

■ **Inject a sense of purpose into your pictures.**

■ **Don't invent markets for your own convenience.**

■ **Look objectively at your work - and your rejections.**

Name one.

And the moral of this story is, don't try to invent markets for pictures that aren't really there in the first place. That busker picture might sell to a tourism market, looking at aspects of London; the church picture might sell to a county magazine with a short caption about the unusual way the spire was built; the polar bear might even sell to a photographic magazine to demonstrate the use of long lenses. All of those markets exist. But don't make up a market just because you have what you consider to be a good picture. You're fooling no one but yourself.

Learn by your mistakes

These three basic problems are at the root of the majority of editorial rejection slips, and if you've recently had one of those land on your doormat, along with a package of returned pictures, it's worth looking at those pictures again in the light of what we've been talking about above.

If you can see that the editor wants a certain kind of picture, don't fool yourself into thinking he will make an exception just for you.

If the market will only stand medium or large format, don't send 35mm.

If the market uses black and white inside the magazine with colour only on the cover, don't send

A good picture, and one that has been used in a photographic magazine, but not one which has an obvious market elsewhere - unless the photographer can justify it with a story, perhaps about the man and his way of life.

them slides. Yes, they can make mono reproductions from colour originals, but it takes time, bother, extra expense and the final result isn't as good as from a monochrome original.

It is, of course, perfectly forgivable for a newcomer to freelancing to make all of these mistakes - sometimes in a single picture. I'd go so far as to say that it's almost impossible to make a start in the world of freelance photography without making at least some of these mistakes at some time.

What is totally unforgivable is the photographer who reads a book like this one, or perhaps takes a course, or gleans information from a successful photographer... and then totally ignores all advice, working in a way that is convenient for him, rather than useful to the market place. Always remember that in most cases the editor has a choice of the pictures he is going to buy and you have to make it easy and worthwhile for him to pick yours. Never assume that he is going to make exceptions to his rules just for you.

A final thought

Many years ago, when I first came into the the world of photographic journalism as an editor, I was given a piece of advice by an elderly and extremely eminent photographic journalist who, at that time, had just retired from the editorship of *Amateur Photographer* magazine and who had had over thirty years experience of seeing and vetting work from hopeful freelances. He had this to say...

'If you open an envelope and a pile of pictures falls out, along with a piece of writing that begins, "Such-and-such a place is a photographer's paradise" and ends, "Good shooting!", reject it immediately.'

Maybe that's why your feature on the beauties of Benidorm didn't make a sale.

CONCLUSIONS

Much of the time, freelances who have their work rejected have only themselves to blame. If your work is rejected, look at it objectively and with total honesty. Better still, look at it before you send it out. If your pictures fall into any of the traps mentioned above, cut your losses and start again. It'll be worth it in the end.

PART TWO

CLOSE-UP ON
THE MARKETS

WHO NEEDS YOUR PICTURES: A detailed look at markets from magazines and newspapers to weddings and commercial portraiture, from picture agencies and advertising to postcards and calendars, from sport and kids to photo contests and more.

Local people with unusual hobbies make good illustrated features for county magazines.

The County Press

BY RAYMOND LEA

ON THE FACE of it you might expect the majority of Britain's populous counties to have their own magazines. All that is needed is a reasonably large readership and enough advertising to make a profit. In practice, only a proportion of counties - mainly the Shires - have a magazine all to themselves, while other journals cover whole topographical areas. These local magazines tend to lead rather precarious lives but have always been useful markets for freelance writers and photographers. So it is well worthwhile discovering if there is a magazine devoted to your county, or sufficiently adjacent to make photographic coverage economically viable.

The content of most county magazines is pretty similar. They usually have pages devoted to fashion, property and gardening, to travel and motoring, sometimes to the arts and eating out. In these sections there is not much scope for casual freelance submissions, but if you have some specialized knowledge in one of these fields, you might be retained to make regular contributions.

The true local content invariably centres upon articles describing historic places and events within the magazine's area, interviews with present-day people of note (most often artists and craftspeople but sometimes local business people too) and general articles about the county's towns and villages. The town articles are often linked to an advertising feature on the shops, restaurants and so on in that town.

Picture needs

Apart from the written word, county magazines make good use of photographs including a colour shot on the cover. The vast majority of pictures inside these magazines are black and white. Cover pictures should invariably be medium format, and a clear space should be left at the top for the magazine's title to be superimposed. Subjects are mainly local beauty

Unusual architecture might have a story behind it. Tell the story and you might make a sale.

spots, fine old buildings, village scenes and the occasional local event such as maypole dancing or a scene at a country show. It can help to sell scenic pictures if you include some suitable human interest. Nearly all county magazines appear monthly, so the scope for selling covers is not large but an editor may favour you if you give good coverage of the types of pictures he or she prefers.

So too with illustrative black and white photographs. Most editors keep files of prints to draw upon as and when required. Their prime needs are for clear, sharp views of old buildings (from stately homes to simple thatched cottages), monuments and other individual features, local views (coastal too if relevant), people and annual occasions, some flora and fauna. If you have any pictures showing local crafts, industry and customs from even the quite recent past, these too can be of interest. Generally the whole emphasis is on the old and the attractive. If pictures

Traditional crafts always go down well with the readers of country magazines. An interview with the craftsman and a few pictures would invariably lead to a sale.

of modern buildings are included it is usually because they are causing controversy.

During the many years when my part of England was served by several county magazines (I live close to the boundaries of three counties), I never went anywhere without at least a pocketable camera, ready to take advantage of any likely subject I came across when out and about on other business. And, of course, to take advantage of unexpected good lighting to make a potential file picture of any attractive scene. Some subjects are especially popular and quite frequently recur in magazines. It is always useful to have a fresh view ready.

Pictures for files

File pictures, which should be a mix of vertical and horizontal formats, may not be used for a considerable time. Editors draw upon them mainly as a whole page frontispiece, to accompany other contributor's articles or to fill an odd corner. They also sometimes use pictures on their letters pages.

The more truly relevant, expertly-photographed material you provide the better your chances of consistent sales and useful, but not very big, fees. That is why it is better to concentrate on your own local magazines rather than incurring the expense of travelling further afield.

Once an editor gets to know you and can rely on

your work, you may be asked to cover a specific subject or event such as the county show, a village open day or a crafts fair. I did a lot of this type of photography for my local magazines. But I also wrote articles describing these events, which naturally led to a bigger fee altogether. In general, editors of local magazines are always on the look-out for people who can combine words and pictures and the production of such articles can be quite a regular feature of your work.

Articles on a particular historic building or group of buildings (such as all the local National Trust properties), on a popular country feature such as a range of hills or a river, or on the commonly-found wild flowers are all potential fee-earners. Features on people past and present who have special links with the county or area are required along with others describing the skills and lives of those involved in the arts and crafts.

Formula for success

Descriptive articles on towns and the more notable villages can also prove acceptable. The formula for these items is to give brief historic details, which can be found in reference books (but do check your facts, because information in books can vary) and an almost street-by-street description of the more interesting features.

You can take a subjective approach, being quite

clear about your likes and dislikes in a reasonable manner.

Personally, if ugly modern buildings or shop fronts were introduced to old places I would duly criticise them. You should be certain that anything you say is fair comment and you must be accurate in all particulars. I have always made every effort to weave known facts into a style of writing that makes the feature seem quite original, and not plagiarised in any way.

You will never make big money from county magazines. But you'll find subjects on your doorstep, and submissions can be a particularly paying proposition if you can acquire material while travelling about the region on other matters. For example I know of a country doctor who takes a camera everywhere to capture any worthwhile subject that presents itself. The better you get to know your county or area, the more chances you have of supplying articles as well as pictures.

All this can also be put to good use when expanding your freelancing into other markets. If you become known as a photographer who can quickly provide pictures of a particular part of the UK all manner of extra work can come your way.

Many country magazines run features on villages within the county, so local landmarks make sales.

Points to remember

- Look for a magazine in your county or one nearby.

- Articles - and pictures - are often linked to advertising.

- The vast majority of pictures are black and white, with colour used mainly for the cover.

- Prime needs: old buildings, monuments, local views, people, annual events, crafts, industry, pictures from the past.

- Give the editor a mix of horizontal and vertical formats for file use.

- Words with pictures add up to bigger profits.

- Check your facts in articles and captions. Make sure what you have to say is deadly accurate.

CONCLUSIONS

While county magazines are not big payers, they do make an excellent introduction to the world of freelancing for both photographers and writers. Cost your time and materials sensibly, concentrating on subjects in your immediate area or in areas that you might be travelling to on other business, and there are small but regular profits to be made.

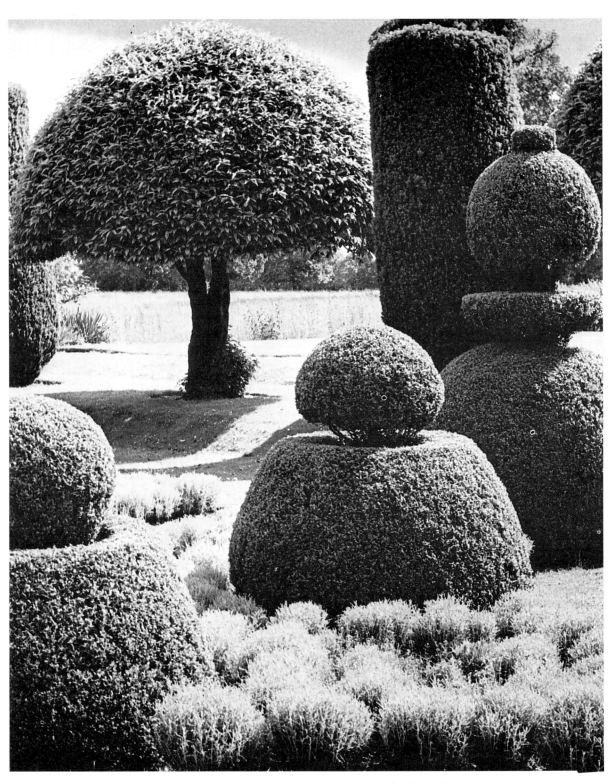

Garden design is as much a part of the gardening press as the flowers or shrubs themselves, so a picture like this one might sell, if accompanied by a feature that tells the reader something constructive about landscaping and the use of various plants as part of an overall concept.

Gardening magazines

BY STEVE BAVISTER

YOU NEED ONLY wander around your neighbourhood on a Sunday to be convinced that the average Brit is gardening crazy. Everywhere you look you'll see people pottering on their plots, be they as small as a postage stamp or as big as a football pitch.

Gardening is one of the most popular of all hobbies, with millions taking to their shovels every week. So it's no surprise that there's a growing number of gardening magazines in this country - and that most of them are doing blooming well!

And where you find successful magazines, you also find opportunities for the freelance photographer.

Gardening magazines are currently serviced by a relatively small number of established freelances and picture libraries. But that doesn't mean you can't break into this circle of contributors to gardening publications - you can. There's always room at the top - but you have to approach it in the right way.

For a start, you have to approach it in a serious way. If you just want to dabble, you won't get far. It's no good going out and shooting a few rolls of film in your garden and sending the results off to a magazine in the hope that they'll use them. In fact, very few gardening magazines accept pictures sent on spec at all. They will occasionally, when what you've submitted just happens to meet their immediate requirements - but that's very much the exception rather than the rule. In the main, they go to their regular contributors, often giving them a ring to tell them what subjects they need.

What they want

So what do they expect from a freelance? Three things in particular.

Firstly, a fast service. Which often means *now*. So you're not going to have time to shoot anything to order - even if the season were right, which it probably wouldn't be, given how far ahead magazines work.

Secondly, they want to deal with people who have good coverage of their particular area. If you say you can offer them pictures of shrubs, they expect you to have a comprehensive selection of all the popular varieties at least.

Third, they're after specific varieties, accurately labelled, preferably with the Latin name. A picture labelled simply 'rose' has zero chance of being published.

As far as most magazines are concerned, 35mm is fine - although they prefer medium-format for covers and whenever pictures are to be used big. In addition to the camera body, you'll need a few lenses: a telephoto for isolation of individual plants, a wide-angle for showing plants and features in context, and a macro lens, if you can afford it, for small specific details.

A tripod is virtually essential, and a small reflector, which will allow you to control light, is very useful too. Flash, unless you can use it very skilfully, should be avoided - it can very easily create unnatural looking results.

To begin with at least, aspiring garden freelances will do best if they concentrate their efforts in those areas where magazines currently struggle to get the material they need.

Let's be specific, where are the best openings?

1. A good place to start is by building up a library of pictures of common, everyday plants. These are the bread and butter of a gardening magazine, taking up a high percentage of its pages every month, so the demand for such plant portraits is consistent and high. Surprisingly, gardening publications find it hard to get enough of them. As one editor put it: 'I can get as many pictures as you like of exotic plants such as the coconut, but not something as common as a columbine.'

The great advantage in starting in this way is that all the plants are readily available, often in public

Everyday flowers are the bread and butter of gardening magazines, so it's a good idea to build up a library of such subjects. Make sure, however, that you know the names of the different flowers and can caption your pictures accurately.

places like parks and gardens, and that no specialist knowledge is required. That doesn't mean, though, that you can just go out and start snapping willy-nilly. The great secret of selling plant portraits is to shoot when the plant is just at its peak: a day later or a day earlier is a waste of film, as is anything with wilted leaves or greenfly - no editor worth his salt is ever going to pick a shot that doesn't show a plant at its best.

As with all areas of photography, lighting is of considerable importance too, making the difference between a picture that's saleable and one that isn't. The ideal light for photographing plants is bright but diffuse, such as that from the sun behind a thin scattering of cloud. This gives good detail and modelling, without excessive contrast. If you must shoot in full sun, try to do so early in the morning or late in the evening, when it's less harsh - or soften the light by filtering it through a diffuser.

Crop in tightly, to really isolate the plant - a tele-photo zoom will help here - and whenever possible, use a tripod. This not only ensures that the shot is pin-sharp, but also lets you set a small aperture for maximum depth of field - essential in this kind of work.

Be systematic about what you photograph. Don't try to tackle everything at once. Limit yourself to one area, such as shrubs, bedding plants, vegetables or trees - whatever you fancy. Then, when you've covered it comprehensively, move on to the next area.

2. Another way may be to specialise in a subject that comes up in gardening magazines occasionally, rather than every month. The demand for such pictures won't be as great, true enough, but then neither will the competition from other freelances.

You could establish yourself, for instance, as an expert on the photography of wild flowers, birds in the garden, insects or pests and diseases. And if your work was up to the mark you could guarantee a steady supply of work, because good pictures of those subjects are none too easy to track down.

3. Cultural techniques, such as pruning and propagation, which come under 'jobs for the week or month', offer another opportunity to the freelance.

Many magazines shoot such photographs themselves, not particularly because they want to but because they can't get them anywhere else.

The first thing you'll need, if you decide to have a go at this, is a good book on the subject, because it's absolutely essential that the picture shows the technique being done correctly. And the second thing you need is an assistant, who will do the job while you take the shots.

Good 'hands-on' material, especially that which shows people full figure, is always in demand. The style of clothes goes out of date very quickly, and quite obviously magazines don't want to be seen using dated pictures. So they always need new pictures.

Sequences such as how to plant potatoes or the way to prepare a hanging basket, may not be great art, but they're easy enough to set up and shoot. And they should sell well if you do them right.

4. The nature of gardeners and gardening is changing, and with it, of course, the nature of gardening magazines. Increasingly the garden is being seen as an extension to the home, and many people are now prepared to pay hundreds, sometimes thousands, of pounds to have a garden properly designed.

Of course, flat-capped, elderly, allotment-owning stereotype gardeners still exist, but their numbers are steadily dwindling - their place being taken by a new breed of people who want a superb garden, without the drudgery. This change is opening up a whole new area of opportunity, as magazines cater more and more for those interested in garden design.

At the simplest level, we're talking about pictures that show the use of a plant - ivy to hide an unsightly wall, for instance. Or a spreading, low-growing shrub for ground cover.

But design is also concerned with features in a garden, such as pools, pergolas and paths, and how such constructions can be harmoniously blended into integrated planting schemes.

Getting access to gardens with such features is the hard part here. But if you take a look through the

Points to remember

- Gardening magazines are on the increase.

- Build up a comprehensive library.

- Be prepared to submit pictures of flowers that are out of season.

- Find one aspect of the subject to specialise in.

- Show techniques being carried out correctly.

Yellow Pages, and make a few calls to garden landscape companies, you might find one that will let you photograph its designs, providing you let them have prints for their own promotional purposes.

Once you've built up a decent body of work in your chosen area, what you should do is send a directory of what you have to the magazine(s) you've targeted, together with a small selection, say 20 transparencies, to show the quality.

If you're interested in working on undertaking commissions, you should mention that as well. Gardening magazines need photographers to help out with news stories, and they might keep your name on file and contact you if anything comes up.

CONCLUSIONS

Freelancing for gardening magazines is not to be undertaken lightly. But if you already know a bit about gardening and are prepared to learn more, and if you are willing to spend time building up a decent collection of pictures, it's well worth giving garden magazines a go. They use a lot of pictures and pay pretty well.

The angling press

BY BRUCE POCKLINGTON

THE ANGLING PRESS, like most other markets, needs a little research before you start to submit. One angling editor, with whom I have enjoyed a good working relationship for nearly six years, spells it out like this...

'My ideal contributor delivers an interesting and authoritative article, typed and double-spaced, well in advance of deadline date. He encloses illustrations to go with it, in both colour slide form and large black and white prints, in vertical and horizontal formats. This not only gives me choice of subject matter but also allows choices in page layout. The more shots depict the various stages of technique or of angling skills, the better. Shots not used immediately are filed for future use.

'My biggest monthly headache is in finding a suitable cover picture. The printers prefer it to be on medium format, on preferably slow Kodak stock. Above all, it needs to be an eye-catcher. In our case, it should look natural and unposed, even if it isn't! The composition should take into account our deep logo and over-printed coverlines. We usually use a full bleed cover which, of course, must reflect the season in angling terms.'

I have noted, too, in angling magazines, that covers do not always directly link with inside articles. But as the inside editorial is usually seasonal, there is naturally a loose link in that sense. Still, many cover shots stand up in their own right. There is, it would seem, a good chance of selling one-off shots if they fit the bill, bearing in mind the seasonal slant already mentioned.

Looking at the angling press in more detail reveals the fact that well over ninety per cent of the contributions are submitted by freelance photographers and writers, many of them part-timers. That's the first piece of good news. The second is that the market offers the photographer a wide ranging variety of publications to deal with and, within that framework, a wide scope of subject matter. There are newsy

Pictures in angling magazines should inspire, inform and instruct the aspiring angler in his hobby.

reportage-type weeklies, monthly in-depth magazines, books, partworks, and even one-species specials. The market as a whole covers sea, game and coarse fishing, and is not, of course, confined to British publications. The European market makes the potential even greater.

Confining our attention primarily to the British market, however, we find that they all, without exception, have as a main theme of when, where and how to catch fish! Whether by direct how-to type articles or by inference, they teach by example, discuss in

depth, report success or directly instruct and inform the aspiring angler. They are liberally illustrated in both colour and black and white, and not a little artwork. Picture quality is not always as good as it might be, but there are valid reasons for that which may become clearer when I have listed some of the inherent problems associated with angling photography. The serious freelance, full-time or semi-professional, will strive to overcome those difficulties, however, and submit superior shots an editor cannot refuse.

Apart from those main themes of how, where and when, subjects allied to angling are often used. For instance, *Coarse Fishing Handbook,* with which I have had a long association, is currently, as I write, running series on aquatic insects and on wildlife found in and near inland lakes and rivers. They are all subjects with which the angler can easily identify.

It has to be said that writer and photographer will stand a better chance of acceptance if they have an understanding of angling lore. The non-angling photographer may wonder why. To him, fishing may seem to be 'just fishing'. Even at the very basic level, for instance, game and coarse fish may exist side by side, but their lifestyles are completely different. Sea and game fish may be photographed dead, coarse fish species, never - unless you are illustrating some form of pollution, the coarse angler's nightmare!

You are dealing with experts

Not all anglers are expert by any means, and to submit, innocently, shots depicting the wrong tackle, tactics or practices in the wrong place for the wrong reasons will ensure return by the next post and a jaundiced eye cast on future contributions. Angling editors are also invariably experienced anglers, and probably were so long before they gained the editor's chair.

Inexpert angling is not a crime, of course, but unless you are illustrating how *not* to do it, don't submit work with doubtful subject matter. If in doubt, ask. Gain the advice of an experienced angler, or even ask at the local tackle shop. It could save waste of time and postage - and even egg on your face! Don't be put off. There is room for good photographers in the angling press, but I do seriously suggest you work under the wing of a good angler, even collaborate with him, if you have a good idea for a feature.

As fishing is seasonal, so the magazines reflect the seasons, putting their issues out prior to the angler making his forays. That means very often

Points to remember

■ **Ninety per cent of pictures come from freelances.**

■ **Pictures must look natural and unposed.**

■ **'When, where and how to catch fish' is the main theme of most magazines.**

■ **There is a market too for angling-associated subjects.**

■ **Be deadly accurate in your captioning.**

■ **Submit well in advance for the appropriate season.**

■ **Go for straight, rather than the artistic, approach.**

taking shots one year for publication the next, and because of this time lag, you should always take detailed and accurate notes at the time the photograph is taken. A picture without such accurate captioning has far less chance of being published than one captioned properly.

Assume a very good picture drops on an editor's desk at the start of the coarse fishing season. He will be looking for work reflecting summer. Tench fishing, for instance. He looks at the picture and finds it shows mid-winter pike fishing - and it's uncaptioned. Not only does he not need it then, he has no idea how, when or where it has been caught - the very lifeblood of the angling press, you will recall. It may be the best pike fishing picture he's ever seen, and he's seen a lot, but as it is, it's useless to him, save for filing... maybe. So be on time, and be accurate with captions.

Don't forget that you are dealing with experts in the readers of angling magazines. They might easily know the details of the fish you are illustrating, and you must get your facts right.

Contrary to popular belief, anglers are no less honest, and no more prone to exaggeration than any other section of the community. Indeed, in many respects they are sticklers for accuracy.

No editor will risk ridicule, or thank you for inviting it. For what may not be realised is that there is a swift and reliable grapevine among anglers, especially specialist anglers of a one-species fraternity. Your beautiful picture, carelessly captioned, may be of a 'known' fish. It may have, believe it or not, a well-known nickname. Easily recognised by aficionados, everything will be known about it - its weight to the nearest ounce, its age and size, who last caught it and when, even its lineage. Suffice to say, they also know where it lives!

Apart from the occasional scenic shot containing an angler, the British magazines do not indulge in fancy photographic technique or in trick photography. They want good, unposed, natural pictures of every aspect of angling, especially action shots - and if you can make them better, or slightly different from the run-of-the-mill, so much the better.

Action shots are more difficult than you might imagine. The long periods of inaction, normal in many forms of angling, are interspersed with short bursts of action and surprisingly quick action at that. At least some elements of the shot move relatively quickly. In the battle with a good fish, both fish and angler may change position very quickly, often continually, until the fish is netted. He is likely to be using a twelve-foot rod, or longer, so that in the restricted space you may find yourself, in the poor light fish often feed in - dawn or dusk - and in difficult, sometimes hazardous conditions, you will find your photographic technique tested to the full.

Take care of yourself!

The windswept beach, the rocking boat and the muddy bank are the natural environment of the angler. No need, surely, to point out the risk to equipment, or indeed, to yourself! Do not be dismayed, there is no real danger - unless you are foolish. Being in a boat without a lifebelt is foolish, for example. You will also need to protect yourself from the elements at least as much as the angler. Taking good pictures in adverse conditions is a challenge, but if you'd rather be in a studio, don't get involved with angling photography!

There are other sections of the market to explore.

The trade press for one. They are more likely to carry in-house writers and photographers but entry can be gained, make no mistake. They differ in content, of course, and need to be studied. The local tackle dealer may well have back copies he'll let you have. He will certainly have brochures from various tackle manufacturers and wholesalers. Much, if not all, of the leaflet and brochure work is likely to be commissioned. If you have the skill and studio facilities, and can confidently produce first-class work, follow such leads, enquire, and if invited, show a good portfolio as a start.

Don't ignore the BFP *Market Newsletter* information. I picked up some lucrative trade-related work and gained entry to an angling photo library simply from following up snippets of information in the *Market Newsletter*. It is interesting to note that the principal of the agency turned out to be a very experienced angler, and an angling press contributor of some repute.

Apart from the laws, rules and regulations concerning angling, there are unwritten codes of behaviour and ethics to be followed. It's as well to learn them.

Take one example: You are a wildlife photographer who has been after the perfect shot of an elusive creature for years. Money, time and effort have culminated in you being about to fire the shutter. At the last moment an intruder noisily stomps into your viewfinder. You feel sick at the sheer incompetence and bad manners of the creep as he begins to ply you with inane, if innocent, questions, such as, 'Have you got any yet?' You could literally strangle him on the spot! Anglers capture wildlife, too, you know.

Pictures should tell a straightforward story about the subject, rather than taking a pictorial approach.

Always ask permission to shoot. Some riparian owners and anglers seek publicity, some do not, to the point of secrecy. Even if you are within your rights, in law, basic good manners do no harm. By the sea or by inland waters, photographic opportunities abound, other than in angling. Angling, being what it is, just as your attention is diverted, the action starts!

CONCLUSIONS

If you feel at a disadvantage because of your lack of angling knowhow, remember it is balanced out in that the angler is unlikely to be a good photographer, or even have decent equipment. It is rare to see a good 35mm outfit on the banks, let alone medium format. Subtleties such as filters, lens hoods and off-camera flash are almost unknown. And other than my own, I've yet to come across a good tripod. A few keen angler/ photographers use remote control devices affixed to their rod butts, but they are a very tiny minority. The good freelance with good quality equipment, good technique and the ability to visualise what is likely to happen, should have no trouble with competition from simple point and shoot-type cameras, more usually seen on the banks, if a camera is seen at all!

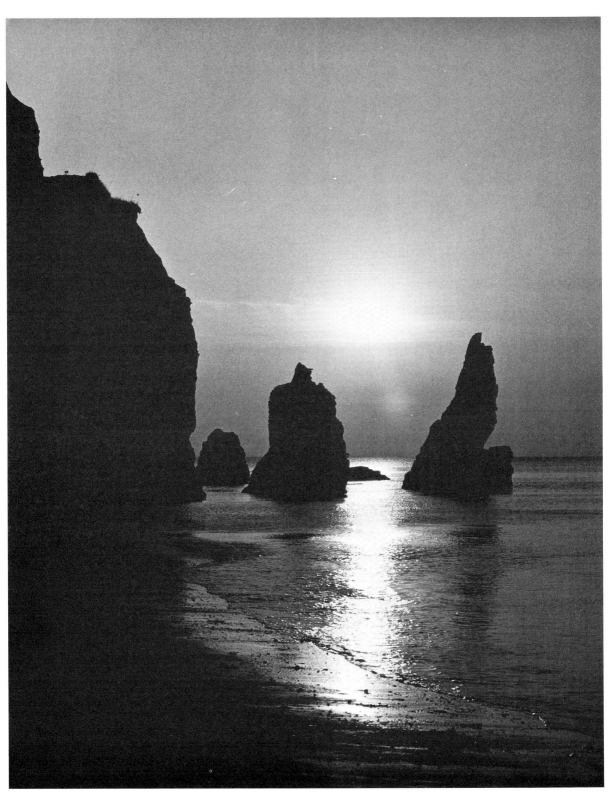

The photo press is always on the look-out for pictures which demonstrate photographic technique.
A shot like this could easily illustrate articles on composition or the use of light.

The photo press

BY STEVE BAVISTER

ANYONE CONTEMPLATING FREELANCING should certainly consider sending work to photographic magazines, as they offer a wealth of opportunity to the competent photographer.

For a start, they have a voracious appetite for pictures. Because photographs are the point, the subject matter of the magazines - and not, as in other areas, merely illustration. A great many shots are used in the course of any one issue.

And if you look at the credits, you'll see that very few of the pictures (other than product shots of cameras etc.) are taken by the magazine's staff. Almost all are bought in from one source or another.

Not only that, because magazines seek to appeal to many different kinds of photographers with many different interests, you'll find that they cover any and every subject you could name.

Consider, also, that since most photo magazines are produced with an amateur audience in mind, it's generally a matter of policy to use a reader's picture in preference to one from a professional or a picture library whenever possible.

The rates paid

All this is good news. And so too is the fact that the rates paid by the photo press for the privilege of publishing your work are pretty decent.

The bad news, though, is that your pictures do need to be technically competent and photographically interesting.

Because the staff of photographic magazines are often skilled and knowledgeable photographers themselves, they tend to have high standards - and will dismiss instantly, as a matter of course, anything that fails to meet them.

So the first rule of freelancing to the photo press is never to send any picture that isn't technically first-class. It must be accurately exposed, pin-sharp, and carefully-composed.

Pictures work in the photo press when they are artistic and have a point to make. This one could be used in a picture portfolio, or in a technical article on a subject like exposure.

If it doesn't meet those criteria, don't submit it, however interesting the content. You might get away with selling an exciting but inferior shot to a general interest publication, but with photography magazines you're wasting your time.

Technical competence is merely the starting point, of course. Beyond that, the magazine needs a reason to publish your work. And that's where most would-be freelances go wrong.

As I write, I have before me a boxful of submissions made to *Photo Answers* magazine. And to give you some idea of where most fail, I'll go through a few of them now, offering helpful comments.

First out of the box is a set of pictures typical of many that photographic magazines, receive. There's nothing actually wrong with them, they're simply very ordinary - a pot pourri of straightforward record shots of family and friends, places visited and so forth. All very resonant with meaning for the photographer, but

There are many different ways of looking at similar subjects, and the photo press is interested in all the variations. Here, a fairly traditional landscape has been enhanced by printing techniques...

Here, another traditional landscape has been given the photo press treatment by the use of infra red film. Explaining the technique behind the picture makes it a winner for this market.

of little interest to anyone else. To get work published in the photo press you do really need to go beyond the obvious, to come up with something with just a little more artistic merit.

What's in the next envelope? Hello, it's a collection of glamour shots - and they're not bad either. But the submission could be a waste of effort if the magazine in question doesn't feature glamour. The photogra-

pher might have been better submitting to either *Practical Photography* or *Amateur Photographer*, both of whom use glamour regularly. So before you send anything to a magazine, check first by reading a few issues whether they use that particular subject.

Our third submission, sent in as a prospective portfolio, is very similar to the first, except - wait a minute - one of the pictures is a real corker. Yes,

we're almost certain to use that for something. And we'll either find a slot very soon for it, or write and ask for permission to keep it on file until a suitable opening appears. You see, we are so desperate for first-rate photographs that we view every body of work that comes in a very creative way - looking at it from every possible angle to see how we might make use of it. We don't just give it a cursory glance and send it back.

Next we have a batch of enprints. Once again, a bit of a waste of time. The truth is we rarely use them - since most of them are machine-printed, and not up to the required quality. And we're not snobbily opposed to receiving colour prints - nor, I believe, are any of the photo titles. As long as they're well printed we're as happy to work from them as the slides which the majority of non-photographic magazines insist upon.

Comparative pictures

Once more into the lucky dip, and out comes a number of pairs of comparative pictures: with and without graduated, starburst and polarising filters; the same scene shot in colour and black and white; a portrait with direct and bounced flash. Now you're talking - these are very useful. We have a constant demand for such comparative shots because they get over with greater immediacy how a technique works than 500 words. Shoot good comparatives, tell the magazines they can keep them on file and the money should arrive nice and steadily.

And here's another appealing submission: out of 20 pictures there are about six or eight good ones, and we have a possible portfolio. Most magazines run a regular portfolio slot, where they profile an

At one time, the photo press would take any excuse to publish almost any type of glamour picture; these days, they need to be more subtle.

> # Points to remember
>
> ■ **Photo magazines have a voracious appetite for pictures.**
>
> ■ **Pictures must be technically perfect.**
>
> ■ **Go beyond the obvious subjects.**
>
> ■ **Don't send enprints.**
>
> ■ **Get your timing right.**
>
> ■ **Think about, and illustrate, photographic techniques.**
>
> ■ **Supply technical details with your pictures.**

amateur and feature his work, generally in the form of about six pictures over four magazine pages. To get picked as a portfolio your photographs need not only to be of a consistently high quality, they also need some sort of thread or angle that links them. This could be subject - all landscapes, for instance - or technique - all taken hand-held in available light.

The same subjects

The next set of pictures looks good too: an excellent set of firework pictures. And it's October, so it seems to make sense. But the problem is we wrote the firework piece to go in the November issue almost two months ago, and it was then we needed the pictures. Now they're no good to us. Read photo magazines for a year or two, and you'll start to see the same subjects popping up time and time again like clockwork: fireworks and autumn in November; winter, night, flash and tripods in January and February; travel and holidays in May/June - and so on. And all

you have to do to take advantage of this repetition is to anticipate it. Send in your firework shots at the end of August, your travel pictures at the beginning of March.

Pull out the next submission and we see a different but related problem: this collection of butterfly pictures is absolutely superb. Literally breath-taking. But unfortunately we did butterflies a couple of months ago, and so we're not likely to repeat it for at least another six months. As a general rule, if you've just seen it published, don't send it in, because it's most unlikely to get used for some time.

Right, not many more packets to open - what's in this one? Oh, that's interesting, a host of slide sandwiches, where two pictures have been merged and rephotographed. This could come in handy. In fact, if you have any kind of special skill, such as using infra-red film, Colorvir toning, high-contrast printing, hand-colouring, it's well worth sending some stuff in, as magazines like to cover such areas occasionally, but find it very hard to get the pictures.

Black and white

Two more to go. This one's a boxful of black and white prints we are being offered to keep on file indefinitely. Well, good on yer mate, thanks very much - I hope it proves worth your trouble. You see, although some photo magazines still use a good deal of black and white, more and more are changing almost exclusively to colour. Add to that the fact that most magazines pay less for a black and white print than for a colour slide (even though the print probably cost more to make) and you can see the case for concentrating on colour as far as this particular market is concerned, unless you're particularly capable at black and white or have a definite point to make about black and white techniques.

To end with we have another pot-pourri of pictures. But not only are they good quality, they're also of

Unusual pictures like this one work well in competitions run by photo magazines.

those subjects which come up time and again in photographic magazines: portraits, landscapes, action, still-life etc. And what's even better, is that they all have full technical details with them: what camera, which lens, shutter speed and aperture, type of film, exposure - the works. We'll certainly want to keep these and make use of them from time to time.

CONCLUSIONS

Photo magazines do earnestly want to use the work of readers and freelances. They're happy to consider pictures sent in speculatively. And the kind of photographs that are most likely to succeed are those with some kind of technique angle, since conveying photographic techniques is what most of the magazines are about.

Women's magazines

BY JOHN DIXON

THERE IS NO market quite like the women's press. As specialist markets go, it is undoubtedly the biggest, and the most diverse. In fact, unlike other specialist markets, it is almost impossible to look at women's magazines in general terms. Most other magazines are aimed at specialist interests. But women - like men - have many different interests and lifestyles. Unlike men, however, they have their own magazines, each of which is tuned very carefully to a specific market sector.

This is a very important point to remember when you come to analyse your market. The only way so many different magazines survive is by each one aiming itself at a sector of the market that isn't completely covered by another. On the rare occasions that a publisher genuinely finds a new slot that has not been filled before, the magazine succeeds. But all too often, editors - like freelance photographers - fool themselves into thinking there is a market when there isn't, or that they can create a market when, time after time, the facts prove that they can't.

That's why, although the market has a multitude of titles that have stood the test of time and gone on for ever, a lot more come and go, sometimes within weeks of their launch.

Different markets

So what sells to women's magazines? Quite simply, *everything* - but not necessarily to all magazines. One might be strong on children, another on landscapes. One magazine might major on the older, traditional women's interests like needlework, knitting and homecraft, another could easily shun such traditions in favour of business projects and the modern working woman. One magazine might publish a lot of personalised travel articles, another might never look at travel. And so it goes on...

If all this proves anything at all, it's that there is no one surefire formula that will tell you how to sell

Landscapes figure in many women's magazines, either as pictures in their own right, or as illustrations to articles.

pictures to *all* magazines in the women's field. To succeed, then, you must go back to basics and put into practice everything you've learnt about market analysis.

Don't think of the women's press as a single market. Instead, think of it as a lot of different markets and single out the *type* of woman's magazine that is most likely to be of use to you. The different types can be summarised by analysing the type of woman who is likely to read the material they publish. Ask yourself is this magazine aimed at a woman who loves the traditional homemaking crafts, or is she a working woman who wants to know about the latest labour-saving gadgets? Is she married or single? Does she have children? Is she interested in the very latest fashions or would she prefer the more down-to-earth fashions that she'll find in the high street shops? Does she cook for pleasure or because she has to? Is she interested in straightforward stories of everyday people like herself, or is she amused by the offbeat things of life?

Remember that every editor who launches a woman's magazine has a target audience and it's

very easy to tell who that editor is aiming at simply by looking at the way he or she pitches features and pictures in his or her publication.

So, just like every other market, you should not be shooting blind. Never take a picture and say to yourself 'This will sell to a woman's magazine.' Because by now you will have realised there is no typical woman's magazine out there waiting for your pictures. Instead, find the type of magazine that suits you best, then go for just one or two actual titles so that, when you shoot your pictures, you can truthfully say: 'This picture will sell to such-and-such magazine because....' If you can genuinely give yourself a good reason *why* a particular magazine would want a certain subject, then you are on your way to success.

Subjects that sell

Here are some of the subjects that you can sell to women's magazines and the sort of magazines you should be looking for to make the sale.

Children: As a subject, children go across the board. Just about every woman's magazine will use them in one way or another. But if you're thinking that contradicts everything I've said above, think again - and think carefully about the type of child picture you aim to send to different magazines. The 'nice' picture of a little girl in a pretty pink dress, helping mum do the cooking that might be used to illustrate a feature on children in the home for one of the traditional magazines, would fail to sell to the more modern magazine that might prefer to see its children looking trendy, in a straight studio shot and dressed in the latest pre-teen fashions.

Family snapshots of children don't work; pictures of children, taken with a chosen market strongly in mind stand much more chance of success. For more information on this important aspect of the women's press, turn to Val Bissland's chapter on children elsewhere in this book.

Landscapes: Some women's magazines run features on travel and holiday resorts. Here, then, is an obvious market for the kind of landscapes you take on holiday, bearing in mind that the pictures are primarily there to illustrate words. So the pictures must have a genuine interest to the traveller and, ideally, they should be supplied with words.

Other magazines use landscape pictures on their own, without an accompanying feature. They might be used purely as fillers, showing readers areas of outstanding natural beauty in the British Isles, or they might be used with a few lines of poetry or suitable prose. If the particular magazine you are looking at

Points to remember

■ Women's magazines are the biggest specialist market around.

■ It is important to recognise the *type* of women's magazine you are aiming at.

■ Think about specific magazines, not the women's press in general.

■ Aim at the more downmarket magazines to begin with.

■ Make sure there is a genuine woman's angle in your story or pictures.

goes for that kind of approach, then you can submit landscape pictures to be kept on file; you don't have to supply the poetry!

People: Pictures of people must have purpose. With women's magazines, remember that the purpose behind the picture must also have an appeal to women. Here is a market for pictures, mostly of women but sometimes of men, who have an interesting story to tell - how they go about a certain craft; why they indulge in an interesting hobby; when they discovered they had an unusual talent; how something weird, wonderful, frightening or unexpected might have happened to them. Again, these are the kind of pictures that work best as illustrations to features, rather than as one-off sales.

Animals: In this market, some animal pictures are like people pictures - they need to tell a story. Perhaps we're talking about a dog that saved his mistress from drowning, or alerted the family to a fire in the house. There is also a market in selected women's magazines for funny animal pictures. Straightforward snapshots of family pets won't sell for the same reason as family snapshots of children don't have a

real market. But put the two together and you could have an appealing picture which might make a sale to the kind of women's magazine that needs such filler shots.

Oddities: There is a growing breed of women's magazines that treat their contents in a much briefer, snappier form than many of the more traditional publications ever have in the past. These magazines, epitomised at the time of writing by titles like *Best, Bella* and *Chat,* have an appetite for the funny, the humorous and the odd. Check out the chapter in this book by Raymond Lea on shooting oddities and then apply that thinking to the pictures you see published in magazines like these.

Cover shots: The majority of covers are straightforward portraits with simple, basic lighting set-ups that any reasonable club photographer should be able to handle. The difficulty might come from finding exactly the right model. She has to be young, lively and have the kind of personality that comes across in a picture. If you can put those attributes together you are on your way. Don't aim at the top glossies here, because most of those will commission pictures from known photographers, using professional models with clothes and make-up that might be needed to tie in with a feature inside the magazine.

A better bet, then, is to go for one or two of the more downmarket magazines who might want little more than a well-taken, lively picture of a pretty girl. Use medium format if at all possible and pose your model, allowing space at the top and sides of the frame to allow for the magazine's title and coverlines, if you see that this is their style.

Romance: Most women's magazines run romantic fiction, but many magazines don't actually use photographs to illustrate their stories - they use artwork prepared by an artist, not a photographer. Those that do use photographs fall into three categories:-

1. The straightforward scene-setting picture. This is not likely to include a recognisable person. It's

Family pictures are useful for the files in many women's magazines.

more likely to be a generally romantic setting like a sunset, with people perhaps in silhouette.

2. True-life confessions. These are story magazines, with fiction written in the first person as though the stories were true. They aren't - and the pictures that go with them are posed by models. Some are posed specifically for a story, but there is still a market for general file shots, providing the pictures show a young heroine and illustrate a specific emotion. She could be reading a letter and crying, for instance, or reading the same letter and laughing, or looking shocked at what someone is telling her, or cuddling her boyfriend... basically, if there is an emotion involved, it will help the picture to sell.

3. Picture stories. Many of these confession/romance magazines today are in the form of picture stories with words added - like comic strips but with real people in real photographs in place of drawings. This is no market for the on spec picture. Each shot is obviously posed to work along with a specific storyline. So don't try this market without first checking with the magazine for their current requirements.

CONCLUSIONS

There is a market here for just about any subject, providing you first identify exactly which magazine you are aiming at. There are many different kinds of women with many different interests and lifestyles, and each magazine is aimed at a very specific sector of the market. The women's press, then, should never be tackled in general terms. Before you start, you must be clear about which sector of the market you are aiming at and which particular title within that sector you aim to contact.

Pictures which sum up English heritage work well in the UK countryside magazines.

Country magazines

BY RAYMOND LEA

COUNTRY MAGAZINES HAVE long provided the freelance with a good market for photographs and articles. The increased leisure time people now enjoy has led to a much wider interest in all country matters and outdoor pursuits. This in turn has encouraged publishers to bring out many new titles and to revamp existing magazines. Overall, the scope for selling material to country magazines has grown considerably and it is one of the easier markets to break into.

Magazines devoted to country matters come in various styles. Some cover a whole range of topics from property and farming to sports (hunting, fishing and shooting), sailing, natural history, personalities, motoring and much else besides. Walking has become one of our most popular activities and a number of magazines concentrate on describing good walks, paying attention to many ancillary topics such as wildlife, conservation and historic sites. Preservation of the environment is a subject under increasing discussion in a wide range of publications.

There are also magazines (such as *This England* and *Evergreen*) of a more general nature combining town and country, with a decidedly nostalgic angle to them. Inevitably some country activities are fairly specialised and only those with access to them and reasonable knowledge can hope to gather material that will sell. I don't think that field sports and modern country life styles need concern us too much. My experience is that there is quite enough scope provided by more general aspects of the British scene to give the freelance ample opportunities to sell to the relevant journals.

Anyone who has even only occasional access to the countryside should be aware of the opportunities it provides to take many types of photograph that will sell. If you happen to live in the country, then the scope for freelancing is limited only by your ability to recognise suitable material. Virtually any quite ordinary detail of the countryside, such as a humble stile, an interesting sign or damage caused to a hedgerow

by stubble burning can make a fee-earning picture.

All country magazines have colour covers. Usually these are bled to the edges and space is required at the head of the picture to take the logo. Some magazines, such as *Country Life, The Field, This England* and *Heritage*, still require cover transparencies to be larger than 35mm. But this format is now acceptable by most of the others so long as sharpness is of a high order. Fine looking landscapes, shots of old buildings, river and lake scenes and some wild flowers, animal and bird shots are commonly used. Seasonal pictures are always in demand. There is no better area of freelancing than the country press to provide the impetus to get out with your camera on photogenic winter days. Sunny snow scenes are particularly in demand.

Human interest

While it is often preferable to exclude the human figure from landscape covers aimed at the more general country magazines, those intended for *This England* and the walking press stand a far better chance if they do include suitable human interest. One editor of a walking magazine has mentioned how difficult it is to obtain really good shots of walkers looking cheerfully at the camera as they hike through rural scenery. Back views of strangers may be easier to take but are less acceptable.

Most country magazines use numerous colour photographs inside. Really sharp 35mm transparencies on films rated at ISO 100 or less are usually suitable. The range of subject matter required by editors to keep on file is wide. All types of landscape picture are in demand but requirements differ. A specific magazine, for instance, might go mainly for creative, revealing pictures making the best use of lens angle and lighting. Merely pretty scenes would not be needed so much as dramatic views depicting definite aspects of the countryside. Any sign of

A picture like this can be used in a countryside magazine, to illustrate an article on the building itself or perhaps to show a landmark along the way of a walk for a rambling publication.

people would usually be excluded. Another magazine on the other hand, which might at first sight appear similar, could prefer pictures to include people such as a couple strolling through a village, a rider on a bridlepath or children playing by a pond. This could make a market for idealised scenes showing England at its most traditional. Then, yet another magazine could require pictures that depict true characteristics of, and changes to, the countryside. Also shots of pollution, modern buildings and the like.

Natural history

Magazines devoted to walking pursuits, such as *Country Walking,* usually link their colour illustrations to articles, most often provided by the author. But there may be a chance to place general interest colour slides. There is a requirement for good shots of well known landscape features such as a range of hills or downland. Again human interest is often welcome. Natural history studies can also find acceptance so it is a good idea to carry the necessary equipment to take close-ups of wild flowers, fruit, berries, butterflies and so on.

Apart from purely country subjects, some magazines, notably *This England* and *Evergreen,* keep on file picturesque colour views of all types of old buildings. The inclusion of appropriate human interest is welcome along with the exclusion, so far as possible, of modern motor cars, telegraph poles and other unsightly details. But you cannot always avoid these things (still less TV aerials) and many are shown in pictures. Straightforward architectural studies of old churches and fine houses do not need the inclusion of people. Attractive views of old towns are also kept on file. *This England* and *Evergreen* like pictures which show simple country lifestyles and evoke the past. The older generation, children and animals can all adorn your photographs to very good effect. Both magazines use 35mm but *This England* prefers 6 x 6 cm.

There is still a large demand for black and white pictures from many of the country orientated magazines. *The Countryman* continues to use only halftone illustrations, comes out just four times a year and insists upon previously unpublished photographs. However, if you can put together a good looking set on a particular theme - such as typical characteristics

of a region, the art of thatching or scenes taken on a hill farm - they may well be accepted.

The walking and outdoor pursuits magazines publish many monochrome pictures, frequently picked from their files. Anything to do with simple rambling or back-packing is of interest, from straightforward landscapes to shots of groups of walkers and pictures of wildlife. Also used are pictures showing the effects of erosion from excessive walking in a particular area, damage caused by storms, fences and signs keeping out the public, features such as dry-stone walls, hedgerows and the like. It can easily happen that a shot which you submit simply as a walking scene will be used to illustrate a particular point being made in an article, which had never occurred to you. But the more you do analyse the country scene around you, in terms of public usage and environmental problems, the better your chances of obtaining successful pictures. It should be noted that while the inclusion of people is welcomed in most walking pictures, they must be dressed for the part.

Colour and mono

In any good location I try always to take colour and black and white shots and although the inclusion of human interest is a bonus I also bear in mind that sometimes a picture will sell because no figures are showing. So I do a good deal of doubling-up. Waiting for people either to appear or disappear can take up some time but if the subject is really good it can be worth the trouble. I also take pictures of camping sites, places to stay with a caravan, cyclists in the country and any other subject that may find a leisure market.

This England and *Evergreen* use many black and white pictures of a similar nature to their colour requirements. *Country Life* and *Field* use small numbers of single pictures depicting dogs, farm and wild animals and birds, people in country situations and landscapes.

Wherever I go I always have in my pocket a good quality 35mm compact camera loaded with black and white film in order to be able to capture any likely subject I happen across. On the SLR loaded with mono film I keep a pale yellow filter permanently over the lens to aid sky tone, and sometimes use an orange for deeper tones. A polarizing filter is excellent for dramatizing blue skies in colour shots, and for generally emphasising colours. On days of pale sky tone I occasionally resort to a graduated blue or tobacco filter but most magazines require their landscapes to look natural.

Points to remember

■ **Note the many different styles of country magazine.**

■ **Check whether or not they like people in their pictures.**

■ **Picture quality is paramount.**

■ **Black and white is still important in this market.**

■ **Shoot in the sun for the best chance of selling colour.**

■ **Illustrated articles sell well in this market.**

■ **Keep thinking about all the many different aspects of the countryside.**

While black and white record shots can be taken in dull light, most pictures benefit from being taken in sunshine. The best lighting occurs quite early in the day and from mid-afternoon onwards when the sun is lower in the sky. But a strong colour subject can be photographed successfully in the sunshine of mid-day.

If you are able to turn out a fair number of acceptable pictures, placing them in magazine files can be quite rewarding on a long time scale. However, combining pictures with an article pays much better. Most of the country magazines will accept speculative freelance submissions but it is a good idea to first consult the editor to discover if he is likely to be interested, or if the subject has been covered already.

Articles can be anything from a few hundred to two thousand words long. *Heritage, Country Life* and

This England all use features on towns, villages, areas of countryside and coastline, famous old houses, churches, people from the past and many other country topics.

When describing a town the emphasis should be on its origins, its history and associations, its best remaining old buildings and, perhaps, present-day developments and problems. *Heritage* uses up-to-date articles about areas of countryside, which can be very subjective and full of personal experience or might concentrate on future threats to a particular environment. *This England* and *Evergreen* publish many articles reminiscing about country life in the past as well as village portraits and features on towns, personalities, old crafts etc.

Know your route

The walking press is an excellent market for articles describing good walks and hill climbs. Walks long and short, truly remote or close to towns, easy or rugged - all are of interest. You need to know your route well enough to describe it in exact but brief detail, mentioning footpath signs, gates and stiles, landmarks and topographical features. Count the mileage, perhaps give an approximate time for the walk and information about access to the starting point.

The British country scene is immensely varied, much of it timeless but also assailed by many changes. Threats to the environment in particular are under acute examination in such magazines as *Heritage* and *Environment Now*. Every facet of the countryside is worth photographing if you can create pictures that make clear statements.

If you wish to write articles, immerse yourself in all matters relevant to the area or place you intend to cover. The more you read about the countryside in the daily press (or glean from the TV), the more books you study, the more magazines you consult, the better you will be armed to contribute yourself.

Some countryside magazines take single pictorial pictures, but a shot like this is seasonal and care should be taken with the timing of the submission.

[It has been necessary in this chapter to include the names of many magazines that are current at the time of writing. The reader should remember, however, that books last much longer than magazines and, over the years, some of the titles mentioned might possibly have ceased to exist. The main subject matter covered, however, will go on and, if a particular title is no longer on the shelves, it would be wise to look around for a new one that, in all probability, will be covering similar ground. - Ed.]

CONCLUSIONS

The country magazine market is a lot bigger than you might have first imagined and, unlike many other markets, requires little specialist knowledge on specific subjects. Not all country magazines are alike, however, and it is necessary to study each market carefully and to take careful note of their different requirements. The magazines make a challenging market for photographers and writers - and the subjects they cover are inexhaustible.

House magazines

BY JOHN WADE

THERE'S MORE TO freelancing than merely selling pictures to the magazines you see on the shelves of your local newsagent. Because for every one of those magazines that you see on general sale, there's a whole lot more that you never see. We're talking here about house magazines - publications produced by various companies for both their employees and their customers.

Selling pictures to magazines like these might not be as ego-boosting as getting a picture into a well-known national publication, but surprisingly, the returns are often more lucrative. That's because an on-sale national magazine relies on cover price, circulation and advertising to make a profit, and when profit margins are low - as they often are on specialist publications - editorial budgets are the first thing to suffer.

A house magazine, on the other hand, is not designed to make a profit. It is there to bring information to employees or to act as a prestigious piece of marketing to customers. It is controlled, not by a publisher with an eye to making as much money as possible, but by a press, PR or marketing department, who have set up the publication with a budget approved for the year. A house magazine doesn't have to spend time proving itself profitable, because, in effect, it is run at a loss right from the start. The 'profit' comes from publicity and goodwill created by the publication.

The right rate

The result of all this is that the department that sets up the magazine recognises right from the start they have to pay the rate for freelance work - something that a good many national magazines could learn.

That's the good news. The bad news is that not all house magazines are lucrative. Some are produced very cheaply, printing in black and white only, written by employees with pictures taken by amateur pho-

tographers on the staff. This type of house magazine is the one you avoid. But against this you must set others, run by large companies who produce a product that is every bit as professional and colourful as an ordinary consumer magazine.

These magazines require several kinds of words and pictures, the most obvious being those that tell stories about company employees, and those which extol the virtues of the company's products.

Your task as a freelance, then, is to keep the possibility of these publications in mind as you go about your general freelance work. Say, for instance, that you are photographing a crafts person for an article in a county magazine. There are two other possibilities here. First, look to see what sort of equipment that person is using, ask the actual make and then set out to find the manufacturers or, if the product is a foreign one, the importers. They might easily have a house magazine that is dying for case

The opening of a local shop or restaurant could easily provide pictures for a company house magazine.

Many companies get involved in local charities and presentations are often made after staff collections. The presentations make pictures and the pictures make sales.

studies or application profiles - small features that tell readers how their product is being used in new or unusual ways.

Secondly, if the craft being practised is a hobby rather than the person's full-time occupation, don't forget to ask where they work. They should be able to tell you if their company has a house magazine and, if they have, there's another potential market for you.

Some house magazines require just general stock pictures. One put out by a company that is into banking or investment might, for instance, be crying out for pictures of investors in action, City buildings, people working in banks and the like. The fact is that many such magazines have plenty to say as far as words are concerned, but they often have difficulty finding illustrations such as these. Their only recourse is to visit a photo library, but if you can get in first, you'll make a lot of friends and a lot of sales.

Getting commissions

Another freelance possibility with this market is to let people know that you are available for commissions, taking pictures that every house magazine needs and very often have difficulty finding a photographer for. This includes subjects like cheque presentations, new managing directors, pictures of new offices, machinery, etc. Every house magazine runs such pictures and they all have to be taken by somebody - so why not you?

How do you find such magazines? That, in fact, is one of the problems. You'll find a good few listed in the *Freelance Photographer's Market Handbook,* but

Points to remember

- ■ **House magazines can be more lucrative than consumer magazines.**

- ■ **Look for the most professionally produced magazines.**

- ■ **Make sure your pictures have a specific link with the company that publishes the magazine.**

- ■ **Some companies need good stock pictures connected with their work.**

- ■ **Build a directory of contacts.**

- ■ **Put out a mailshot to advertise your services and look for commissions.**

directories such as this are more usually full of consumer, business and trade magazines. One useful hint is to watch the situations vacant pages in places that advertise journalist jobs. The *Daily Telegraph* and the *Guardian* are two useful areas here. Most of these house magazines employ at least one or two full-time staff to run them, and they are continually advertising for writers and editors. It doesn't take too much trouble to build up your own directory of house magazines, addresses and telephone numbers from the advertisements.

Alternatively, you can get in touch with house magazines by advertising your services and letting them come to you. First make yourself a mail shot. It doesn't have to be printed, it can be little more than a typewritten letter. If you have access to a word processor, even better, because you can churn out the same letter fifty times and put a different, personalised name and address on the top of each one.

Making the introduction

In your letter, you introduce yourself, saying that you are a local photographer, available for taking basic promotional pictures, suitable for house magazines or other internal publicity purposes. To that, you add a brief resume of the kind of pictures that you have on file and which can be supplied at a moment's notice to liven up otherwise unillustrated copy.

Then you mail that out to the press or publicity department of every large company in your area, together with a daytime telephone number. That could easily bring you in some local commissions. But there's no reason why you shouldn't also venture further afield, sending your mail shot to as many large companies as you can think of. Tell them who you are and ask them for a copy of their house magazine if they have one. From that you can soon determine whether or not they are the kind of company that need stock shots that might be on your files or which you could be capable of taking.

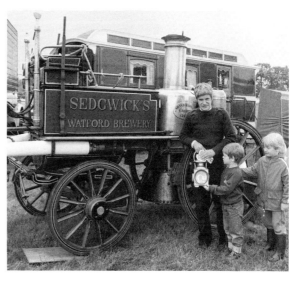

Most people have hobbies, and those hobbies can be of strong interest to work colleagues. A picture of an employee, involved with his or her hobby, then, makes another chance of a sale to a house magazine.

CONCLUSIONS

The sort of pictures you take for house magazines won't be the kind of pictorial masterpieces that satisfy camera club judges, publication won't boost your ego the way a national consumer magazine success might and it takes a bit of work to track them down. But they do give you an outlet that other freelances often ignore - and they can be very profitable.

If you are in the right place at the right time, you might beat the local paper's staff photographer to the action - and you might just get a picture that's worth the national press.

Local newspapers

BY DAVID HUGILL

DESPITE WHAT YOU might have heard, local newspaper photography can bring in the profits, providing you tackle things in the right way. But don't expect to get rich overnight because it can be a long hard road to follow.

Most local papers are fair and will pay you a reasonable sum of money for your effort. But be warned. There are some that are next to criminal. Generally, they all have a budget to work to, but if your work is good enough to publish, it is good enough to buy.

As a freelance press photographer, most of the time you are out on your own. You will have to think for yourself. There will be nobody over your shoulder telling you what to do. At least, not at the outset. Later, if you stay with it you will work alongside others from the opposition. They can be very helpful and the best of mates. But when the going gets tough, it is a very competitive occupation. You may be given some advice you would rather not hear. Like 'Get lost' or words to that effect.

If you have a picture - or just a picture idea - that you think could sell, ask yourself a few questions before you bother a busy editor. Does your picture tell a story? Does it inform? If you have doubts, look at the work of others. Go to your local newsagent and browse through the papers on the news stand. Say to yourself: I will have to match this or, better still, do better.

Do not try to cover events that you know will be covered by your paper's staff photographer. You will be wasting your time and that of the editor, and he will not thank you for it. It's better to find something different. The odd. The person with an unusual hobby. And, if you are lucky, you might just be around when something newsworthy happens - like a fire or flood. Remember that the photographer employed full time by your local newspaper cannot be everywhere. That happened to me once. A bit of luck for me and it gave me an easy introduction to the editor,

a front page picture, and requests for more work. I was on my way home from a trip to the local shops when I heard a crash. I grabbed the camera that's always with me. A van that had been chased by the police had crashed right in front of me. It was quite a mess. I quickly took a number of photographs and rushed back home, first to ring the local paper, then to process the film and make a set of 10 x 8 inch prints. By the time the reporter had arrived at my home I had a set of pictures for him to look at. As a result of my efforts, a photograph of mine appeared on the front page of our local paper.

This shows the importance of having a darkroom and the ability to make a reasonably competent print. Most newspaper pictures are in black and white and there's no time to use a commercial processor. The pictures you make must show a good range of tones without too much high contrast.

Move close, get involved

When you take pictures for local or national newspapers, don't be afraid to get involved with your subjects. It's rare that you'll sell a picture taken from a distance with a standard lens. The lens I use most is a 28mm. I like to work in close and it is fine in some of the cramped places that I find myself in at times. Like taking photographs in small bars in village pubs.

There are, of course, exceptions to every rule. There are times when it will be impossible to get close, at the scene of an accident, for instance. That's when you use your telephoto or medium range zoom lens. You might not be able to get close to the action, but you can still fill the frame with the subject, and that's the important thing.

At some time you will have to make yourself known to the editor of your selected local paper. But do not pester him, demanding his opinion on your pictures. Editors are very busy people.

Unless you really do have a big scoop, on no

account call on press day. That's the day that the paper is finally put together before printing. It might be the day the paper actually appears in the shops, but on a local, it's more likely to be the day before.

When you supply pictures, give as much information as possible with any telephone numbers that are relevant to the story. Leave your name and where you can be contacted, then get out of the way.

If the story is important and the deadline short, it may just be better to hand your film in as it is, especially if you are new to the game. Long-time staffers are old hands at turning round a finished print. You try it and you just might go wrong and waste valuable time.

It is always worth looking after the people that have helped you and the stories that you cover because people are your bread and butter. Without them you would not have any photographs to sell.

But be careful. Despite my many years experience working as a freelance, things have gone wrong for me resulting in embarrassment all round. I recently covered an event in which some girls had collected a lot of money for a well-known charity. The photograph appeared in one of the town's many papers. After that, I thanked the young lady who had given me the story and gave her a print. The young thing must have been quite overcome by all the publicity and was unable to resist giving it to another paper with the story. The same photograph and story appeared the following week in the other paper. A number of quick phone calls had to be made to explain the reason. Remember - it's your head on the block. You can never be too careful and something like this can mean the loss of your integrity.

When it gets quiet...

At times things can get a bit quiet. Or, to be frank there is no work to be found. Do not let this put a damper on your enthusiasm. This is the time when I start looking in my files of old photographs. Pull out some of the photographs that you took when you were no more than a lad. People like to look back at the old days. Select a photo of an area that has been rebuilt. Write a story around it. It is quite surprising the response you can get from an old photo.

Try to build up an extensive library of your photographs - even the most commonplace subjects such as the little corner shop or a strange street sign. Do not only photograph the main event and the dignitaries at the events you cover. Photograph the people that have come to watch. Not very important now perhaps. But give it a few years.

Points to remember

■ Be prepared to work alone.

■ Make your pictures informative.

■ Don't cover the same ground as the staff photographer.

■ Get involved with subjects.

■ Set up your own darkroom.

■ Build a library of local people and places.

■ Look for the unusual.

■ Keep up to date with your filing.

■ When the time is right, move fast.

I have recently sold a number of photographs to a local newspaper that I took many years ago under a new theme which I called 'Do you remember?' I am delighted because I have made some extra sales. The editor is pleased because the readers are writing to the paper with their memories. Remember today's photographs are tomorrow's history.

I think that this would be a good time to mention files. Are you good at keeping files? I hope you are better at it than I was a few years ago. There was an incident in which a number of people from the area where I live were involved. I had a number of the nationals ringing me asking for photographs of the individuals. They were prepared to pay high fees for them. No, I told them, I'm sorry they are not in my files. It was not until some weeks after the event when the story was almost forgotten that I found the negs that would have made me a lot of money. I now cross-reference everything. Make no bones about this.

National celebrities making films in your area are good fodder for local and perhaps even national newspapers.

Spend a little time filing now and you will thank yourself sometime in the future.

As you go about your daily routine of taking photographs and writing stories that are destined to be read by the people in your own area, keep your eyes open for that something special. Some stories have a twist that will enable you to sell them to the nationals. But don't get carried away. What may be a small sensation in Upper Wallop will not necessarily be of interest anywhere else.

To give you an example of this, a surprise wedding of a well known couple will be of interest to the readers of your local paper. But it would be a waste of time trying to sell the story anywhere else. But one story that I sold to the nationals not so long ago started out in just that way.

'Do you know that Bob and Jane are getting married this afternoon,' a contact asked. 'We have arranged a little reception for them when they return from the Register Office.' Not bad, I thought. A nice shot of the happy couple with all the friends would make the next edition of my local rag. It was not until the chap who was telling me the story was about to go that he casually told me that the wedding had been arranged by everybody: friends, parents and the Registrar. Everybody that is, except the future bride. Then the story came out.

The loving couple were going to get married at some time. But the girl just could not make up her mind as to the date. So groom, friends and family arranged for the wedding behind her back. What a story! What a picture! Despite the shock, the girl went through with the ceremony and I had a great picture. I also had a good story, which I sold to a national daily.

Contacting a national

Exactly how you do that is actually much simpler than you might at first think. To start with on this occasion, I had enough experience to know that here was a good story. Secondly, I did not waste valuable time processing the film. I chose a paper (their numbers are all listed in the London telephone book or you can get them from Directory Enquiries), asked for the picture desk and told my story as well as exactly what I had on film.

The picture editor said yes they would like it, so my next task was to get the film to them. That's when you have to work fast. I got the next train to town with my film and handed it to the picture desk. I then had enough sense to get out of the way. I came home. After all they had my phone number and the story. It appeared next day and my cheque was in the post.

Finally, don't sit there wallowing in self-made glory because of a picture in print. Today's pictures and stories will be a wrapping for someone's fish and chips tomorrow. So, as soon as one assignment is over, get out and take some more photographs. They are, after all, your bread and butter when you are a local newspaper photographer.

CONCLUSIONS

Local newspapers are probably a better market than you might have thought. But to make sales, it's best to make yourself known to the editor in advance, to recognise the kind of pictures that make news and to make sure you don't merely duplicate the work of the staff photographer.

The golden age of steam is obviously of interest to rail enthusiasts, but make sure you can caption a picture like this accurately if you want to ensure a sale.

Railway magazines

BY STEVE BAVISTER

FANCY DOING A bit of freelancing for the rail magazines? Then read these first:

Time warp: The last years of Southern Region steam were recalled on October 1 when a 'Merchant Navy' Pacific once again stood at the country end of Waterloo Station. Freshly-outshopped, No.35028 Clan Line was the highlight of a Network Day display at the London terminus, having appeared 12 days previously at Eastleigh works open day in company with fellow 'MN' No.35027 Port Line.

Class 26 No.26005 is working hard as it accelerates out of the exchange sidings at Bilston Glen colliery on March 1, 1988. The 26HAA hoppers from the 7B26 working from Millerhill which will take the coal to Cockenzie power station via the Monkton Hall curve.

Both captions come from railway magazines, and I've quoted each in full to give you an idea of the knowledge that's required to become a successful railway freelance.

Steam isn't everything in this market, remember the modern railways as well.

If it all sounds like mumbo-jumbo or a foreign language - and you don't know your freshly-outshopped Clan Line from your coal-carrying 26HAA hoppers - then you've got two choices. Either you give up the idea of railway freelancing and have a go at something you know more about, or - if you're really keen on tackling the railway markets - start regularly reading as many rail magazines as you can, to build up the required knowledge. And pay a visit or two to your local library to get some books for background information.

There are a number of important things you need to understand about rail magazines. The first is that they're essentially news-oriented. So it's no good going out and taking a nice picture of a train at a local station or an engine shed somewhere and sending it to a rail magazine in the hope that it'll get published. It won't. Unless it's got a news angle.

Is it really news?

If the loco is about to be shipped to America, or if the station is about to be demolished to get a facelift, then a magazine may be interested. And remember - news is often what is about to happen, not what just has. If you've read about it, forget it. Pictures are, therefore, extremely time-sensitive. If you think you have something which will interest an editor, be sure to get it in quick: what's news this month is history next.

The principle requirements of any news story are the who, what, why, where, when - so captions are absolutely essential. But they should never simply say what you can see. The caption must include the loco number, where it is, the date, and preferably the time.

That's the bare minimum. Captions should be expanded as far as possible - but only, as one long-suffering rail editor puts it: 'With good old-fashioned fact. Not, please, with waffle.' Accuracy is crucial,

While the market is mostly for well-captioned, specific types of engine, there is a certain amount of leeway with some magazines for the artistic approach to railway photography.

because many readers are experts, often more knowledgeable than the staff who put the magazine together!

Having scared a few prospective rail freelances off, I can tell those of you that remain that if you are pretty well informed about railways, or very knowledgeable about one specialised area, then the opportunities for getting your work published, and of making money, are very good.

The simple fact is, that almost every photograph used in a rail magazine has been submitted to it. *Rail* magazine, for instance, receives around 50 communications a day, with a large proportion of them including photographs.

Certainly there's a hard-core of contributors, whose work is used on a regular basis within the magazine. But few are full-time photographers, being in the main committed rail enthusiasts. Even so, the reliance of the magazines on what comes in is such that editors are happy - no, make that *keen* - to see more,

especially from photographers new to the subject, who might well be able to approach it with a fresh eye.

Indeed, many of the covers on *Rail* magazine are taken by people who have never had work published before - so you can see that the openings are there, if you shoot the right kind of pictures.

Pictures that sell

What are the right kind of pictures?

Well, it depends on the particular publication and, as ever, you need to do your homework about what sort of shots any one magazine uses before submitting to it.

A glance through the various titles will tell you that while the three-quarter, fill-the-frame picture of a locomotive is standard fare, a rather more exhaustive analysis reveals that there's a lot more to railway photography than that - with track information, signal boxes, architecture, coaches and people.

It isn't just the engines that make sales. There is a market too for pictures that depict track-side information, railway architecture, signal boxes and the like.

While many of the photographs could certainly be described as standard record shots, others show a willingness by magazines to take risks, and be a little more artistic in their treatment: trains in the landscape, night scenes and backlight coming through the plume of smoke from a steam train for instance.

As with any subject, it's your personal vision that will make your pictures stand out from the crowd. So be on the lookout for ways in which you can make the most of any situation. Take care with your framing. You obviously won't lop the tops off gantries and signals - it's an elementary mistake, yet one a surprising number of contributors make.

Picture composition

And pay attention to your composition. If the loco is moving, be sure to leave it sufficient space to move into, or the picture will look wrong. And, whenever possible, organise the photograph so it has a diagonal in it - making it more dynamic and eyecatching.

Use whatever lenses you have at your disposal. A kit comprising 35mm SLR, wide-angle lens of 28mm or 24mm and a telephoto zoom of around 70-210mm will be perfectly adequate for a good 95% of the pictures you're likely to want to take.

Whether you shoot colour or black and white is up to you. Increasingly, rail titles are using more colour, but their monochrome requirement is still very high. If

you do opt for colour, go for slides. And if you work in black and white, make sure the pictures are well printed and sufficiently contrasty, not flat and muddy.

Points to remember

- **Start by learning about the subject.**

- **Go for news pictures, but make sure it's up-to-date news.**

- **Supply informative captions.**

- **Look for rail subjects other than engines.**

- **Don't be afraid to try an artistic approach.**

CONCLUSIONS

Like so many specialist markets, railway photography demands a sound knowledge of the subject and an understanding of why a picture will sell - why the editor wants to buy it and why the reader wants to look at it. Learn a little about the subject, however, and the market is wide open.

Motoring magazines might use their own photographers for the majority of their needs, but there is often a place for the offbeat picture that the freelance can produce.

Motoring magazines

BY CHRIS LEES

MOST OF YOU reading this piece own both a car and a camera. So it seems easy to branch out into the car market. The reality, however, might not be as easy as it looks.

Unless you pay careful attention to market needs, selling work to one of the motoring titles can be hard and depressing. A lot of editors aren't interested in speculative material, and being the busy people they are - whisking around the world to the latest car launch - they can be rather curt on the phone.

Expect phrases like: 'We are always interested in new ideas, but as we have a staff photographer we wouldn't want you to waste your time unnecessarily.' Which can be translated as, 'We're well covered thanks. Don't waste our time.'

That's the negative side. But wait. Don't give up just yet. All you need is drive and a willingness to go off the beaten track! For a start, don't automatically go for the biggest, glossiest magazines from the large groups such as Haymarket, Link House and Reed Business Publishing. They all have staff photographers who produce 90 per cent of the work.

It's best to approach some of the smaller, more specialised magazines, and have a portfolio of published work to hand. So how do you get work published in the first place? Answer: think laterally.

Five tips

There is more to the car market than just car magazines. Here are five examples:

1. Every car needs to be insured. The best way to show the benefits of insurance is with dramatic shots of cars involved in crashes or on fire. This may all be very unpredictable, but it pays to carry a camera in the car, especially when conditions are bad. There are a number of trade papers covering insurance that would be interested.

2. Shots of general breakdowns have their place in a magazine's library. A collection of pictures showing

Road signs make a good source for humorous pictures in the motoring press.

broken windscreens illustrates the importance of screen insurance. Others, say a shot of a car broken down in a desolate spot, illustrate the importance of joining the AA, RAC, etc.

3. Road safety is becoming increasingly important, so shots of drivers in fog, heavy rain and snow are potential sellers - if you can bear the suffering. Don't make yourself a safety hazard and never stop on the hard shoulder of a motorway just to take a picture.

4. Garages and repair services sometimes need publicity pictures. For instance, a local garage may

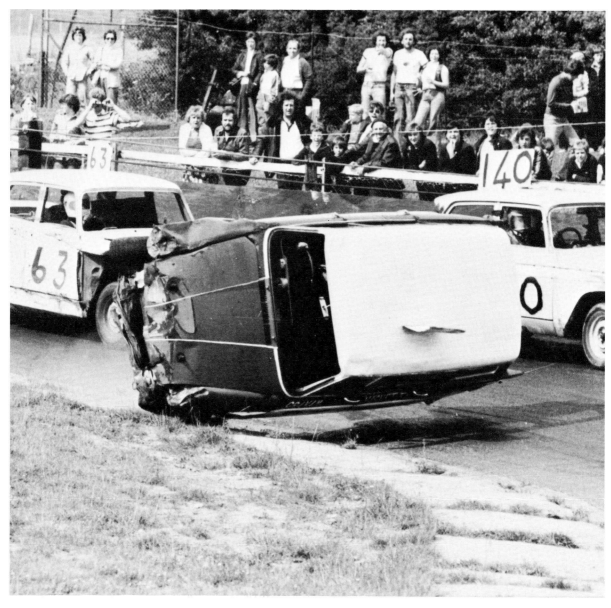

Motor sport can produce spectacular pictures for the magazines devoted to this branch of the hobby.

want to launch a new car with a press release to the papers and major clients. Or photos may be needed for a brochure to show what services the garage offers.

5. Join a car club. Once you get to know the members you can set up group shots of rare models and sell enlargements to the owners. Contributing to a club newsletter can be good experience in writing and photography. Become the club's official photographer and you will take the press pictures for forthcoming events. Don't expect the car magazines and local papers to pay for promotional pictures, but use the opportunity to become better known.

Having tackled a few minor assignments, it's time to consider the magazines again. But which ones? Titles like *The Disabled Driver* will probably offer more potential than *Car*. Equally, a title like *Company Car* would be more promising than *Autocar*. Whenever a magazine specialises, it has more need for enthusiasts in that specialist field.

Which would you rather shoot - the latest Ferrari or a fleet of company Fords? You'll probably never get

Car club members are often in the market for the more pictorial approach, buying pictures of their cars photographed in tasteful settings.

a chance at the former, but the latter offers distinct possibilities.

Trade titles lack the glamorous image, but they offer scope. A black and white feature for a trade paper on the way directors buy classic motors as company cars could also sell in colour to a classic car magazine as long as both titles are non-competitive.

The fleet car titles are one example of specialist car magazines. Some are aimed specifically at Ford owners, Volkswagen owners, etc, while others cater for the kit car market, souped-up models and renovated vehicles. Payments may be small to start with but the potential is good.

A major need

Such titles have a major need for before, during and after pictures. Even if a magazine has a staff photographer he may not want to travel to Scotland on six separate occasions over two years to photograph the renovation of one car. If you live down the road and know the owner, you are in a good position to illustrate and write the feature yourself.

The car market is large and needs to be closely monitored. Titles are often relaunched, which can provide an opening for your type of pictures. The club page may be extended and the staff could need help to cover more events. A change of editor may allow you to get your foot in the door, but it brings terror to the heart of a regular contributor. A case of dead men's shoes? Maybe, but it's a close-knit market, so an editor who likes your work will probably turn up on a similar title if he decides to move.

Tastes in cars change, and sometimes a new type of magazine is born. For instance, four wheel drive cars are now popular for on and off-road use so there are several titles to match the trend. The sudden boom in this area of the market has led to a thirst for new contributions and great potential for the enthusiast of off-road driving.

CONCLUSIONS

It's a real benefit if you can be both a car and camera buff, and handy with a typewriter, not to mention having the gift of the gab! In this market, a phone call to the editor is far more important than a feature on spec, but let him or her know you are more than capable of covering a specialist job - i.e. one that the regular staff can't do, or don't want to - it's surprising how fast you can gain the magical status of regular contributor.

Aviation magazines
BY PETER KIRBY

MAGAZINES IN GENERAL are not good markets for news pictures, simply because the time it takes to produce and print a magazine means that published news is inevitably stale by the time it reaches the reader. Aviation magazines, however, are one of the exceptions.

News pictures will often get published if sent at the right time and to the right publication. News usually means a new type of aircraft on the British register or a foreign visitor.

Magazines such as the monthly *Air Pictorial* and *Aviation News,* which is a bi-weekly, all carry pictures of this sort. Don't forget also that there are club magazines such as *Air Britain News* and *Stansted Aviation Society News* which will publish pictures if of sufficient interest, but obviously that sort of magazine really only relies on enthusiasts who are not interested in making a fortune out of their hobby!

Most professional aviation magazines have their own tame photographers who attend shows such as Farnborough and the Paris Air Show but if the right pictures get there at the right time there is a fair chance they may use yours amongst the others. The smaller, less important shows offer good opportunities for newsy pictures. The PFA rally at Cranfield each year is an ideal place to find exactly the right kind of subjects.

Obviously the airports themselves offer a huge selection of up-to-date aircraft as subjects and again any foreign 'Biz-jet' or foreign airline which may have first started using a particular airport are always newsy.

One point that must be made is that this is a market in which the photographer needs to do his homework. Nice pictures of aircraft are not going to be of interest to the real buff, unless the photographer knows a bit about the current aviation scene.

Novelty value

Any number of great pictures can be taken at shows and airports but unless they have any novelty value as well it is a waste of time submitting them. Good quality pictures are, however, desperately needed for news columns as long as they have this added interest to the enthusiast.

Extra money can be made in this market by writing features, but they obviously have to be meticulously

Vintage aircraft at airshows add a novelty value to pictures, helping them to sell to this specialist market.

Can you identify specific aircraft? If not, then you could be wasting your time with this market.

researched and presented as a complete package. Articles such as histories of squadrons or particular aircraft types or known personalities are used by certain magazines which concentrate on the archaeological side of the subject. Obviously writing a history of a subject would likely as not involve using other people's photos which would have to be gleaned from albums and libraries such as that at Hendon.

There are one or two successful freelance writer/photographers in this field and they have access to current RAF and foreign squadrons on their day to day work. These people, however, are very few and if you have the ability to supply the right kind of package, there's no reason why you shouldn't join them.

Save your time

Speculative features can obviously be submitted but if in doubt about needs, contact the magazine first to find out their requirements or a lot of time and trouble can be wasted.

One final area for up-to-date pictures these days is the aircraft auction. These seem to be happening quite frequently at various venues around the coun-

Points to remember

■ **Look for aircraft that are in the news.**

■ **Don't forget the smaller club magazine markets.**

■ **Visit smaller airshows as well as the larger well-known ones.**

■ **Learn as much as possible about the subject.**

try. These auctions are nearly always open to the public on the selling day and the price of admission can be recouped from the right kind of picture sales.

CONCLUSIONS

The aviation press won't make your fortune. But it provides a worthwhile outlet for the enthusiast who knows his or her subject and who is looking for a way to recoup the cost of film on a day's shooting.

Getting close to the subject isn't always easy, but it is essential for the right kind of picture.

Sailing and boating

BY PETER PHELAN

YACHTING IS GENERALLY thought to be a glamorous sport. Ever since the magnificent 140 foot 'J' Class boats with their professional crews raced in the Solent, the pastime has been associated with Royalty, the rich and the famous. Furthermore, media coverage of events such as Cowes Week, the Fastnet Race and the America's Cup Series, showing large expensive yachts crewed by immaculately-dressed young men, has served only to uphold the belief that yachting is a rich man's sport.

Yet such images tell only part of the story, for boating takes many forms. There are racing dinghies, dayboats, sporty speedboats, canal narrowboats, powerful motor cruisers, offshore racers and family cruisers of all sizes. And of course there are few beaches nowadays where, whatever the weather, the ubiquitous windsurfer is not a familiar sight. Throughout the year, countless thousands of people derive enormous pleasure from simply messing about in boats and, as a result, there are a host of magazines and publications which cater for their interests.

Know your subject

As with any specialist market, the freelance hoping to sell work consistently to the boating press needs to acquire at the very least, a working knowledge of the subject itself. By becoming a 'boating person' he or she appreciate the qualities an editor looks for when selecting pictures for publication. Having worked as a sailing instructor, a charter skipper and yacht delivery skipper and cruised extensively in my own boats, the experience I have gained over the years has helped me to tailor my work to the needs of the market; it has also enabled me to write knowledgeably on the subject. Whilst I am first and foremost a photographer and find time spent at my typewriter much less stimulating than working with my cameras, being able to produce illustrated articles has undoubtedly led to greatly increased picture sales.

Crewing for someone else is probably one of the best introductions to the sport, and so if you are new to the game, a visit to your local yacht club will undoubtedly prove worthwhile. Crew vacancies are generally posted on the noticeboard and many clubs and marinas are happy to display a small card giving details of your services, even if you are not a member yourself. Don't be discouraged by a lack of experience. Even if you cannot tell your port from starboard, adaptability, enthusiasm and a willingness to learn are all that is required. By making yourself available in this way and seizing every opportunity to sail aboard boats of various types, you'll gain valuable experience and the chance of some exciting picture opportunities.

I began by submitting fillers - usually news items or short instructional articles of a few hundred words accompanied by one or two black and white pictures.

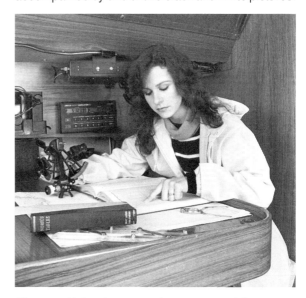

Pictures with boating connections are as useful as actual boats on the water, providing you use the picture to inform the reader.

Despite the increasing use of colour inside magazines nowadays, there is still a healthy demand for monochrome work where appropriate - a factor often overlooked by aspiring contributors. For me, catering for that need served as a useful introduction to freelancing and later encouraged me to try my hand at colour and producing full-length articles on a variety of subjects.

Successful action shots are invariably taken afloat, either from another boat or on board the subject vessel. Windsurfing pictures are an exception however; powerful telephoto lenses mounted on tripods ashore are the order of the day here. I am fortunate in having a boat of my own which often serves as a photographic 'platform' when shooting pictures of yacht racing or other vessels under way. It is also the subject of some of my instructional articles and is used to gather stock pictures, cruising and pilotage material.

However, do not despair if you are unable to gain access to a photographic boat in which to speed off in search of glamorous action pictures. Interesting shots of people actively engaged in the various aspects of sailing can be equally successful and these are best taken aboard the vessel concerned. Harbour scenes, pictures of prominent headlands and lighthouses, boats laid up ashore and people working on their boats all sell and need not even be taken afloat.

The right angle

With action shots, try to get in as close as possible for maximum 'impact'. When looking at some of my pictures, people outside the boating world sometimes comment that I have 'chopped off the top of the mast,' as they put it. And yet to include it, often results in a disappointing picture. Some of the most dramatic shots published, those which convey the power and excitement of a yacht travelling at speed, are close-ups. You should of course include shots of the complete boat in your coverage, especially if she is flying a colourful spinnaker or has an attractive or unusual rig. However, in yachting, the general rule of thumb is: if your pictures are not good enough, you are probably not close enough!

Once you have established a certain rapport with editors, you'll find them willing to discuss article ideas in principle and this is a great help in establishing a magazine's current and future requirements; it also minimises your speculative submissions! In due course you could look forward to receiving commissioned work on a regular basis. I now conduct boat tests or reviews on behalf of magazines and find these particularly rewarding since I usually get a cover shot in addition to the article (editors will often use a cover picture which ties in with the editorial content of a particular issue), and sell pictures to the boatbuilder afterwards.

Don't confine your submissions to magazines only. There are a surprising number of picture buyers in the market for top quality boating shots, especially if you include such things as harbour and inland waterways scenes in this category. Books, calendars, postcards, greetings cards, and hotel, holiday and tourist brochures are all potential outlets for your work. One of my most successful pictures in freelancing terms has been a shot of a Falmouth Working Boat (a traditional sailing oyster dredger) sailing past St Mawes Castle, situated in the Fal Estuary in Cornwall. In addition to appearing in a variety of publications, on

Points to remember

■ **Try to get a working knowledge of the subject.**

■ **There is still a healthy demand for monochrome.**

■ **Harbour scenes, headlands, lighthouses, people working on boats make good sellers.**

■ **The closer the subject, the better the impact.**

■ **Boat builders make a second market for published pictures.**

■ **35mm is accepted as the norm.**

■ **Take care of your equipment around salt water.**

one occasion it was used for promotional purposes (with the caption 'An Englishman's home is his castle') by a firm of estate agents.

Probably 95% of my work, both colour and black and white, is shot on medium format with a Bronica SQ-A. For cover and brochure work, the larger transparencies have the advantage over their 35mm counterparts, and I find a Polaroid back useful for checking lighting on interior shots, particularly when a balance between daylight and flash is required. I have a modest Minolta 35mm outfit which I carry when I occasionally need to travel light, but I feel more comfortable with the Bronica and am prepared to accept the weight and slight inconvenience of the system compared with 35mm for the benefits of the larger format. In my early days, I used a Mamiya C330F TLR complete with 'L' grip and porrofinder!

However, I'm a little unusual in using medium format almost exclusively, since 35mm transparencies are widely accepted throughout the boating world and are probably considered the norm. Zoom lenses are convenient to use, allow you to compose your shots easily and, with fewer changes of lens, there is less chance of water finding its way inside the camera when working afloat. Focal lengths (in 35mm format) from 24mm to 210mm will cover most requirements. Wider angle lenses are occasionally used for yacht interiors, but distortion of verticals becomes apparent and, since I dislike the effect, I avoid them. With anything more powerful than about 200mm, camera shake becomes a problem afloat.

Taking precautions

Cameras and salt water do not generally mix well and if you intend working afloat in rough weather or from a small boat such as an inflatable, some form of protection is essential. A proprietary brand plastic water-tight housing offers complete camera protection and will even allow you to use it under water to a depth of about 30 feet. However, operating a camera encapsulated in this way is a little cumbersome and if you intend using one frequently under such rigorous

To get maximum impact, it is sometimes necessary to crop the top of a mast. This won't necessarily detract from its commercial chances.

conditions, a modern SLR fitted with motor-drive and autofocus will undoubtedly make life a lot easier.

Since my own boat is fitted with a cockpit shelter, I rarely take any special precautions like this. I merely dismantle and carefully clean the camera immediately after a session afloat. Despite receiving more than its fair share of spray over the past four years, it remains virtually unmarked and has never let me down. However, I have found placing the camera inside a clear plastic bag with an aperture cut out to allow the lens to protrude, useful if conditions are particularly rough.

Finally, try not to become too preoccupied with equipment. I regard my cameras and associated gear as simply the tools of my trade. Of course a photographer, like any other skilled craftsman, needs top quality equipment if he is to give of his best. However, it is the way in which he uses those tools that determine his success or failure.

CONCLUSIONS

A basic knowledge of the subject is a prime requisite for this subject, but that doesn't mean that you have to be a sailing expert. A willingness to learn, coupled with a modest 35mm outfit will lead to success.

Copying other people's glamour poses can give you a good introduction to this kind of photography. You'll soon find a style of your own.

The glamour market

BY GRAHAM BETTS

IT IS EASY to imagine yourself on a deserted, sun-drenched island with three beautiful models and a couple of assistants shooting the next set of glamour pictures for some prestigious calendar production. Alas, the world of freelance glamour photography is rarely like that, so let us return to the real world.

For most glamour photographers, success is based on planning, practice, persistence and a totally professional commitment to producing and selling glamour pictures. These, in common with mastering the techniques of photography, have to be supplemented with an ability to work and communicate with people.

Taking a series of pictures is not simply an equation of photographer plus camera plus model equals picture. Many hours may be spent planning a glamour session before the shutter release is pressed.

One of the first problems to tackle is deciding what type of pictures are required. Market analysis provides guidance in this matter, and, having decided upon which area is to be worked, the next stage is to amass a number of ideas to suit.

Copy the success of others

Originality is one of the rarest commodities in glamour photography. After all, most of it has already been covered. How do you photograph a girl in such a manner that is so different and so appealing, the picture is bound to sell? When I started out, I found the answer lay amongst the pictures produced by my contemporaries. I quite simply copied by using a pose from one picture, the dress from another and the setting from a third. The use of tracing paper to sketch the combined ideas proves useful here, enabling the picture to be viewed in reverse to give it a different look.

To help me cheat, I collected masses of pictures. Magazine clippings, old calendar pictures, newspaper pictures and anything else which prompted an idea, the end results being original pictures. Work

Seasonal glamour pictures work well in markets such as puzzle magazines where they can be used for cover shots.

this way at the beginning and, eventually, original ideas will develop automatically.

When I first started building up my stock pictures I decided to keep my pictures simple and very soon found that I had a reasonable collection of well-taken,

Always give the editor a range of different poses and shapes. Not all glamour pictures need to be shot in vertical format.

plain background, material which quickly sold to a number of puzzle magazines. These included portraits and pin-up pictures (girls in swimsuits, etc). Only later did I start taking more ambitious pictures for calendars and magazines.

Restricting photography totally to one narrow parameter I found was a mistake. Having committed a hefty sum of money engaging a model, it made sense to include as many peripheral variations as possible such as topping up stock portraits and including clothed glamour even if the model was booked for topless work.

Increased selling potential

I habitually shoot both colour and black and white during each session as this opens up more potential for sales. Not every publication is colour only.

Organising ideas into a sensible order is also very important. If the session requires building a set, this should be sorted out before the model arrives and be the first part of the session. It is time consuming erecting sets when the model is already in the studio, so be prepared. Similarly, if you require the model to

get wet , this should be left until the end of the session and time is not then wasted whilst she dries her hair.

Shoot all pictures requiring the same background together, even if it means asking the model to change clothes repeatedly. Most models appreciate being kept busy and would prefer this to watching a photographer wrestle with background papers.

Always remember that time is money. There are two areas of expense which glamour and portrait photographers incur and which can be a great drain on resources - studio and model time. Both should be utilised to the full by careful, logical planning.

I was lucky in the fact that no studios were available in my part of the country and I was forced to utilise my house instead. This, over the years, has not been a handicap and has actually proved useful in the availability of settings around the house. My investment in good quality studio flash equipment has also proved economical over a period when compared with studio hire. With the exception of a few, all of my pictures have been taken at home and this has not affected their saleability at all.

The equipment I use to take pictures consists of two 35mm Canon SLRs and a Mamiya RB67 with film

backs for 6 x 7 and 6 x 4.5 formats. My black and white pictures, which are home processed, are shot on Ilford FP4 and colour transparencies are taken on 35mm Kodachrome 64 and 120 Fujichrome 100.

Models can be obtained through a variety of sources, the most expensive being agencies. Models from agencies do have the advantages of experience, grooming technique and a good wardrobe which all help to make good pictures.

At the other end of the scale, there are the amateur models - the girl next door for example. Generally they will lack the finesse of professionals but with a little coaching from a photographer, can provide some good pictures at very low cost.

It may be difficult to book models from an agency until they have assured themselves that the photographer is bona fide. Similarly, asking amateur models to pose can present problems without some evidence of good intention. To overcome this, having a reasonable portfolio of work available which can be shown to both agencies and prospective models is very desirable. Comparing success rates of picture sales, the professional models do have the edge. There have, however, been some notable exceptions where pictures of amateur girls have sold and the professionals been rejected. The highest single fee I have ever received for a picture was of a sixteen-year-old amateur, used by a calendar company.

Keep the model informed

Wherever a photographer obtains his models, it is absolutely essential that the model understands that the pictures taken are for sale and a signed model release is obtained.

The photographs I take are placed in my own picture library, carefully itemised, and kept on a computer database which enables me to keep accurate records. My mini library does not compare in size with some of the big boys, but with just a few thousand images on file I know that each submission despatched contains the work of one photographer - myself. Had all of my work been committed to a picture library I would have no control over their destiny and I feel sure that they are marketed far more vigorously by myself.

The market for glamour pictures is very large and for someone new to the subject the problem is not so much where to send pictures but where to send them *first*. For example, *The Freelance Photographer's Market Handbook* lists seven publications under the heading 'Male Interest' alone. Only when the obvious markets have been circulated does the job become

Points to remember

■ **Plan your sessions carefully in advance.**

■ **Try to be original.**

■ **Don't forget the importance of black and white.**

■ **Don't waste model or studio time.**

■ **Get signed release forms for every session.**

■ **Learn by your mistakes.**

more difficult.

When searching for new markets, look for the unusual. When studying the *Handbook* I noted that *Club Mirror,* listed under 'Arts and Entertainment', used glamour for front covers which resulted in selling two pictures.

Finding myself in this position, having offered my work to all the obvious English magazines, I started collecting foreign publications using similar material. These were collected whilst on holiday and by friends whose work took them abroad.

With my first submission I sold three black and white 'Page 3' type pictures to a German publisher, followed by a front cover. With my third submission, two more cover pictures were sold to another German company.

One of the illustrations used by a German publisher has gained repeat sales in the UK and is without doubt my most successful shot. To date this very simple plain background picture with a girl exercising with dumbells has appeared on four magazine covers and two calendars.

Calendars presented some problems when I was researching for markets because not all give an

obvious identity of publisher and it is essential to study them closely. Look at the backs and the small print for the information required. One calendar publisher, for example, prints the company name at the bottom of the December illustration and it's no good waiting for December to arrive before you start submitting work. Many calendar companies start receiving submissions as early as September.

Not all publications use overt glamour. Many use tasteful pictures of pretty girls. Find out the general policy, including preferred formats or print size before submitting.

Another approach to the market is to create a demand yourself. I was contacted by the editor of my local newspaper who had noted my advert offering portfolio services. He required pictures of local girls to supplement a personality girl competition being organised by the newspaper. Unfortunately I could not assist him. Later, having thought about his request, I returned his call and suggested using pictures of other models, some of whom had appeared in the national press. Since then I have been supplying pictures on a regular basis with an albeit modest income in return. Wherever appropriate, supply details of models, background, hobbies, etc. This can make the difference between selling a picture or not. However, care must be taken to ensure that details supplied are correct if the model's name is used.

Adding spice

Occasionally some men's magazines make up stories to add spice to the picture sets. In these cases, ensure that a false name is used. Local advertising and publicity agencies sometimes use a glamour shot and it is worthwhile circulating details of pictures and facilities to them. This could result in a picture sale or even a commission if they do not have glamour expertise.

Other areas of sales include keep fit magazines, photographic magazines and record sleeve producers in Australia, Austria and Brazil. The record sleeve

Not all glamour pictures have to show nudity. A model's expression can often say just as much.

sales were made through a picture library which has a select batch of my pictures and appropriate credit must go to them.

To assist in approaching editors and to create an impression of professionalism I have my own stationary printed, consisting of headed paper and business cards. When contacting foreign publishers I always have my letters translated into whatever language is required. I consider this vital and the minimum of courtesy. With any publication, find out who to contact and keep up to date with staff changes. Editors like to see their names at the top of a letter, not that of a predecessor.

Having written of my methods and achievements, it would be unfair to give an impression of total success without failures because this is a long way from the truth. There have been many failures, far more than I like to recall, which only serves to illustrate what a tough area of photography glamour work is. The important thing is to look at your rejections, to compare them with the market and to try and see honestly where you went wrong.

CONCLUSIONS

Get the right girl, polish up your technique, think of original poses, give the market what it wants and you'll be on your way to success as a freelance glamour photographer. But never forget the final quality needed for success - sheer determination.

Camping magazines
BY CHRIS LEES

PICTURES AND WORDS go hand in hand when you sell to the camping and caravan market. These titles are all about the outdoor life, yet they are usually edited by a small number of staff, stuck in an office, who rely on work from enthusiasts... and that means you.

When you set out to work for these magazines, think more of travel than of tents and caravans. There are many sites at home and abroad which people want to learn about. The art is to piece together a vision of the area you have been to.

Few writers take good pictures and vice versa. To start with you may want to work with a friend or family member. But note that fees are often on the low side: most pictures will be in black and white and copy will rarely extend beyond 1,500 words.

So to start with, submit a feature simply for the fun of it. Check with the editor to see if he is interested on spec, and that the subject hasn't been covered.

Then build the feature around the trip, taking shots on the good days and writing on those dull, drizzly days.

Keep a notebook

Don't go into great detail about the campsite unless asked to. Do keep a notebook with details of the address, how to get there, the state of facilities, number of pitches, charges and a contact phone number.

Even if your first feature is used it may be held on file for some months, so don't be too seasonal. For instance, 'Coping with Camping in Autumn' is likely to be held back for an entire year. By that time site charges will have changed. The editor will need the contact phone number to update details.

A map will be the most vital piece of gear. It pinpoints a site and is needed to check places of interest, such as castles, country walks and nature parks. Tour books are also a good guide and will help

Camping information can be tied in with other hobbies - and they can be used to illustrate a camping magazine article.

build a folio of picture and feature ideas. But beware of turning the piece into a simple travelogue.

Another idea is to link the story to a hobby or pastime. If a caravan acts as a base for studying, say, wild deer, then the readers will want to know what sites to visit, the best times of year, and the best ways to kit out yourself and the caravan for the occasion. The same could apply to windsurfing, diving, hiking or even pub-crawling!

Hiking is the most obvious outdoor pursuit to

Good quality landscapes sell to this market - providing, of course, the location can be tied in with camping or caravanning in some way.

cover. Some of the newer magazines devote a lot of pages to this, and have a higher number of colour pages than normal. But the standard of pictures on colour pages will need to be very high.

Medium format is the norm for cover shots of landscapes and a sturdy tripod becomes important if not essential - not the sort of gear you want to drag around on a hike.

Camping by bicycle or motorcycle is another off-shoot of the outdoor pursuit theme, covering the problems of carrying gear, where to find secluded country lanes and out-of-the-way campsites to go with them. Even if the camping mag isn't interested, there's a second bite at the cherry with the bike titles.

Matters of land development and environment are causes for concern to many editors. Some development is to the good: the opening of the channel tunnel opens up many features in itself, including the best ways to get abroad and the most interesting sites in Northern Europe. But you could feature the negative

side of this: the way countryside in the South of England and Northern France is being eaten up by the developers to provide new housing (and fewer campsites).

Other matters, such as pollution of the very rivers we camp next to, the illegal dumping of waste in beauty spots and the destruction of rare species also show the less happy side of camping and caravanning. These all offer a small but lucrative sector of the market and can be developed for other magazines as well. But do plenty of research into each title's slant or be prepared to pick up a lot of rejection slips.

On the plus side, an area reclaimed for camping and recreation would be of interest. A trip to the nearest library to study local papers gives some idea of facilities and the most radical changes happening to the area.

Don't forget that before and after pictures of an area are an effective way of illustrating a feature, whether it be the way a campsite or the surrounding area has grown over the years. You'd have to visit the site often and remember where you took the pictures from, but the resulting shots will have sales potential in photo libraries as well as the camping mags.

Points to remember

- **Pictures sell best with words.**

- **Build your submission around an actual trip.**

- **Make notes on campsite details.**

- **Refer to maps and guidebooks.**

- **Couple camping with other hobbies or interests.**

Pictures which show the way the environment is being eroded or spoilt can make good file shots for this market.

CONCLUSIONS

Camping and caravanning magazines make a good starting point for the newcomer to freelancing and, with a little thought, they can turn a holiday into a profit-making trip. But remember that you're not just writing and illustrating a travelogue. Keep the information relevant to campers - and remember the importance of black and white in this market.

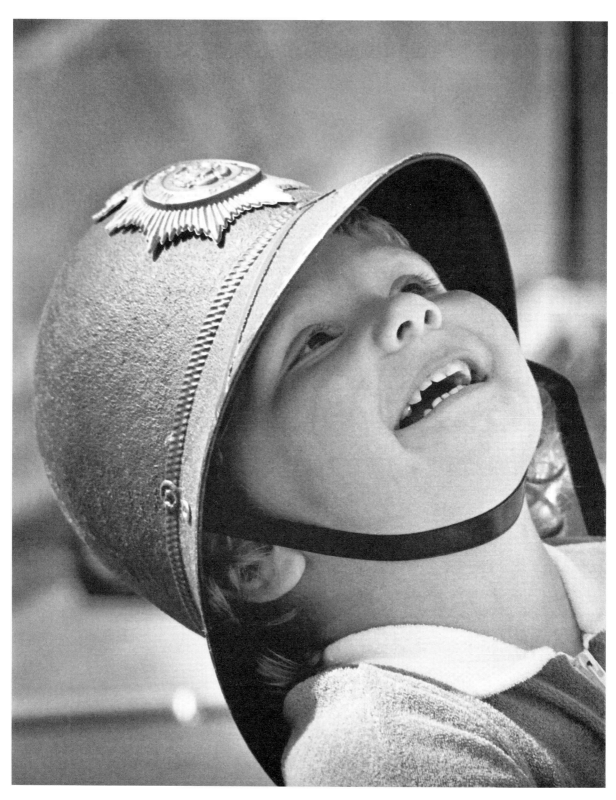

A saleable child shot should be several steps removed from a family snapshot. A good happy expression always helps the sale.

Markets for children

BY VAL BISSLAND

PICTURES OF CHILDREN are in constant demand by editors and advertisers alike, as a glance through almost any general magazine or newspaper will confirm. In many ways children fall into the same category as attractive women - they catch the eye and can be featured to call attention to anything from asprin to airlines.

An example in the quality papers illustrates this point. An airline from the Far East took a whole page black and white spread depicting a close-up of a bespectacled, bright young lad, immaculately dressed in his school blazer. Maybe they couldn't say it directly, but the implication was that here was a company to trust. The advert had a direct emotional appeal. This was no hi-tech image of computer-based, error-free flying, even though these were implied in the straightforward gaze of a trusting child from an obviously caring family background.

This analysis of an advertising shot does not mean that it would be a good idea to arrive at a company headquarters waving a similar top quality set of pictures and expect a warm reception - far from it. Advertising material is rarely acquired in this manner. However, dissecting the different elements in this airline ad demonstrates the way to make sense of the diverse images of children which find their way into print. Each fulfils a very specific function, usually in connection with an accompanying text and many of these pictures are supplied by freelance contributors who know the type of shot a particular editor is on the look out for.

First of all let us deal with the familiar images of children with little publication potential. Portraits of the type that sit on doting parents' mantelpieces and grinning young faces in holiday snaps fall into this class. Two features that these genre have in common are cheesy smiles and a posed look. Yes, the children may be pretty as a picture and be ever so cute, but what most editors are looking for are natural activities recorded in an unobtrusive way.

Before exploring technique, let's first take an in-depth look at the editorial side by looking at one market where there is an undoubted market for top class child studies. From this detailed examination, various principles will become obvious which can then be applied to whichever magazine at which you are aiming. We are going to look at women's magazines.

Despite the changing positions of men and women in society, there is little shift in emphasis in the traditional women's magazines. They are aimed at those who take pleasure in the role of child-carer and home-maker, although nowadays these women may well combine this with a career. *Woman's Weekly* is just such a magazine, selling over a million copies per week.

Important facts

There are some important facts for the budding freelance to note here. Firstly there is the obvious one that 52 issues come out each year, not twelve as is the case with a monthly: given that you are submitting pictures of the correct content and quality, there is a much greater chance of acceptance. Secondly, with a large circulation, they can afford to recompense their contributors more generously than a low budget specialist magazine and they pay promptly. Thirdly, your material will be handled in a business-like manner. If it is not what they are looking for, it will be returned in pristine condition (provided, of course, that it was adequately packed originally with return postage included). Fourthly, *Woman's Weekly* has a long pedigree and the chances are that if your work meets their rigorous standards it will provide a regular source of income for as long as you continue to deliver the goods - many magazines are here today and gone tomorrow. So there are four good reasons to look again at the kind of pictures they require and in what context.

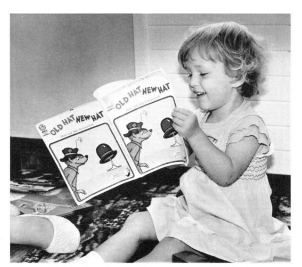

Show children involved with some aspect of their normal life and you'll increase your chances of making a sale.

Three regular features use child studies, although not at the same rate. The most obvious one is by a child care expert and covers the whole range of ages from birth to adolescence, although the younger stages predominate. Often it has a medical slant - allergies, earache, immunisation and so on. However this is not a medical journal and they have no wish to show disease in all its gory detail nor depict children in distress.

So however good your photography, horrific pictures are out. But a shot of an attractive child sneezing in the case of allergy or turned towards the camera with an ear prominently displayed to illustrate earache would be quite appropriate. There is a general point to be made here about non-specialist magazines - they shy away from the realism found in many publications targeted specifically at mothers of babies. It is not uncommon for the latter to feature a step-by-step series of a live birth in full colour.

Be positive

This sort of clinical detail has no place in normal illustrative photography. In fact almost the opposite is more likely to succeed, with the accent very much on non-stressful situations with positive, happy children who are coping with life very well.

Apart from medical advice, they also feature education, language and writing skills and cover widespread problems like dyslexia. Illustrations for these topics can be set up in your home or the child's with just one subject. Alternatively, you may find an obliging teacher who will be happy to let you take pictures in her classroom. If you do this, it is a wise policy to approach the ruling authority as well so that your status as a bona fide photographer is established.

There is an important point to make here about the way your pictures are used, when the subject matter they are illustrating is a sensitive one, such as learning difficulties. The parents of the child you have photographed could take umbrage if there is not some indication on the page that it is in fact *only* an illustration and not a picture of the real thing. Editors are aware of this dilemma and tackle it in one of two ways. They can add the caption - 'Posed By Models' or simply print underneath, for example: 'Most children learn with ease'.

These are simple tactics but extremely essential if the very people who trust you with a camera are not to be alienated or upset unnecessarily. It is not a bad idea to draw attention to this when submitting certain pictures, even though you have the full consent of the parents to offer for publication. *Woman's Weekly* are well aware of this problem and always proceed with caution and tact.

Pictures of opening Christmas presents, Halloween, meal times, cleaning teeth, twins, playing games, picnic time and the like are on much safer ground and are used to illustrate aspects of normal childhood development. The essential elements are that healthy and happy children are depicted busy, active and absorbed.

Don't take false pictures. Show children in their natural environment.

The second feature where pictures of children crop up now and again is a philosophic piece about how to cope positively with life's ups and downs. This can sometimes stretch to a double page with one of the pages taken up totally by the picture, which means, of course, more remuneration at the end of the day. For example, in one issue the theme, 'Feeling at odds with the world but taking action to change this' used a picture of a four year old boy hoeing the garden with a toy rake. Another week the article propounded the benefits of time for quiet reflection and used a shot of a five-year-old girl pouring out a cup of tea from a toy teapot. You can see that although the links are tenuous, what scores here are the positive attitudes displayed, combined with good photo technique, attractive children and natural expressions.

Angelic expressions

The third setting where a child study occasionally occurs is in a small theological item written by a minister of religion. Normally a picture of a church illustrates this feature. However close-ups of a child's face with a suitably angelic expression have been used. Childhood innocence is an elusive quality but if captured on film it is a winner.

As regards the first and third items mentioned above, they tend to be predominently monochrome and this is often for technical reasons connected with their positioning in the magazine. The philosophic piece is now always a colour slot, but of course it uses not just children, but many subjects. So to submit only transparencies reduces your chances considerably.

The general point to emerge from this close look at *Woman's Weekly* is that success in freelancing comes from providing editors with the pictures they want - which are not necessarily your ten best child studies. These ten superb shots, providing that not only the content but also the quality is right, will probably sell over a period, although not to the same concern.

Apart from general women's magazines there are specialist publications aimed at specific groups - mothers-to-be, mothers of toddlers, young parents, etc. The same criteria apply as with the general magazines. How much colour? How much black and white? Realism or romanticism or both? These two magazines welcome portfolios but, remember, not your ten best shots! Offer only comparable style and quality or it is a waste of everyone's time. A brief phone call to the editorial office will establish whether they are in the market for pictures but do not expect

Points to remember

■ Note the difference between family pictures and commercial pictures.

■ Look at the different ways pictures of children are used in one market.

■ Extend that way of thinking to other markets.

■ Shadowless lighting works best.

■ Keep a good library of different situation pictures.

■ Avoid fast-changing fashions in clothing.

to talk the editor into putting your material on file if they are snowed under with other people's work. Accepting their decision without question saves time, energy and embarrassment.

Knowing what kind of shots are required is one thing: knowing how to create them is another. This is where there is no substitute for technical expertise. It is taken for granted that you can produce grain-free, sharp pictures with a full range of tones if working in black and white and spot-on exposure and controllable contrast if using reversal film. These are basic requirements for any freelance, but especially when photographing the complexions of children. Coarse grain and deep shadows are rarely appropriate.

There is a technique which I often use indoors which creates a type of even lighting which does not restrict subject movement too much. This is especially important with young children to avoid continually interrupting the flow of activity to re-position equipment. Two flash units are involved - one mounted

on a stand or tripod with the head bounced off a white wall or ceiling (or a white screen if absolutely necessary) with the sensor directed towards the subject; it is attached to a slave unit; the other gun is set on manual and bounced from an umbrella on the other side of the camera.

If you are a young parent yourself, you are bound to have friends with families. This puts you in the best possible position to have uncomplicated access to other children. Whether a parent yourself or not, your social contacts and your social manner will determine how easy or how difficult it is for you to find subjects. It is possible to advertise very cheaply in your local newsagent for families to model but it is never so easy to walk into a strange household and take the variety of natural pictures that occur normally when you are a familiar and trusted face. This is especially the case when the children are older and more self-conscious: with a relationship already established they tend to relax quickly and get on with their own activities.

Use the light

Local playgroups, however, usually welcome a photographer in their midst. Available light is safest with a hoard of youngsters careering around. So choose your visit to coincide with a bright day. As a last resort you could use direct flash. By carefully selecting a suitable background which is close to the subject, the scene will be evenly lit. In a large hall, the light from the flash falls off and the area behind the child can resemble a black hole. Also with direct flash there is the characteristic hard shadow under the chin and behind the figure. It is, in fact, much better to use the flash in its bounce mode.

When you have gone to the trouble of arranging a good picture-taking opportunity, tackle it from as many angles as time permits - a few general shots and some group pictures as well as individuals. It is a good idea to present a playgroup with a numbered set mounted on a board because you can be sure that parents will want to order. Without some means of identification it would be difficult if not impossible to

do this. Even your local newspaper might be interested in a group picture. From such contacts your name starts to become known and other doors open.

As your pictures begin to appear in print and editors become used to receiving regular batches, the day will dawn when a request for a specific shot will come in. Provided that you have a good cross reference system for your library of pictures (or a very good memory!) it may be possible to print something suitable from your files. However, more often than not, the request is for a child of a particular age or sex photographed in a precise way that you have to set up specially.

When this happens it is essential to act quickly and a good network of ready and willing contacts then pays dividends. In a case like this the copyright remains with the photographer so the chances are that you will be able to sell that shot again or others taken at the same session. In this way you will more than recoup the initial outlay, time and effort and broaden the scope of your work.

Another way of improving the chance of multiple sales is to make small prints of your best shots and mount them with their reference numbers on A4 paper. These sheets are photocopied and mailed off with a covering letter to possible magazines and publishers to be held on file. Not only does this provide a cheap and ready visual reference but it means that you do not have the expense and trouble of producing a top quality print until it is required and you are paid.

However, if the publishers are unfamiliar with your work it is sensible to include a sample photograph which demonstrates clearly the standard of a final print. Don't expect there to be a stampede to your darkroom door but such tactics pay off in time especially if you periodically add to the file, keeping your name to the fore.

With long-term potential in mind it is important to exclude certain things which will date, like fashionable toys or pop T-shirts. Trade name on garments are also to be avoided. Shirts, shorts and print dresses in pastel shades stand the best test of time.

CONCLUSIONS

To achieve the most effective degree of control and to take the most saleable pictures needs planning, organisation, attention to detail, tact and diplomacy. Given these attributes, a freelance photographer of children can look forward to a successful and enjoyable, if somewhat energetic, career.

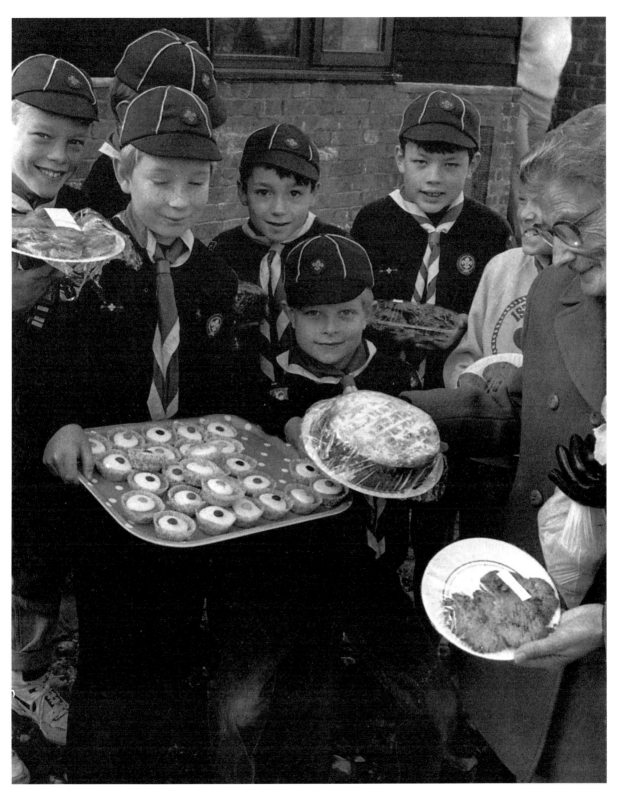

*Playgroups, schools, local clubs and organisations like cubs or brownies all offer
potential for freelance sales in the market for children.*

Not all sports pictures need to be deadly serious. Adding a touch of humour will often help to make a sale.

Selling sport

BY MERVYN REES

SPORTS PHOTOGRAPHY APPEARS to have an aura of glamour which attracts many would-be followers. The reality is that it is now an overcrowded profession, and making a part-time or full-time freelance occupation out of it demands planning, dedication and skill... and that's just for starters.

At some early stage the aspiring freelance sports photographer needs to define clear objectives and aims in relation to his or her sports coverage. Whilst a deeper knowledge of, and interest in, one or two specific sports will provide a sound foundation, success may be attained more easily by involvement in a wider range.

Having decided where we are and where we hope to go, it is necessary to consider how these ends are to be achieved.

Although most of us initially tend to develop brand and system loyalties for equipment based on financial realities rather than planned anticipation of needs, at some stage there is a need to consider a systematic approach to equipment. Planning is needed to ensure that hardware will match the longer term demands imposed by working needs and environments. Systems need to be tough, have a wide range of compatible lenses and accessories, and have good service back up.

A good lens range

I find that my needs are matched by Nikon; I use two manual focus bodies, both with motor drives and a selection of a dozen lenses ranging from 16mm to 500mm. My guiding principle as far as lens selection is concerned is based on all my lenses, wherever possible, having a minimum f/2.8 aperture capability. Anticipating future developments I also use an autofocus Nikon with two AF zooms, 28-85mm and 70-210mm.

An appreciated bonus with Nikon is registration with its VIP service which guarantees fast servicing of

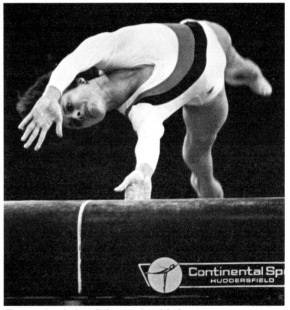

Fast action in low light needs wide lenses to compensate for the fact that flash is never allowed in the sports arena.

equipment and regularly up-dated information of new products.

Sports photography demands total familiarity with and knowledge of the camera and equipment being used. Response to rapidly changing situations needs to be instinctive, and the camera must not intrude between the photographer and the action.

Some basic techniques are worth practising until they become second nature: follow-focus, involving maintaining sharp focus on moving subjects, is an essential skill. Action replay, sadly, is for television only and every sports photographer has sad memories of opportunities lost or wasted because of technical incompetence.

A motor drive is not a solution to catching the action peak, even the fastest available could miss

that critical moment. A motor drive, for me, enables *developing* action to be recorded, takes away the distraction of manually advancing the film and provides a quick means of rewinding.

Whilst the need to know how equipment operates is an obvious skill, another area which will repay research is knowledge of the sport or activity which you intend to photograph. What are the high spots likely to be for photogenic activity? Are you aware of at least the basic rules, regulations or laws of the activity and of the programme structure? Is flash permitted? For many indoor sports, especially gymnastics, flash can be highly hazardous to the participants.

When using long lenses such as 300mm, I will always, by first choice, use a tripod, or if conditions do not allow, then I find a monopod to be a must.

Colour or mono? There is still a considerable market for mono and for most freelances it still, probably, offers the greatest scope for sales.

Many freelances, particularly the less experienced, regard accreditation - the obtaining of a press pass - as their major area of difficulty. I have rarely found it to be an insurmountable problem. In the first place, be realistic. Some major international events are very difficult: Wimbledon is a classic example. My answer to the problem of obtaining annually up-dated shots of the tennis elite consists of going to the two lesser tournaments which take place in the fortnight preceding Wimbledon, at Queens Club and at Eastbourne. Most of the stars will be competing and there will be opportunities to get closer to them than is ever possible at Wimbledon.

Choose your level

The level of expertise and experience attained will influence the event level, whether local, national or international, to be operated in. Decide which level you have reached when looking for events and venues. Opportunities abound for novice and aspiring sports freelances in local sporting events taking place weekly at playing fields and leisure centres across the country. Get to know the leisure centre manager or sports organiser and persuade him that it would be mutually advantageous for you to be recognised as a photographer at events. The sporting super-stars may not be present but these are fertile classrooms for the aspirant. Be generous, at least initially, with hand-out photographs, they are an excellent investment and may lead into a regular source of marketing.

For events at a national level, freelances should be

aware that the sole reason for their existence at the heart of the action is to provide publicity for someone. Finding out who needs that publicity will provide your starting point for accreditation but be prepared to show that you have potential marketing capacity.

Passes may be issued by governing bodies of individual sports. For example, all gymnastic events at national and international level have passes issued by the British Amateur Gymnastic Association. Other events may be controlled by public relations companies. Researching event organisers is part of the joy and mystery of freelancing. Plan ahead; repetition can sometimes take the sting out of achieving accreditation. Here, again a few good prints or duplicate transparencies can make your name more instantly memorable to the accreditor thereafter.

When all else fails, don't write off taking photographs from the public gallery. Even top sport photographers are to be seen in these areas on occasion and not always by choice. Sometimes fresh perspectives can be achieved from this viewpoint.

Watch out for the winners. The moment of victory at the end of a race can make a great picture.

Get in close to the action, if necessary with long lenses. If you are aiming for the peak of the action, make sure that it *is* the peak, that it fills the frame and that it has impact. Although we all love taking the creative sports shot, it tends to be the action shot which earns the bread and butter. I always aim to get under my belt a high proportion of impact shots in relation to creative or atmospheric shots.

Intensive schedule

Many freelances find that the greater the degree of success they achieve, the more constraints they find imposed upon them by the market. A commissioned photographer will have an intensive schedule of work to complete, will be expected to produce high quality, high volume output whatever the weather or lighting conditions, and produce it very quickly. If he or she is photographing on behalf of the sponsor the freelance will be expected, wherever possible, to have the sponsor's name clearly visible in each frame.

Whilst many aspiring freelances tend to think in terms of using high speed film stock, whether in colour or monochrome, to overcome adverse lighting conditions, the successful freelance is likely, particularly if using colour materials, to be concerned to use the slowest film compatible with the situation. The ideal tends to be Kodachrome 64 or Fujichrome 50. This is partly explained by the need for good colour saturation and fine grain but is also essential for the production of good quality duplicates. Good duplicate quality is a must for multiple sales.

I tend to watch BBC and ITV sports schedules, particularly with regard to minor sports. We are all aware that television can, almost overnight, popularise a sport. Passes are easier for minor sports, and, because television cameras will be present, there are minimum standards of lighting which will be observed. In my experience, using Ektachrome EPT film stock, up-rated two stops, the exposure under television lighting is likely to be around 1/250 second at f/2.8-f/3.5. This is adequate to produce a usable quality image and is capable of stopping all but the very fastest action.

CONCLUSIONS

The final advice I would give is to treat all the foregoing suggestions simply as points for consideration. Your own approach and experiences are likely to be unique to you and will be part of the continuing learning process to which all of us are subject.

Selling curiosities

BY RAYMOND LEA

MY FIRST PUBLISHED photograph was of a large, step-ladder like stile giving access over an iron fence in the Chilterns near my home. The picture appeared on the letters page of *The Field* and earned,by today's standards, quite a small fee. But it was later published in *Country Life*, in my local county magazine, a book and several other magazines. It is a picture that I can still hope to sell again.

This is typical of the very wide scope offered by the curiosities market for pictures of the unusual, a market on which many a freelance has cut his or her teeth and well worth the attention of anyone hoping to earn cash with their camera. The key-word is 'unusual'. Quite simply, if you come across something man-made (or of nature's creation) which is in some way unusual and, better still, has an interesting story, it is worth photographing.

Do not be held back by the thought that others must also have happened upon it and sold its picture. As a constant, involved observer of the curiosity markets for over twenty-five years I have seen numerous instances of the same subject appearing many times in the same magazine (with long gaps in between), sent in by different people. I have also (dare I say) sold the same subject more than once to the same market. The years go by, editorial staff and readers change but the subject remains just as interesting and just as viable in your files.

Observation and imagination

As it happens I think the stile was a first and has remained mine ever since. This is part of the fascination of discovering curiosities. While many are well known and much photographed, others still exist to be realised for the first time as a potential money earner. Research plays a part but it is due mostly to observation and imagination. You see something that looks different, you think how it might relate to various magazines (even newspapers), you photo-

A unusual stile over a fence. It took only a moment to shoot, but has been selling steadily for years.

graph it to its best advantage, write as informative a caption or letter as possible and give it a try. One market may reject, but another may accept.

There are very obvious curiosities that can be listed. There is the unique (always a useful factor) Maharajah's Well at Stoke Row in Oxfordshire. Of oriental design with an impressive dome sheltering its fine ironwork, it was given to the village last century by an Indian Maharajah, has present-day royal connections and has earned fees for many a freelance including myself. Wells, in fact, are a good curiosity to seek out since many are of unusual design or have a story behind them.

Another ideal curiosity is the figurehead of admiral Lord Howe which sits inside the gate to a house in Buckinghamshire. When its warship was broken up, the figurehead was purchased by the Liberty family (of the London store) and preserved at their home. No freelance photographer worth their salt is going to

The unusual 'brickwork' here was actually regency wallpaper printing blocks. The unusual sight made sales.

pass by such an oddity without taking a few pictures and discovering its story. Similarly with an old favourite, several farm barns near Henley-on-Thames which are covered in Regency wallpaper printing blocks. What a funny thing to come across! And how typical of a particular trait in the British character to give a new job to something sound but redundant.

This trait, indeed, is a constant source of curiosity material. It extends from very small objects to whole buildings. One of my best-sellers is a picture of a tiny brass sundial reused as the escutcheon to a church door keyhole. Old millstones often turn up in new positions such as flooring to the lichgate at Wing in Bucks. While barns converted into dwellings are too commonplace for such curiosity value, the conversion of a dovecote, windmill or ex-railway station can be a fee-earner. Other reuses I have come across include wheelbarrows and small boats as flower beds and a boat's anchor as part of a gate.

The odd and the unusual

Churches and their environs are good sources of the odd and unusual. Church interiors contain a host of potential subjects, from memorials of all kinds that have something extra that sets them apart (design, inscription, person remembered, etc) to curious carvings, fonts, lecterns, candlesticks, stained glass, brasses - the list is endless, depending upon your observation and research. Some subjects can be photographed by available light, for others a small flash may be necessary. Whenever possible I obtain permission to take pictures (never yet refused) but sometimes there is no one about to ask.

Church exteriors yield more memorials, carvings including doorways and tympanum, windows and early sundials. Many old church clocks are unusual. Churchyards often contain interesting headstones and other types of memorial including lych gates. Even the obligatory yew tree, if it is old and massive enough, may rank as a curiosity. And have a look at the latch on the churchyard gate. The older ones can be of very odd and ingenious design such as the iron plunger type I came across at Little Hampden, Bucks.

This is typical of a great many curiosities that can easily go unnoticed. Everyday objects still in use and taken for granted but created in days when blacksmiths, carpenters and other craftsmen had to make up their own designs rather than the use of mass produced articles. This extends to old pillar boxes, direction signs, pumps, stiles and many other artefacts. Plenty of interesting individuality is found among weathervanes. They come in enormous variety, very often depicting a subject to do with the building they fly above. Cases in point are a schoolmaster (over

Always carry a camera for unexpected moments - like when a figurehead was discovered by the front gate to a house in Buckinghamshire.

Bradfield College), a farmworker with horses and plough, and a soldier with a cannon. Animals, birds, horses and traps, galleons, men with guns, grapes, a priest facing empty chairs are just some weathervanes I have sold either separately or in collections.

Wherever I go, I always look for anything that might have curiosity value such as an unusual sign, monument, mechanism, construction, thatch design, individual bridge and so on. If you see something that looks odd but has no obvious purpose, try to consult a local guide book. Visiting Chipping Campden I was puzzled by a walled depression in the verge near the church. It turned out to be a former trough, filled with water, which farm carts were driven through to wash the country road mud off their wheels before entering town. A simple record shot of this turned into a good fee-earner.

Before and after pictures can sell quite well. If you learn that an old structure, such as a dovecot or windmill, is to be thoroughly renovated, capture it on film before work starts, take a shot or two as it proceeds and then shoot the final result. There are potential sales for all such pictures. Collect a group of similar subjects together and you have the material for an article.

Although the countryside and its smaller towns and villages are probably the greatest source of curiosities, many also exist in urban areas. Older streets often contain adornments to shops left over from another era, such as the occasional Victorian street lamp or pillar box. Old shop signs, really unusual pub signs, preserved Georgian shop fronts, are all capable of earning fees.

Ancient and modern

Happily, curiosities continue to be created. Best known among modern examples, perhaps, are those plastic cows stuck in a field at Milton Keynes. But there are also signs, memorials, statues, decorative motifs, etc. The modern police station at Farnham in Surrey has panels in its brickwork showing farming scenes in relief. I have had good sales from pictures of these. A totem pole in Berkhamsted, an ingenious new gate latch, advertisements painted all over a Rolls-Royce (of all things!), a new folly in the grounds of a stately home - anything like this has curiosity value which can earn reproduction fees.

Apart from man-made curios, there is much scope found in nature. Trees sometimes grow into peculiar shapes, like having two trunks joined together in a loop. Even extraordinary root formations can find buyers in the country press. Flowers sometimes

Points to remember

■ **Curiosities make a good starting point for the beginner to freelancing.**

■ **If it's unusual, it's worth shooting.**

■ **Churches are always worth investigating in detail.**

■ **Always carry a camera, ready for the unusual find.**

■ **Look for man-made curiosities and those made by nature.**

■ **Letters columns make good targets.**

mutate oddly in a way that interests the country and garden magazines.

There is a host of fascinating topiary to provide curio value. It can be found in the gardens of fine old houses or in your local street. If someone has cut his hedge to look like a battleship, or has created a zoo from a group of bushes, you have a subject that can sell again and again.

Curiosities usually are quite easy to photograph. Often you need no more than the standard lens of a compact or SLR. Very small subjects require the close-up abilities of an SLR camera, and distant ones such as corbel carvings on a church wall, or those weathervanes, a lens of 135mm or longer. Some curiosities are in quite a confined space and for these a wide-angle lens of 24mm or 28mm is necessary.

Although saleable pictures can be taken in dull light, attractive side-angled sunshine provides the best results. A dramatic shape such as an item of decorative ironwork or a peculiar tree shape can be photographed as a silhouette. The better your pictures look, the more markets they will appeal to.

While every curiosity should be photographed in black and white (still the easiest to sell in this field) it is a good idea to take colour shots of suitable subjects. They are particularly useful if you put together collections of curios and write articles about them for the glossy magazines.

The markets

And so to markets. The long established, basic way to sell curiosities is to submit pictures to the letters columns of various magazines, along with a brief letter giving full, relevant details. Alas *The Field* is no longer a market but *Country Life* continues to publish many curio pictures each week. Other magazine outlets include *This England* (which will also use selections of curiosities), *Evergreen* and some of the county magazines. It is worth keeping an eye on letters pages. It is often possible to make a sale by sending in a subject that is similar to one already published. The topic might be odd trees, amusing signs, restoring dovecots or a particular type of church monument.

Specialist magazines will also publish curio shots. Garden journals accept curiosities to do with plants and trees for their letters pages. They like to see shots of the odd things people use for growing plants, such as an old rowboat, a cart, bottles, even an iron pump. Unusual types of wall or fencing, the trimmed growth of bushes around doorways and windows - these are other types of subject that appeal.

The magazine section of *Farmers Weekly* will accept curios to do with farming (including weather-vanes!), and I have sold the occasional curiosity of a nautical nature to *Motorboat and Yachting*. If you come across a strange looking car, or one that has been customised in a curious way, a photograph may be of interest to the motoring press.

You can always try your local newspaper with a really interesting curiosity picture (but make sure they

A definite curiosity - and sales to local papers when arguments broke out over the sculpture in a back garden.

pay a fee) and some of the religious papers are also interested in curios. Obviously those found in or near churches would be of particular appeal but anything to do with a past aspect of life, or something strange from nature, could also be acceptable. And don't forget the photo press, especially when they have a special picture each issue on the letters page.

CONCLUSIONS

Curiosities provide a simple, unglamorous side to freelancing but they can be quite profitable. A good curiosity, intelligently marketed, can sell many times over the years and you should always keep an eye open for new outlets. You can also put together collections of similar curios and hope to have them published either as a photo feature or with an article. Collecting the odd and unusual can be quite educational and lead to finding other ways of earning cash with your camera.

The model market

BY RAYMOND RIMELL

IT'S SURE TO command the rapt attention of any fellow party-goer discussing careers when it goes the rounds that you specialise in photography - in particular, photography of models. The envious murmurings of over-imaginative males rapidly dissolve into snorts of derision, however, when more insistent probing drags out the fact that the models in question may include miniature steam locomotives, battleships and airliners rather than the leggy blondes or brunettes your colleagues were fondly visualising.

There are, it has to be said, an extremely small number of professional photographers who specialise in recording the images of small trains, boats and planes, and who are able to make a comfortable living from it. Usually such work augments more profitable sources of income. The model field is specialist and, as a result, the number of potential clients is comparatively small and their budgets necessarily limited.

As with any area of interest, there are plenty of magazines to cater for modelling enthusiasts and the majority of the more successful titles tend to cover specific subjects such as radio-controlled aeroplanes, cars, or boats, plastic kits, steam locomotives and model railways. Many of these magazines are run on a shoe-string and cannot afford a staff cameraman let alone the luxury of commissioning a freelance one.

The need for specialists

The more successful specialist publication groups, however, do boast their own - usually quite modest - studio and processing department. Frequently, their editorial staff will double-up as photographers to cover events rather than contract out the work, but there will always be the odd occasions when the services of a specialist cameraman will be sought out.

These events might include large outdoor model contests and display rallies or indoor competitions for plastic modelling and railway exhibitions. Each will demand its own particular approach and type of equipment - especially the latter where the necessarily small dimensions of the subjects involved will demand a comprehensive range of close-up lenses and even, on occasion, extension tubes. Pure studio work is usually more suitable for these small scale models and according to the whims of the client can include a wide number of simple round-the-subject angles on a well-lit plain background sheet, carefully selected to show the model to its best advantage.

Particularly when shooting on colour film, it is important that the background contrasts well with the subject. Avoid strong primary colours as these often cause problems of reflections and seriously affect the appearance of the subject, especially if it is a generally pale colour. Choose pastel or pale shades for the most suitable effect. Specific model subjects will require specific treatments.

Let's take a look at some examples....

With very large models, particularly aeroplanes that can be flown, cars that can be raced and ships that can be sailed, outdoor photography is most usual

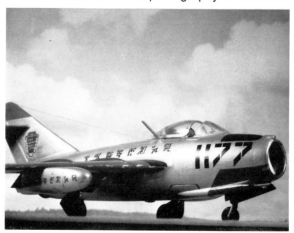

Simple scenic backdrops and low angles heighten realism in model photography.

and is to be preferred. Most specialist magazine editors will require at least two kinds of shot; sometimes one or the other - often both. Broadly, these are the action shot and the competition winner pose.

The former is a pretty vital ingredient for any picture editor's file since a model aeroplane in flight, steam locomotives puffing out great clouds of steam and ships pushing out bow waves in the water have obvious appeal. Not only do such photographs provide realistic, life-like images that are always attractive, they also help to promote the idea that these models, rather than being mere static showpieces, actually work just like their full-size counterparts and that their owner/builders derive great pleasure operating them. Low-angle ground shots can be especially realistic since this is usually how the viewer sees the full-size subject. Careful use of a wide-angle lens, especially for cars and aeroplanes, may further enhance such angles and impress picture editors.

For fast-moving aeroplanes, cars and boats, fast film and a telephoto or zoom lens of up to 300mm will be more than adequate and early co-operation with the model's operator may work in the photographer's favour and result in better shots. Few pilots or sailors can or will position their full-size charges for photographers, but most modellers involved in the radio-control hobby are willing and able to do so which is certainly a great advantage.

Take your own background

With a pre-arranged sortie, the modeller can position his pride and joy exactly wherever the photographer wants it, which will avoid a great deal of wasted film and impatience. Static shots are easier to cope with and in certain cases, close-ups of models will be required to illustrate specific detail or points of interest. It's a good idea for the photographer to carry with him a few rolls of plain coloured paper for backcloth purposes.

Photographing intricate models against grass or sun-dappled water is to be studiously avoided. Such backgrounds do not aid lighting and often obscure the very detail the cameraman is striving to record. In competition events, participants holding or posing with their entries are always popular with editors and most modellers will be co-operative, especially if they are among the winners!

A notebook to record details of both modeller and his or her model is essential. Such details appended to the relevant photograph will certainly be warmly received by the editor and will endear you to him.

Points to remember

■ Most magazines specialise in individual aspects of modelling.

■ Choose between studio and location photography.

■ Aim for action shots or people involved with their hobby.

■ Go for low angles to enhance realism.

■ Work closely with the owner of the model.

■ Take care with backgrounds.

■ Look beyond the magazine market to the trade itself.

Commissioned photographs of large models for magazine covers, particularly aeroplanes, demand other considerations. With such subjects, there is a natural tendency for both amateur and freelance photographers to persuade some hapless scantily-clad female - usually an embarrassed young relative in the case of the former; a bemused professional in the latter - to strike a suitable pose. It is not always successful. Few models (the breathing kind) really know how to display or hold a thumping great model (the heavy kind) correctly and the process can become something of a juggling act. The models need to be shown to their best advantage - both of them - and careful composition is all important.

Since most of these type of shots are taken outside - rarely is a studio going to be large enough - background clutter can become a problem. Avoid trees if at all possible. Even the best photographs inadvertently reveal examples of Arborial man (or woman) with a set of headgear that any self-respecting elk

More ambitious effects may include reproductions of sea, sky and terrain for realism. This model boat is actually less than 28 inches long.

might envy. Clearer backgrounds as may be afforded by a hillside or cliff top are much to be preferred.

Photographing miniatures such as scale plastic models of aeroplanes or ships, tanks, soldiers, etc, has its own rewards and most of the small number of freelance modelling photographers specialise in this field.

Some of them produce quite detailed backdrops and accessories in an effort to produce as life-like an image as possible while others will rely on plain, uncomplicated backgrounds. Either approach, or a mixture of the two, is a valid one but a more comprehensive range of equipment will be necessary in the case of the former.

Many model publishers prefer these, more realistic, shots which if skilfully done work well on covers and special internal colour features. The photographer, unless he already has a feel for the subject, would do well to discuss the model with its builder if possible in order to discover the best angles for lighting and detail.

Special efforts are often called for depending on the publisher's requirements and, to some extent, the model itself. Again lower level eyeviews are more realistic and popular than overhead angles in which the full-size counterparts are rarely observed.

The skills of photographing models to look exactly like real life subjects may, in the end, owe almost as much to film processing as it does to actual photography, where darkroom techniques may be employed to enhance realism. The value, in terms of freelance work, in such skills may lie outside the modest requirements of the specialist publisher as more and more large advertising agencies rely on modelwork to get their image across.

The agency angle

In recent years, agency photographs have won several awards such as in 1982 when *Air Transport World of the USA* granted top honours to a Birmingham studio for its dramatic Jumbo Jet night-time runway approach, achieved purely by incorporating a carefully-staged backdrop with an Airfix plastic kit!

I have enjoyed many years' experience not only as an editor/publisher, but also as a modeller/photographer, and know well the limitations of finding sufficient freelance work in the latter fields. In all truth it is far, far easier to teach a modeller the techniques of photography than the other way round.

To be a successful freelance in this field some modelling experience is going to be very useful

unless one relies totally on the input of ideas from the modelmakers themselves. The essential requirement, if you are on the periphery trying to get a foot in the door, is for a suitable portfolio.

Obvious enough, but if you are not a modeller you are going to have to seek some assistance from those willing to let you photograph their masterpieces in a variety of ways so that you can build up a library of prints and slides on a wide range of subjects - the wider the better of course - that you may then submit to prospective clients.

One other possible outlet is the model trade itself. Most of the mainstream model kit and accessory companies rely on commercial photographers and studios to undertake model photography for box and catalogue packaging. These larger companies should be strongly canvassed and may yield dividends, especially if you are mobile and are willing to travel to meet clients. Usually the requirements are quite basic studio work although the customer may well have very definite views on how the subjects should be posed and lit.

Shoot for the market

There will certainly be relatively few opportunities for creativity on your part and it will be more diplomatic, and ultimately more profitable, to meet their requirements as closely as possible, even if you don't agree with them.

Catalogue photography falls within the same confines and may be somewhat repetitive in nature if there are a great many models to be photographed in one session. Usually such work is already well behind schedule even before you set up the shoot so be prepared to work fast as well as accurately.

Two tripod-mounted cameras will be of help but one keep one important fact in mind: if using photofloods as opposed to flash guns you should be aware that most of these small models, being of polystyrene plastic, are subject to heat. Never leave photofloods on such subjects for longer than it takes to focus and take the shot. They can, and will, melt! I've seen it happen many times!

Large scale models at exhibitions can pose problems, but they can usually be solved by the use of flash to fill in detail in the model, while reducing the clutter of the background.

CONCLUSIONS

Don't expect to make a fortune from small model photography. But as an interesting and rewarding sideline to your normal work, and by remembering certain special skills and considerations, it is well worth the time and effort involved.

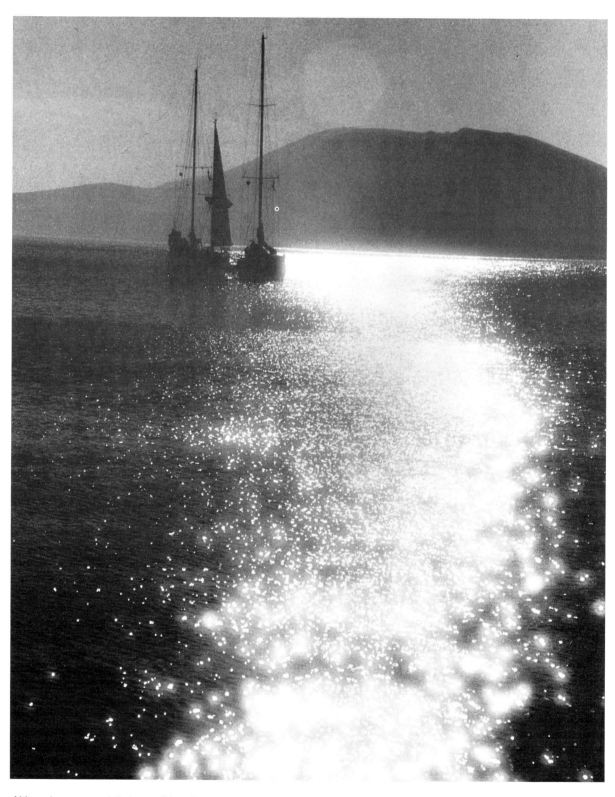

Although posters might be traditionally thought of as a colour market, there is a large and growing market for black and white pictures in this field.

Cards and posters

BY PETER LESTER

THAT GREAT VICTORIAN photographer, traveller and entrepreneur, Francis Frith started the trend for picture postcards before the turn of the century. When the laws were changed governing what you could stick a stamp on and send through the post, he employed legions of photographers, who set off from his Reigate photographic works, the biggest in the world at that time, to capture every scenic, and not so scenic, view in the country. Almost 100 years on, a quick survey of the postcard stands outside the post office in Sludgeville-On-Sea, will leave you thinking that most publishers are still using up their old stocks of Frith's pictures: they are so dated, and boring.

Postcards fall into two very broad categories. There are the scenic views of coastal resorts, beauty spots, stately homes, museums and heritage centres, normally sold at or near the location, and there are the general subjects, such as windmills at sunset and horses, which can be sold almost anywhere. There are of course many sub divisions within these two categories, which are usually determined by markets - i.e. general themes suitable for young people, males, females, etc.

By and large, the *scenic and tourist* category is catered for by appalling pictures, which are usually selected by publishers for their blue sky and sunshine content rather than any creative merit. This is because publishers know that tourists want to take away a record of what the place might have looked like if the sun had been shining while they were there.

Assess the market

Assessing the market is the first step in successful postcard publishing. Coachloads of Saga holiday makers on a trip around the Cotswolds will demand images of the traditional rose-covered cottages, while Penelope Trend will be shopping in Knightsbridge for something a little more 'Now' on which to scribble a line to her young man Rupert, who is missing her madly at University. You will of course be aware of which category your own work is best suited for so, at this point, a little market research, touring personally around the outlets that sell your type of work is now in order.

You could find that the most popular images are simply not the type of pictures that you normally take, so it is up to you to decide either to adapt to the current trend, or find a different outlet for your style of photography. There is little point in going through the expense and trouble of putting together a set of pictures to show a publisher, or to try to publish a set yourself, if you are the only person who likes them. You might enjoy taking perfectly wonderful pictures of vintage buses, but if the public is buying cuddly puppies, then you either shoot the pups or add a couple of hundred postcards to your personal collection of bus pictures.

At the time of writing, black and white postcards are very much in vogue, which is good news for the photographer, as they are obviously cheaper to take and to have printed. The current trend is for larger images on quality card, images which suggest an upmarket, sophisticated life-style, based on the style set by quality magazines for kids such as *The Face, Q, ID* and so on. A study of this type of publication and the advertising that goes with it will give you an idea of the type of feel that appeals to the young, aware, postcard and poster buyer. In visual terms, a postcard should be a very direct, simple composition, with instant impact, and this rule applies irrespective of markets.

Getting a postcard published is actually very easy, if you have some cash to spare you can do it yourself. There are plenty of printers around who will run off an edition of 500 or so at a reasonable price - in black and white of course. But that is just one postcard. You might feel that you need a set of three or four to sell into a retailer. Talk to a printer about this and you might find that they could print four different images on a single sheet, giving a hundred or so of each

Post cards don't begin and end with traditional seaside views. There is a big market for the more artistic type of picture as well.

image for not too much more than the cost of 500 of one.

Talking to a printer is essential before you hand over the work. You need to ensure that they can cope with the quality you require, and it is as well to ask to see samples of their work. Many printers will not mind you being around when the run is made, so you can ask them to make adjustments before they press the button. If you are lucky, you might find that there are plenty of overs, which can offset the cost of printing by a considerable amount.

Adding artwork

You may or may not want information on the back of your card. The artwork for this can be as expensive as the printing if you have it typeset and pasted up by an agency, so have a go at doing it yourself with some rub-down lettering. Get the dimensions of the card drawn out, rule pencil lines where you want the copy to fall, and rub down the letters. This will do for artwork. Alternatively, ask the printer to quote you for it. Costing a project like this is critical, as you can easily end up losing money on it. If the type of card you are aiming to produce is going to sell for 15p, then you are in with a chance of breaking even, but not much more. Even at 35p retail price, you are probably not going to make more than 10-12p per card sold, so do not plan on making your first million this way.

The next step is distribution. Here a comfortable pair of shoes is required. If you have taken shots of

a particular location, then life is easier, you simply call at every likely retailing site in the neighbourhood and sell them on a cash basis, if you can, to the proprietor. Sale or return is less satisfactory for you, as you need to monitor the turnover.

General topics and themes can be sold into any card shop or to a wholesaler. It might be a good idea to do the rounds of all the outlets in your town, talking to the buyers if you live in a small town. On the other hand, this might be too time-consuming, so you might prefer to add to the production costs further by sending out samples by post and following up with a phone call. This will of course allow you to aim at targets in other towns and to include major wholesalers and even publishers who might be impressed by seeing your work in print.

Some of your initial run could be used for several speculative submissions to publishing houses along with further selections of original work. This would certainly set yours apart from the normal unsolicited submissions. Obviously, editions of your work published by a large specialist company could be more profitable for you than self publishing, but you will be in competition with other photographers, many known specialists in this field, so your pictures must be of a very high technical quality and look very commercial.

Posters are back in fashion again, as are what the publishers call fine prints, (small posters on thicker paper). The difference in content between the two is hard to define, although posters are perhaps a more disposable item, intended to enjoy a few weeks of

glory on a bedsit wall, while fine prints are intended to be framed and kept for posterity, so perhaps the content should reflect these qualities.

Fashionable themes

Photographic posters and prints are doing very well for publishers these days, particularly the very fashionable, young life-style themes: sexy saxophones, cool cars, moody cafe interiors, all of which draw very heavily on the trend for yuppie type advertising images. Girls are the most prolific buyers of posters, and they tend to want sensuous, but not overtly sexual images, often in black and white or at least monochrome browns or blues which have a period feel to them, and which blend with their decor.

Asking a poster and print publisher what type of images they are looking for is just about as fruitless as asking a bookie who is going to win the Derby, so for the erstwhile poster maker, it is simply a matter of a clinical assessment of what is currently selling and jumping onto the bandwagon. Fine prints in black and white need to be reproduced from excellent originals, so if you are not much of a printer, or you don't have the facilities, pay someone to do it properly on good fibre-based paper no smaller than 10 x 8 inches, if you are submitting to a publisher, and actual size if publishing yourself.

Colour images should be transparencies, and you'll be risking rejection if you submit 35mm. Although most well focused, fine grain trannies are capable of enormous enlargement, prejudice still exists in favour of medium and large format.

Posters and prints are sold by the million all over the world, and publishers such as Athena can make you a lot of money if they choose to distribute your work, but many are called and few are chosen. What distinguishes the chosen few? Not a lot in my opinion.

Points to remember

- Note the different types of post card market.

- Investigate the possibility of publishing your own cards.

- Girls are the most prolific poster buyers.

- Current modes change so check out what is most popular at the moment.

- 35mm is unpopular in the poster market.

If you can't face the rejection, you could have a go at self publishing; again you'll find black and white popular, and cheaper to print. Outlets for prints and posters are many, including hairdressers, coffee bars and restaurants, wine bars, health clubs, night clubs, hotels and most significantly, art shops and picture framers. The profits to be made on these items are of course greater than postcards and self publishing can be fun as well as lucrative.

CONCLUSIONS

There isn't a fortune to be made from posters and prints, and less so from postcards, but for the effort involved, it can be financially worthwhile. Market research is all important in this as in most other fields and so time spent looking at what is selling is certainly time well spent. Find a printer that you can talk to and who is sympathetic to what you want to do. He can save you a lot of time and money by his experience, and some will enjoy doing 'craft' jobs as a change from mailshots and brochures. If you are selling to a publisher, make sure that your work is of the very highest technical quality as well as being commercial.

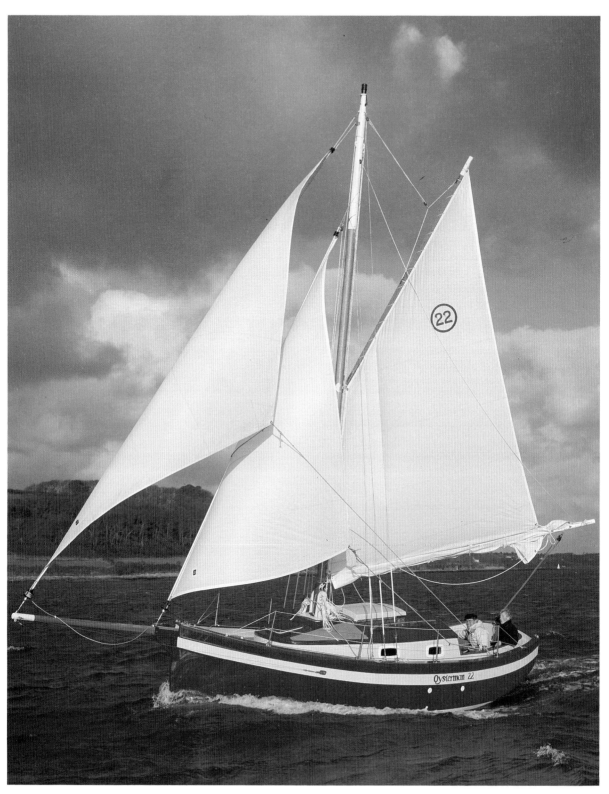

A calendar picture must be well exposed, perfectly sharp and aesthetically pleasing. Medium format transparencies sell better here than 35mm.

Calendars

BY TERRY HOPE

IN MANY WAYS the picture which is chosen to grace a particular month of a calendar has to have extra special qualities. Not only must it have impact, to ensure that it makes the right impression when the viewer first sets eyes on it, but this impact has to be sustained. After all, the typical calendar picture is the centre of attention for anything up to 31 days, and that's more than enough time for any deficiencies to become not just noticeable, but downright annoying.

The pictures which sell best to the calendar market, then, tend to be those where the composition is thoughtful and controlled, and where no extraneous detail has been allowed to intrude. The image will be strong, often simple, with no colour clashes to distract the eye. Quality is everything: the picture will be pin-sharp, perfectly exposed and in the shape required by the format of the calendar, since severe cropping is usually ruled out.

Big business

That's just general guidelines, however. A more intimate knowledge of the calendar market is gained simply by spending some time in your local book shop and getting a feel for the calendars you'll find there. Calendars are becoming increasingly big business, and every year the market is more diverse, but by browsing you should be able to get a good idea of companies worth approaching. You should also get some idea of the subjects which seem to be popular, to further help you get a selection of pictures together.

Joan McDowell is Chief Diary Editor of Collins Publishers, and is responsible for that company's substantial calendar output every year, which covers a wide diversity of subjects. The pictures used come from sources such as the Tony Stone and Bruce Coleman picture libraries, and from books which Collins have published.

But there are still plenty of opportunities for freelances to have work accepted. McDowell out-

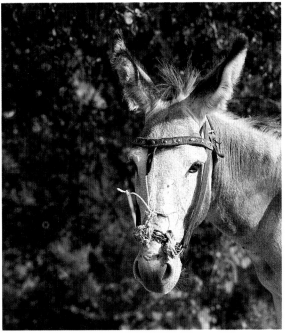

Many calendar companies specialise in specific subjects, and animals are among the most popular.

lined her individual policy for selecting pictures. 'We're always happy to look at sets of pictures,' she says, 'and are open to ideas for new calendar subjects too. But invariably the work we accept in any area has to be something a little out of the ordinary, simply because it does have to hold the attention for such a long time.

'Generally too we're looking for pictures in sets that might be suitable for an entire calendar, although there are occasions when we might decide to use work from anything up to half-a-dozen different photographers when we're putting a set together.'

Interestingly enough, although medium format is preferred for quality reasons, the use of 35mm is not

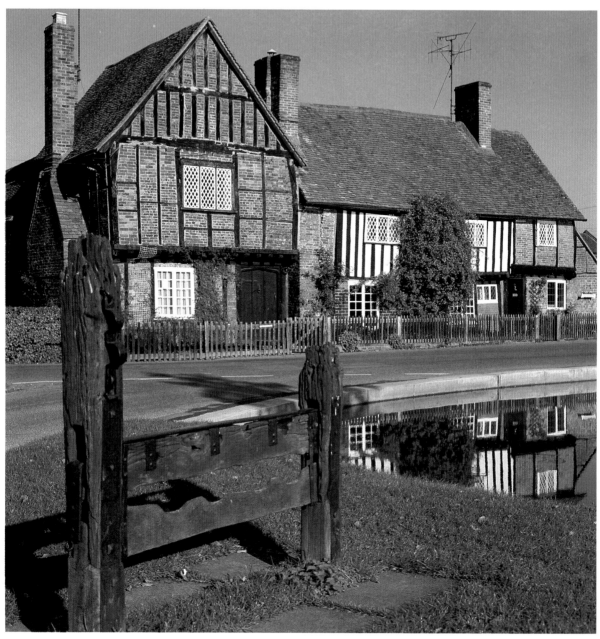

The traditional English village sells over and over to the calendar market.

entirely frowned upon by Collins. Those submitting smaller format work, however, must use fine-grain material which will stand up to the fairly considerable blow-ups which calendar use will demand - and they must also be aware that overall sharpness is super-critical once enlargements start to be made.

Whether approaching Collins or one of the other calendar publishers, the ground rules are the same. First make sure that the subject you're submitting

appears to fit into the area the publisher is covering. That's worded carefully, because it's not always advisable to send in a selection of pictures of a subject that's already been covered - there's obviously an established source for these pictures, and you may be putting yourself up against top professional or picture library opposition. Aim rather to hit general areas, so that if you perceive one calendar company to be keen on animal subjects you might

decide to send in a set of horse studies, or pictures of British wildlife. Likewise with landscapes, a published calendar featuring scenes of the Scottish Highlands should suggest that the company is open to a set of landscapes featuring other beautiful areas of the country - make sure you follow a strong theme, however.

That doesn't mean to say you shouldn't try new ideas, but you'll have to use your judgement to decide whether it's in the style your chosen company might consider. Those producing calendars which might appear on the shelves of your local bookshop or newsagent might, for example, be persuaded to look at a set of action pictures featuring off-beat sports - they're unlikely, however, to be interested in a glamour set which would have to be sold through different outlets.

Popular subjects

It's worth a quick polite phone call to those in charge of picture choice at various calendar companies just to check what they are after - and those subjects it will be a waste of time submitting. At Collins, for example, popular subjects are wild flowers, landscapes and cuddly animals. That latter category doesn't, surprisingly, include cats and dogs however, simply because the company considers this area of the calendar market to be too competitive at present. Rather less surprisingly, however brilliant a set of pictures of snakes and spiders you have might be, it's unlikely to be accepted because of the subject matter's dubious appeal to the public.

Check whether your calendar company prefers upright or horizontal pictures, and send them a selection of work which gives them a choice without burying them under pictures - aim to provide a set of no more than 30, and stick to the same film format throughout. You might also consider that, because of the nature of calendars, pictures are often required to have a seasonal feel. Bear that in mind before sending off a dozen beautifully sunny landscapes or a set of action scenes featuring winter sports!

We've mentioned briefly the use calendar compa-nies make of picture libraries, and this is another route you might consider for your work. It can be a particularly successful one for certain subjects like glamour where there's a big demand for general timeless studies of pretty girls pictured Page 3 style. Submitting your work to a picture library might also make sense if you have a small selection of really top quality pictures on a certain subject, but haven't enough to make a complete set. Once again a quick preliminary phone call is advisored to ensure you send the right material in the right form - weeks of wasted time can be save in this way.

Points to remember

- **Picture composition is all important.**

- **The market needs a wide range of subjects.**

- **Pictures should be just a little out of the ordinary.**

- **Medium format is preferred.**

- **35mm must be technically perfect.**

- **The shape of pictures is important.**

- **Research each company's particular needs.**

CONCLUSIONS

Calendars are now important enough to offer a real opportunity to the freelance photographer. With a little care and the right amount of planning, you can capitalise on that fact, and find a new outlet for some of your best and most considered work.

The travel market

BY HELENE ROGERS

EVERY PHOTOGRAPHER WOULD love to be paid to travel to exotic locations and, whilst having a holiday, earn a living. Despite that, however, there are still plenty of opportunities for the photographer who has the ability to take top quality photographs that capture on film the essence of the country he or she is visiting.

The market for travel photography is large and varied. Travel pictures are used in magazines, books, holiday brochures, newspapers, postcards, calendars and advertising literature produced by airlines and travel firms, and well over fifty per cent are supplied by freelance photographers.

The type of pictures required are wide ranging, from the broad overall scene-setting shot to tiny detail such as produce on sale in a street market.

Success rarely comes overnight, but the photographer who takes time to assess the type of pictures used in the various markets and studies magazines and books before leaving home, will have a better idea of the types of photographs he should be looking for. Time is the most expensive commodity for the travel photographer and working out in advance the likely areas to target his pictures on his return will help plan the initial itinerary. A few telephone calls to prospective clients before departure can also be useful, establishing any specific photographs needed immediately.

Occasionally, a travel photographer will be commissioned to travel to a specific country and be provided with a comprehensive picture list compiled by a picture researcher. Frequently, these lists include more pictures than are actually needed, suggesting alternatives for the photographer should a picture prove either impossible to take, or too time consuming. Commissioned photographers should, where possible, request picture lists in advance since they frequently are the only link between the text and the pictures of the book or article, as well as defining clearly the client's needs and expectations.

To earn a living, the travel photographer cannot rely only on commissions. It is often necessary to try to single out specific countries where there is likely to be a reasonable demand for photographs. The photographer then travels at his or her own expense and shoots photographs on spec that can be marketed on return. The rewards can be extremely good but the commercial risk can also be considerable. The more experience the photographer has, the easier it will be to identify specific countries and the types of photography that sell well. For the beginner in the travel field, it can seem rather daunting, the world is an enormous place and successfully identifying markets can seem a difficult task.

The best way to begin is to pick a country and work out all the likely markets in advance, listing ideas on paper and arranging them in order of priority.

The tremendous improvements in films over the past few years has resulted in most magazines, newspapers and books being quite happy to accept 35mm, although if a photographer is aiming at brochure or calendar work, there is still quite clearly a preference for the larger format pictures.

Mixing colour and mono

The equipment selected for travelling should be dependent on the type of photography being undertaken. Most experienced travel photographers shoot their photographs in both black and white and colour.

Although my colour sales still outstrip the black and white, black and white sales are currently increasing dramatically: black and white is also far cheaper to reproduce and with increased printing costs, many books are increasing their usage of black and white pictures. Taking both black and white and colour photographs at the same time necessitates two camera bodies with preferably a third one in reserve in case of camera failure. The lenses will be largely dependent on the photographer's style but in

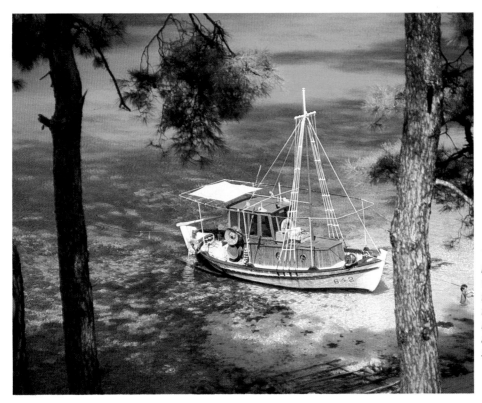

Travel brochures are in business to attract visitors to holiday destinations, so pictures for this market should make the location look as attractive as possible.

general, it is best to go for less equipment rather than too much. Any lenses required only for specific pictures can often be securely packed in a suitcase and only carried in the camera bag when necessary. Ideally the photographer should have a wide angle, a fast normal lens for low light situations and a tele-photo lens.

My own travelling kit consists of three camera bodies. I carry a separate meter for precise reading, although I hardly use it, preferring to rely on my own assessment of the lighting conditions and using the in-camera meter as a guide which I invariably over-ride. I nearly always carry a 17mm wide angle lens, a 24mm lens, a 50mm fast lens and a 70-135mm zoom. Frequently the 50mm lens, the spare body and a 500mm telephoto are packed in my suitcase and only taken out when I feel I need added variety or for a specific occasion.

My own style of photography means that I rely very heavily on available light but I do carry a small portable flash unit in my suitcase which I occasionally use. Other items of my equipment include a tripod, always in my suitcase unless I am shooting late in the evening and a bean bag which I find more flexible than the tripod. My bean bag is filled with two pounds of chick peas and frequently, when I come across museums and churches where no flash or tripod is

allowed, there is never any mention of a bean bag. Usually I am able to take my pictures unchallenged and by using my bean bag against a pillar or the back of a chair, can manage an exposure of up to five seconds without any camera shake. A good travel photographer takes little equipment but uses it to its maximum potential. Too many photographers miss pictures because they can't make up their mind which lens to put on which camera. When travelling, a photographer may find that he has to walk long distances and being mobile is of extreme importance.

Look for a theme

Frequently I find that collecting pictures on a theme whilst travelling can pay dividends. The pictures can be marketed not only as illustrations to books and magazines, but if the material collected is sufficiently strong, can lead to a travel article in their own right. If the photographer can then write words to go with the text he can make an extremely good sale.

Whilst travelling around Iceland shooting on spec pictures for a book on the country, I began to realise that I was collecting a series of pictures which illustrated steam: geysers, hot springs and steaming volcanoes. As soon as I realised this, I began

consciously to look for pictures to further the theme. The result is an article I have just written on the exciting landscapes of Iceland. The magazine commissioned the article to go with the photographs and had never previously considered Iceland a tourist destination worth writing about. The editor was so excited by the photographs he immediately commissioned the article. All photographs submitted should be adequately captioned, ideally with too much information rather than too little. How, when, why and where are very important - frequently sales are lost for lack of such information.

It is always better to travel regularly to a place, updating pictures so that the collection remains current. Too many photographers spread themselves too thinly paying fleeting visits rather than concentrating on a few in depth. Some photographs never date, others are superseded within a year of taking. Countries where I have spent a great deal of time are Taiwan and North Yemen. In both countries I have visited nearly every town and have become known as an authoritative source of pictures. Sales of my pictures from these two countries are generally spread by word of mouth. In North Yemen I have written and illustrated articles on the architecture, the Yemeni people as well as the country itself. In Taiwan, I have illustrated a book and am now involved in writing and illustrating a guide for businessmen and a tourist guide for Taiwan.

Film is cheap!

When I first started working as a travel photographer I read many books on the subject: most implied that a photographer must take a few days to acclimatise in order to avoid wasting film. Film to a travel photographer is cheap, a transparency costs only a few pence when compared to the real expense of the cost of the flight and accommodation. Very often it is those first experiences that are valuable as they frequently sum up the flavour of a place and if the photographer notices them, in all probability the traveller looking at the photographer's work will recognise that same feeling. Waiting to acclimatise can loose the photographer valuable pictures. It is undoubtedly easier to take pictures in a new, strange environment.

Everything in a strange country seems so fresh and exciting and frequently travel photographers find it hard to take pictures on their return, needing this extra stimulation. I have often found that my very best pictures are taken within a few days of my arrival in a place, on long trips it is easy to miss important detail

Points to remember

- **Take time to assess the market.**

- **Use your initiative to find suitable markets before you leave.**

- **Be prepared to travel at your own expense.**

- **Match film formats to markets.**

- **Don't carry too much equipment.**

- **Be adaptable when it comes to solving problems.**

- **Beware of X-rays!**

because they sadly gained familiarity after only a few weeks.

The ability to be adaptable and find solutions to situations can prove invaluable. In Greece, in the height of the busy tourist season, I received a request to take a picture of the Acropolis for the cover of a magazine. Realising immediately that the request was going to be extremely difficult, I tried to find a way round the situation; to go to the proper authorities to get permission to photograph at dawn before the tourists invade would have been one solution but after initial enquiries I discovered it would probably have taken three months before my request would even be considered, too late for the client's needs. During the day was hopeless, queues of people were waiting just to get through the entry gate.

My solution in the end was to attend the Son et Lumière one evening; using my 300mm lens on a tripod in the gangway to avoid people's heads I was able to take a whole series of exposures which showed the Acropolis lit up against a dark sky. The

picture was subsequently used and the client delighted. I have since been to Egypt and applied exactly the same principle on the Pyramids. There is nearly always a solution, the problem is being flexible enough to find it.

The security factor

One of the greatest worries of the travel photographer is the security of his equipment and the problems of passing through inumerable Customs checkpoints. A good insurance is invaluable, and the best are the type that replace new for old. When travelling, always keep your cameras safe. If they must be left, leave them with hotel security, never leave them in a bedroom. I have frequently made use of left luggage lockers in stations and airports for bits of equipment which I do not wish to carry with me for the day.

Unprocessed film is also extremely important and it is almost impossible to insure the undeveloped film which frequently cannot be replaced. If an item of equipment is stolen during a trip, it will depend on where the photographer is as to whether it is better to replace it abroad or on return at home. In certain Far East countries equipment is so cheap that it is better to replace the equipment overseas and declare it at the Customs on return, paying the import duty as it will still be cheaper than replacing it at home.

In other countries the price may be so astronomical that it will almost pay the photographer to fly home, replace the equipment and return! In between lies a grey area, but always take account of the lost days of photography which must add to the value of the equipment. Checkpoints and X-ray machines are a nightmare for many photographers. The effect of modern X-ray equipment is far less than it used to be, but it is still accumulative.

If possible, ask for a hand search. The higher the film speed, the more severely the film will be affected. Most Customs officers realise this, so always ask advice. Some countries still use the old-fashioned

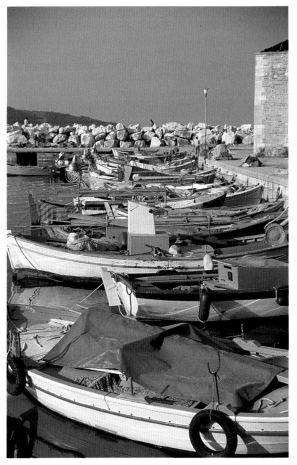

A picture which could double as both a magazine illustration and a picture for a brochure.

equipment that severely harms films, notably poorer third world countries. Even when new modern equipment is introduced, the old may be transferred to internal airports; always ask before putting film in if the X-ray machine is film safe and never put film in a suitcase as these are frequently strongly X-rayed away from view.

CONCLUSIONS

There's more to travel photography than hoping you might sell some of your holiday pictures. Real travel photography is not for the faint-hearted. It must be carefully planned before you start out and you should take into account how much it will cost you to get to a place even before you start to shoot. But with careful planning, plus a determination to take the right kind of pictures, the rewards are numerous and lucrative.

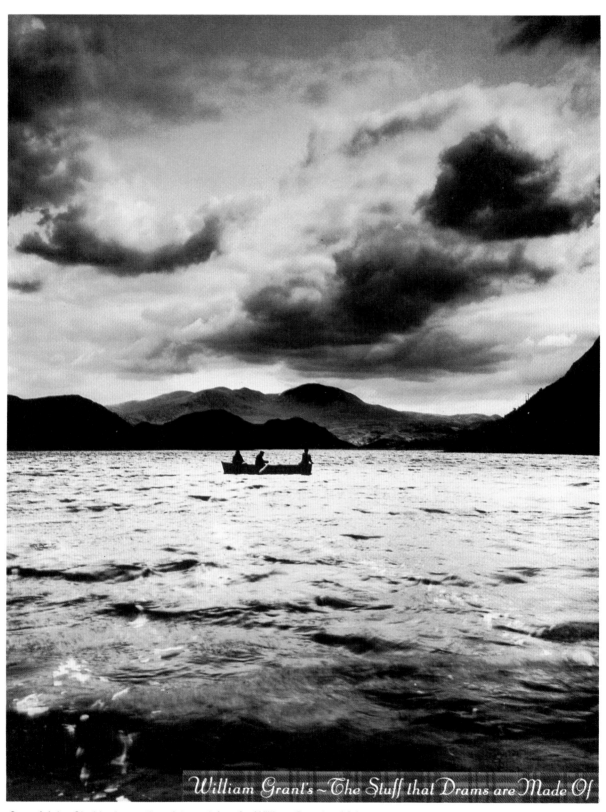

One of John Claridge's emotive pictures taken for William Grant's whisky.

Advertising

BY DAVE SAUNDERS

AS MUCH AS £2,000 for a day's work is pretty easy money. Or is it? Financially, the advertising photographer is near the top of the tree, and the envy of many other freelance photographers. To an outsider the job seems exciting and glamorous - shooting for big campaigns, with big budgets and getting a big buzz when the advertisement appears.

But the moments of glory and gratification are invariably the result of days or weeks of preparation. Even apparently straightforward shots involve considerable planning, patience and often a lot of frustration. For every picture that tells a story, there is a better one about how it was taken.

Although there is no rigid formula, advertisements generally develop something like this.

A company employs an advertising agency to communicate to a sector of the population a message about its product or services. Perhaps a new product is being launched or a new ingredient has been added to an existing product or maybe the company is aiming for a larger share of the market. Advertisements often focus on one key advantage of the product. For example, is it cheaper, smaller, faster or does it wash whiter than its rivals? An effective advertisement must please the client, suit the product and target the appropriate audience.

In response to a brief from the client, the advertising agency formulates an overall campaign strategy. Once this has been agreed by the client, an art director and copy writer work together to come up with ideas or concepts within this framework.

The art director then calls in the photographer most suited to the type of photograph required, and works with him or her to produce a picture which fits the idea. Photography is just one element in an ad, along with the design, the written copy and so on.

The concept for an advertisement usually originates within the agency. Ideas may emerge from a list of statistics or as a result of market research. It is rare for the photographer to be the first person to work on an advertising idea. His or her contribution comes later in the form of technical knowhow, artistic interpretation and, sometimes, the development or elaboration of an idea.

For example, the agency Gold Greenless Trott chose to use punchy black and white posters in a series of quick visual jokes to advertise programmes on London Weekend Television. A new advertisement had to be produced each week. Initially intended to run for only twelve advertisements, the campaign eventually extended to more than 100 posters, selected from over 1,000 ideas.

Unlike advertisements in newspapers and magazines, posters do not have a captive audience. They must therefore be simple, eye-catching and immediate. The image must grab people's attention, then the headline pushes home the selling line.

Rough sketch

For one of the London Weekend Television advertisements, photographer Ian Giles was given a rough sketch of the idea illustrated over the page. He photographed a face and razor separately, with the blade held in position with wires and superglue. Finally, a clever retouching job blended the shots together, creating a striking visual pun. The double chin belongs to a stand-in, not the man himself!

Although advertising photographers earn their living from advertising, they often devote little time and effort to promoting themselves. Many photographers keep their names upfront by buying space in advertising publications such as *Campaign,* the *Directory* or *Hot Shoe International.* Some distribute cards, calendars and posters of their work to art directors, art buyers, magazine art editors and so on.

To promote his skill in photographing people, photographer Michael Joseph used his own swimming pool to reconstruct a 1930s shot of a row of divers. The poster was sent to those in the business

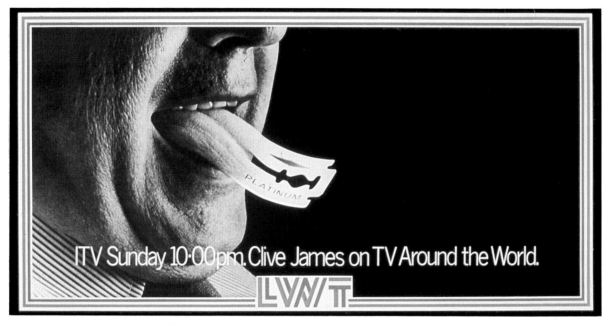

Advertising poster, shot by Ian Giles, for London Weekend Television.

responsible for commissioning photography. Art buyers and art directors usually select photographers on the basis of their portfolios or their previously published work. Advertising photographs are nearly always commissioned or selected from picture library stock shots. It is extremely uncommon for a picture submitted on spec to be used in an advertisement. And, as an advertising agency is accountable to its client, it is very unusual for an art director to entrust a major campaign to an inexperienced photographer. Most photographers have to cut their teeth on lesser shoots, such as uncomplicated pack shots, before the agency will risk ruining a prestigious shoot.

The art of survival

Most top advertising photographers start out by spending many soul-destroying hours hawking their wares around the advertising agencies. Both novice and established photographers need a tough hide to survive the emotional buffeting which comes with criticism, rejection and the ever-present competition from other talented photographers. Success comes only to those who are dedicated, determined and, of course, talented.

An advertising agency may have ten, twenty or more art directors. Rather than attempting to see them all, it is more usual to approach the art buyer first. Most agencies have one or two art buyers who act as buffers between art director and photographer

(or illustrator). They sift out people who are entirely unsuitable, while channelling promising prospects towards appropriate art directors.

It is the art buyer's job to know who can produce the types of pictures the agency needs. They therefore want to view as much work as possible. Although generally very busy, they welcome photographers who come prepared. So, if you think you could impress an advertising agency, here are six tips to keep in mind.

1. Make an appointment; don't just turn up and expect to be seen. Most art buyers try to restrict the number of portfolios they see, as it is difficult to do justice to more than about two a day. As a result, they may not be able to fit you in for a week or two.

2. Put together an impressive portfolio of, maybe, a dozen or twenty photographs. Avoid the temptation to include everything you have ever done. Be very selective; too many photographs will dilute the overall impact.

3. The images do not have to be advertising photographs as such, but they should demonstrate an eye for a good picture.

4. A distinctive style will ensure your work stands out. If you specialise in photographing food, people, animals, cans of beer or whatever, then the art buyer will find it easier to categorise your work and therefore recommend you for a particular campaign. However, many art buyers want to see that you are also capable of a wider variety of work.

fairly mundane trade ad with a small budget, because it means so much more to him.'

An advertising photographer works with an art director, and shoots to a brief. A successful photographer understands the thinking behind an advertisement and how the photograph will be used. For example, if it is to appear as a double page spread, the main subject should not be in the centre of the picture. If it is to appear on poor quality paper, the original photograph must be harder and sharper, for its reproduction may be rather soft. If the advertisement is targeting mothers, it should be soft and

Janet Savile, art buyer with J. Walter Thompson, asked the London colour laboratory, Studio 10, to make some changes to a tropical beach scene photographed by Graham Hughes on location in Antigua to promote Bacardi rum. Lettering on the bottles was sharpened, glasses lightened, the beach umbrella removed and a new sky inserted. The man on the left was removed using a technique called copy brushing. While the image was on screen, data was taken from nearby areas of sand, sea, branch and cactus, then repeated in place of the man. This retained the textures and tones in a way that conventional retouching techniques are unable to do.

5. Most art buyers prefer to see transparencies rather than prints or laminated sheets torn from a magazine.

6. Art directors do not want to work with inflexible, awkward, unprofessional or miserable photographers. There are lots of photographers who are technically capable of handling the majority of jobs; successful photographers are chosen because they are also able to co-operate with others.

Room for new people

Photographers who are serious about advertising work, and have what it takes, can take heart from the words of an art buyer from a leading agency, who told me: 'There is always room for new people. A new photographer will put much more energy into even a

sensitive, not hard and gritty.

The photographer's brief may be very specific, leaving little room for further creative input. A more general brief allows the photographer greater freedom to follow his or her own feelings about the aesthetics of a shot as well as its selling impact. In the advertising world it is a luxury for photographers to be able to fulfil their creative instincts while also meeting the client's needs.

John Claridge is an advertising photographer who has reached a compromise which satisfies both criteria. 'I accept that I am there to help sell a product,' he says, 'but I don't let that get in the way of the photography. For me, the pictures should always come first.'

For a series of shots in a campaign promoting William Grant's whisky, the brief from Gary Denham,

art director with Aspect Hill Holiday, allowed flexibility, stating simply that, 'the pictures should look like they were taken for an exhibition.'

Armed with rough sketches of a variety of scenes, Claridge was able to respond to the dictates of the local circumstances and interpret them in his own way.

The more unlikely or fantastic an idea, the greater the ingenuity required to turn it into a photograph. Some photographers consider it a challenge to produce a complicated image entirely in-camera, with several exposures pieced together on one sheet of film. But, in advertising, most photographers are also resigned to the fact that their job is to find the best solution to visual problems. When it is technically impossible, or too time-consuming, to achieve the desired result through photography alone, photocomposition of several transparencies at a later stage may provide the solution.

Computer technology

Besides manual retouching and manual photocomposition, computer technology has introduced a new level of precision manipulation. A computer-generated photo-composition can be made by transforming any number of images into digital information. Each transparency or piece of artwork is wrapped around the drum of a laser scanner, which 'reads' the picture and converts it into electronic impulses. These are intercepted, recorded on disk and stored along with other transparencies, artwork or text. The information on several separate images may be retrieved and displayed on the screen, and then manipulated using a function keyboard and/or electronic pencil or digitiser tablet. The conventional retoucher works with grain, whereas the computer retoucher works with pixels, which are sharper.

Points to remember

- ■ **Pictures come out of planning, patience and frustration.**

- ■ **Pictures are keyed to products.**

- ■ **Ideas start with the agency, not the photographer.**

- ■ **The majority of pictures are commissioned.**

- ■ **Success comes only to the dedicated.**

The screens in some retouching houses are linked by telephone lines to monitors in advertising agencies. In such cases the art director at the agency is able to comment on the image as it is being manipulated by the technician.

Via satellite, high resolution images can now be beamed across the world in digital form. For example, advertisements generated in Los Angeles or New York can be sent to London for retouching and/or tailoring to different European publications.

CONCLUSIONS

Love it or hate, advertising plays an important role in our society. Whether you view the pictures on the hoardings and in magazines as insidious persuaders or amusing wallpaper, they are obviously effective, or else companies would not allocate so much money to them. Photography can take much of the credit for the impact of many of the best advertisements. But photographers who insist on having full control over their pictures will find advertising a very depressing business. Yet, if you appreciate the need to work in a commercial world, as a part of a team with compatible objectives, it can provide an inspiring and rewarding outlet for your talents.

Photo contests

BY JOHN WADE

ONE OF THE things that many beginners to freelancing have difficulty accepting is the need to match their pictures to the requirements of a particular market. They spend too much time trying to sell pictures which were originally taken for no other reason than the enjoyment of taking them. That way of working is rarely the way to sell pictures but, very often, the kind of pictures produced this way are precisely the ones that win photographic competitions.

Photo contests are an area of freelancing that is often ignored. Yet the right sort of competition can easily provide a means to win cash, equipment, holidays and much more besides. And precisely *because* so many freelances ignore competitions, the average newcomer stands a good chance of success.

When you begin to look for them, you will be surprised at just how many photographic contests there are around for the entering. Maybe the most obvious place to start is with photographic magazines, any one month seeing tens of thousands of pounds worth of equipment on offer for the winning. The photo press is probably the most prolific magazine market for contests, but it is by no means the only one. Many other types of magazines also launch contests of their own. There are more women's magazines on the market than any other category, and that is a good place to start. Many of the top glossies run photo contests.

Specialist press

Then there are specialist magazines other than the photo press, publications that aim themselves at many different hobbies. Gardening, motoring, motorcycling, wildlife... these and many other hobbies all have their own magazines and have all been known to run photo contests, usually with a set subject that is tied in with their own specialist interest.

Watch too for announcements in the more non-specialist magazines. These are the publications which aim themselves at a general readership, rather than one with a specific interest or hobby. National newspapers and their Sunday colour supplements run photo contests, as do many local and provincial dailies.

But the world of journalism isn't the only place you'll find photo contests being organised. Travel companies are fond of launching them for travel pictures with luxury holidays as prizes. Manufacturing companies such as those who market baby food often launch a contest with, in this example, maybe children as the theme. Organisations like the Game Conservancy Council get involved, as do giant combines like British Airways and British Rail.

Film processing companies often run contests through the summer months, details of which can be found in or on the pre-paid envelopes they distribute as loose inserts in magazines.

Even a supermarket can be a good place to find photo contests. Go in and take a look at all the packets and bottles. You might be amazed at how many contest announcements find their way on to boxes of cornflakes or bottles of disinfectant.

Film companies like Ilford, Kodak, Fuji and Polaroid involve themselves heavily with photo contests each year, running their own and also co-sponsoring contests with organisations like the *Daily Telegraph,* the Sports Council or the National Trust. Other photographic manufacturers and distributors often link up with various organisations other than the photo press, as do some of the larger photo retailers. Car manufacturers too have been known to go in with a photographic chain store to offer a car as a prize in a photo contest.

Most of these contests are organised by the public relations departments of the various companies concerned and they nearly always prepare a press release on the subject which is sent out to publica-

Judges look for impact and pictures with a different approach. So a shot like this would stand a better chance in a photo contest than one which showed a straight boating picture of the type more favoured by the boating press.

tions with an interest in their particular field. The majority of releases are also sent to the photographic press and you will find details on the news pages of the relevant magazines.

Once you have located a few contests, your next line of action is to begin whittling them down until you find one that is exactly right for you. Firstly, are you an amateur or a professional photographer? It's a fair bet that the vast majority of this book's readers will be amateurs, so that will usually rule out contests like the Ilford Photographic Awards or any other that might be aimed specifically at professionals.

Amateur or professional?

Assuming that you are an amateur, there is little point in giving yourself more opposition than you need. So try to find a contest aimed *specifically* at amateur photographers. Read the rules and look for one that bars professionals. Few contests do that, but if you can find one that does, you automatically better your chances of success. On the other hand, it must be admitted that, with the exception of the really large national contests with top cash prizes,

few professionals bother to enter anyway. So look for a small contest - and by that you could still be looking at one that might be offering, say, a camera worth around £500 as a prize. A professional photographer can demand in excess of that figure for a day's work and so he often won't think it worth his bother entering such a contest. For you, taking pictures as a hobby, the reward will be far greater.

Now look for a contest where you won't be up against too much opposition. Not in quantity of the entry, but in the quality. When you first start in this field, then, it is a good idea to ignore the photographic magazines where every entrant will be a keen photographer. Instead, look for contests in the non-photographic press or those organised by manufacturing companies, film processing labs and the like. Especially the latter. These are the people whose customers invariably take nothing but colour enprints; they are the snapshotters whose pictures are, more often than not, competent but boring. As a dedicated enthusiast, your work should be streets ahead of the average entry.

Finally, analyse your own photographic talents - and be honest with yourself! What particular subjects

are you good at and what are your failings? If your chosen contest has a set subject, make sure it's one that you are equipped to tackle. If it has a more general theme, enter only the type of pictures at which you know you are proficient.

Don't think you can afford to relax and submit substandard work just because the contest is aimed at a market that is primarily made up of snapshotters. It's not the 5,000 snapshot entries you are going to have to beat; it's the half-a-dozen good shots from regular contest winners. Because if you know about the contest, you may be sure that they know about it too.

It is time now to be brutally honest about competition entries. The fact is that the vast majority don't stand a chance of ever being short-listed, let alone winning a prize. Why? Here are six reasons.

1. The entrant hasn't bothered to read the rules correctly.

2. The quality of the printing, especially in monochrome work, is very poor.

3. Technical expertise in basics such as exposure, focusing and picture composition is lacking.

4. There is a total lack of originality in the treatment of the subject.

5. The entrant has attempted a branch of photography without understanding the basics of how that particular subject should be tackled.

6. The overall presentation is abysmal.

As a keen amateur photographer you should have a good grasp of both the technical and the aesthetic

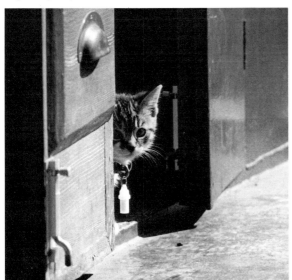

The chance picture of the type that comes from always carrying a camera can very often win favour with photo contest judges.

Points to remember

- ■ **There are a lot of photo contests open to you.**

- ■ **Find the contest that's right for you.**

- ■ **Don't make things difficult for yourself.**

- ■ **Stick to the rules.**

- ■ **Learn how contests are judged.**

- ■ **Go for quality, impact and originality.**

sides of picture taking. That will give you a head start over much of the opposition. If you have had any experience of freelancing, you will know something about analysing a market and submitting only the type of picture that the buyer wants. A similar strategy applied to competitions will stand you in excellent stead against the average entry.

The first and foremost requirement when setting out to enter a photo contest is to read the rules. Read them, make sure you understand them and then obey them. You might be surprised to learn just how many entrants fail to do just that one simple thing.

Opening moves

Let's pause here for a moment to consider how photo contests are judged. Every contest has a panel of judges or a single judge. In either case, the first moves are much the same. The judge or judges will start by weeding out all the pictures which are completely unsuitable. These include those which do not comply with the rules, others which don't fit the theme of the contest and all those that are technically imperfect.

This takes them down to a general short-list, in which each picture is worth considering. From that,

Move in close, get involved with your subject, create something a little out of the ordinary and your pictures will find their ways to the winning pile.

a much smaller short-list will be prepared to contain those pictures which are better than average, pictures which for one reason or another have stopped the judges and made them take a second look. Somewhere in this short-list will be the winner.

Up until now, the procedure will probably have been a fairly rapid one. Prints will have been in piles, quickly thumbed through with rejections put to one side and short-listed entries to another. It is unlikely that transparencies will have been projected. Most judges are competent enough to be able to simply hold the slides up to a convenient light to assess their potential for the short-list. A picture that is worth keeping back for further consideration will stand out against the crowd easily to the trained eye even without the aid of a projector or magnifying glass.

The short list will now be looked at in much more detail than the others. Slides will be projected or, at the least, examined under a strong glass on a lightbox. Prints will be laid out side by side for comparison. Gradually pictures are thrown out, with the judges trying to reach full agreement on each rejection but, in the case of strong views for and against, with a final vote taking place. Eventually, the pictures are whittled down to the final few and then down to the one picture that all agree stands out above the rest.

That's the winning picture and that's the picture you want to own. So, having learnt how your work is handled, let's return to the problem of how to make sure that it's your picture the judges end the day with.

It is imperative to find exactly the right picture for your chosen contest. Once again, this starts with reading the rules. If they specify a certain subject, make sure your picture sums up that subject to perfection. If you have a great shot already that *almost* fits the theme, forget it. Save it for another day and another contest. The judges will not be swayed by either its technical or its artistic perfection if it fails to comply with the subject of the contest.

When a contest has a set theme, it is a lucky man or woman who can find a suitable picture in their files, however extensive they might be. Maybe you will be lucky enough to already have just what the organisers are looking for, but never kid yourself. If in doubt, go out and shoot another picture specifically for the contest.

Stop that judge

Your job is to stop the judge as he continually reviews and re-reviews all the pictures and there are a number of ways that you can do your best to make sure that happens.

Give him quality. Most slides that are entered for contests are not too bad as far as quality goes, but prints are another matter. Black and white photographers are the worst culprits, often failing completely to recognise what good print quality is all about. Even the most mediocre of subjects will stop the judge if the print quality is sparkling. For the same reason, don't

submit trade-processed enprints, even if the rules allow it. The 'averaged-out' printing that most automatic printers turn out is inferior to a good hand-made print. And that goes doubly for trade-processed black and white. Apart from the really top specialist processing houses, commercial mono printing to a high standard seems to be a dying art.

Give him size. Check the maximum size for prints and make yours as near to that as possible. That applies to transparencies as well. The vast majority of entries in any colour slide contest will be on 35mm. So if you have access to a larger format camera, such as a rollfilm model that takes 6 x 6 cm or 6 x 4.5 cm slides, use that for your competition pictures. A 5 x 4in camera that takes cut film is, of course, better still. At the end of the day, it is the subject of the picture that will win the contest, but there is nothing like sheer size to make a judge stop, and anything that helps to get your pictures short-listed must be considered fair game for the competition entrant.

One step further

Be original. Just about everything in photography has been done before and so it is rare to see a picture that can honestly be described as totally original. Even so, few entrants will take the trouble to enter anything more than the usual boring view of a traditional subject. So think first about the sort of picture you want to enter. Having done that, take a mental step back and look at your idea objectively. If it came to you in a flash and was relatively easy to think up, then it's a fair bet that other entrants may have had the same thought. So trade on that. Having arrived at your initial idea, try to take it one step further. Add something extra. Force yourself to improve on your first thoughts. The judge who has seen the same theme put across the same way ten times in a row is bound to look more favourably on the eleventh picture that does the job differently from the rest.

Be your own greatest critic. There is little point in

Good action shots will attract judges of photo contests, but you need to fill the frame to give your picture the necessary impact.

being dishonest with yourself, so if you have any doubts at all about your chosen picture, don't bother to enter it. It isn't always easy to analyse your own work, but one way is to live with a picture for a while. Try to produce it at least a week before you plan to send it away to the contest. Pin it up somewhere in the house where you are continually forced to look at it and keep doing just that. Look at it every available moment. Most photographers have experienced that little churn of excitement in the stomach that comes when you know that you have produced a great picture and you should always be feeling that about any picture you produce for a contest. More important, you should still be feeling that excitement a week later when you look at the picture. But don't try to fool yourself. If in doubt, throw it out.

CONCLUSIONS

Your chances of winning a photo contest are probably better than you ever imagined. But in order to win, you have to be totally honest with yourself. Don't fool yourself into thinking your picture quality is good when it isn't; don't fool yourself about how well your intended picture fits the contest theme. Be bold, be original, show impact and quality in your work and you could easily be onto a winner.

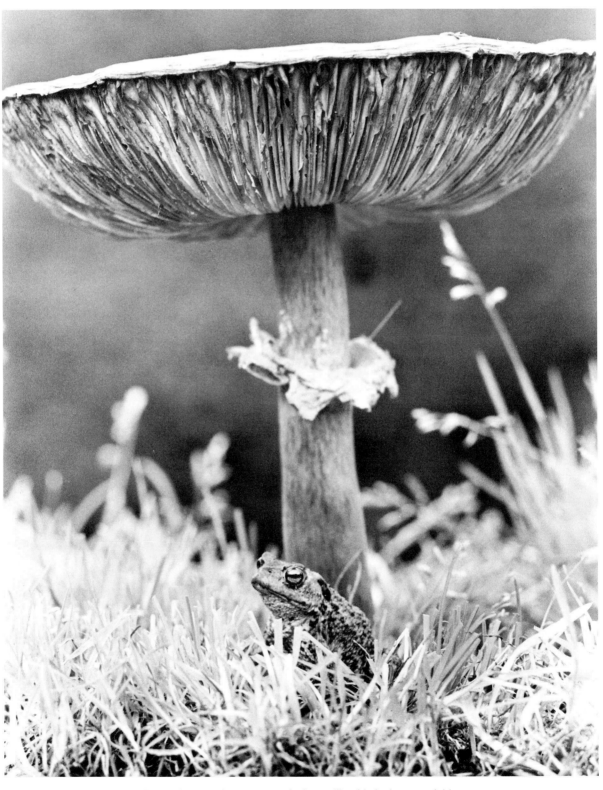

An agency gets many specific - and unusual - requests. A picture like this is the sort of thing that most would be delighted to keep on file.

Using an agent

BY DAVID ASKHAM

IT MIGHT APPEAR to be seductively simple: fire off a few films, persuade a photographic picture agency to take them off your hands, then sit back and wait for the cheques to roll home! Unfortunately life is not that simple. You may be one of the world's most creative or technically adept photographers, but unless the pictures you produce are readily saleable, not even the most successful agent is likely to make your fortune.

Selling through a picture agency requires a special understanding of how that agency operates and how a contributing photographer needs to harmonise his efforts with the library. Only then does the partnership have the potential to prove profitable. Unfortunately a novice freelance seldom has this understanding at the outset. Nor even does an advanced professional photographer seeking a fresh outlet for his fine photographs and who is turning to a library for the first time. It is all too easy for a competent photographer to enter into an agreement with a picture library and subsequently suffer disappointment as sales fail to materialise.

Be methodical

Invariably, the reason lies in a mismatch between his product and the library's idiosyncrasies or specialisation. However, this need not happen if a methodical approach is adopted, supplemented by common sense, perseverance and patience.

What follows are some thoughts which will help the newcomer to make a thorough initial assessment and avoid the pitfalls and disillusionment which beset many who rush in blindly. My experience is based on contributing to one of Britain's leading libraries for many years and gradually earning a modest income. A distillation of that experience forms the basis of this chapter.

Before looking at some of the issues, an important assumption is made that the aspiring contributing

Some agencies specialise in subjects like wildlife.

photographer has already reached the stage where he or she can produce, consistently, top quality photographic images. Any lesser standard is quite unacceptable and will be a waste of time for all concerned if an attempt is made to try to market substandard material. Any doubts in this area should be remedied before submitting material to any picture library.

It is not easy to obtain universal agreement on definitions. The terms Picture Library and Photo Agency, together with variations on those themes, are often loosely used to mean the same type of operation. There are a few agencies whose main business is negotiating work for photographers on their books. But generally speaking, most picture libraries which market the work of one or more photographers do so on the basis that finished photographs are deposited in the library. From there they are available, on loan, to the many customers who pay a fee for their use depending on many factors. The type of reproduction rights, size of reproduction, repetition factor, publication circulation figures or advertising rating, all influence the fee charged.

The contributing photographer normally receives half the fee negotiated by the agent. There are

Travel pictures work well in the right kind of agency from where they might sell to markets such as travel books and magazines or travel brochures.

variations on this formula which can be distorted if pictures are placed through second agents overseas who also deduct 50% of the fee. So two or more agents in a transaction can diminish the return to the photographer. Against this apparently poor return has to be set the fact that few photographers would normally be able to reach some of the less obvious but quite lucrative markets around the world. So such sales have to be seen as an unexpected bonus.

Another characteristic of picture libraries is the fact that the great bulk of picture material rests almost permanently in storage receptacles. A relatively small percentage of stock sells regularly and a photographer's aim is to produce material which fits into this category. But fashions change from time to time so that dormant material suddenly becomes active. Perhaps the obvious deduction to draw is that one should aim for a balanced range of subjects represented by a library.

It is important to understand the marketing cycle and its impact on the timing of possible returns on your contributions. Picture researchers are the main clients of photo libraries. They work to customers' briefs and cast widely in their search for suitable images. Sometimes they visit the agencies and take away short-listed material; other times they telephone or write and the agency has to interpret the requirement, search for and despatch a selection.

The waiting game

Weeks or often months elapse before a decision is reached and then further delays occur during the editing and production phases. Even this is not the end of the road. Receiving or chasing fees can take further time and it is not uncommon for the better part of a year to elapse before a photographer's share is paid to him. Add the time pictures spend in an agency's files and one can clearly see that contributing to an agency is a long-term investment. This is why one condition of joining an agency is the declaration of long-term commitment.

During the course of researching a book on picture libraries and photo agencies I discovered a bewildering choice of active operations in the United Kingdom, let alone in Europe, North America and the rest of the publishing world. In the top league of well-known names are several very big and active libraries which cover a most comprehensive range of subjects and markets. You can see their credits in many publications. They tend to be the ones which most major publishers and other users of images turn to regularly in their quest for quality material in a wide range of fields.

At the other end of the scale are many small libraries, often the product of one photographer, which tend to specialise in their choice of subjects. Their work is highly competent and appeals to picture researchers who are seeking subjects in a comparatively narrow field.

Where can you find details of the many British picture libraries? One of the most accessible listings is in *The Freelance Photographer's Market Handbook* published annually by BFP Books and available from most good book shops.

Make a list

Some agencies are listed solely for the benefit of picture researchers, editors and art directors. From this you can build up a list of eligible agencies which could meet your requirements. Scrutinise your short list carefully and reduce it to a manageable number for the next stage. This is a letter of enquiry to selected libraries seeking more details of their requirements, methods of working and terms of business. While there is no harm at this stage in sending samples of your work, it is better to wait until your short list has been reduced to one or two libraries, if only to avoid scattering your valuable work too widely. Enclose a stamped addressed envelope - a golden rule in freelancing.

By approaching more than one agency you have a better basis for comparison. Some agencies are stronger in certain markets than others or may specialise in a specific subject range. Your ultimate aim is to match your product with the strengths of a chosen agency. Then is the time to assemble an outstanding portfolio of your work so that your chosen agent can decide whether it is worthwhile taking you on his books. Some agencies specify a minimum number of pictures required initially. This helps them to assess how serious you are and how sustained are your standards. It also discourages the 'light-weight' who may not keep up a steady flow of contributions.

Points to remember

■ **Learn how the agency works.**

■ **Match your work to the agency's specialisation.**

■ **Submit only top quality images.**

■ **Be prepared to pay at least 50% commission.**

■ **Look an agency over before committing yourself.**

■ **Accept that you have to keep the pictures coming.**

Before finally making a decision try, if possible, to meet the principal of a library face to face. When you consider the big investment of time and money you are likely to make in the agency over a period of years, it is reassuring to know and to have confidence in the people handling your work. During this meeting your ability and personality will be appraised. However, remember, this assessment is not one-sided: you should be scrutinising the agency. Find out whether it actively markets pictures or is predominantly reactive to incoming requests for material. How widespread is its client base? (For example, one may be too tied to the holiday travel market and suffer when there is a down-turn in that particular business.)

Try to find details of the agency's track record. Some are comparatively short-lived while others have survived and prospered in the marketplace for many years. Establish the frequency and policy for payment of your share of fees earned. Commission is generally 50% of fees received which seems a lot until you discover the high costs of running a big picture library. Try, also, to get a feel for the efficiency of the business, its relationships with clients (you will probably witness callers and telephone enquiries), and to what extent it has embraced modern office technology. This latter fact can often give a business

operation a competitive edge in a highly competitive business.

An agency will judge you by the quality and diversity of your photography. Therefore it is vital that you pay special regard to the assembly of your portfolio. Study very carefully the agency's requirements, noting particularly the number of images required, format and subject range. If 100 colour transparencies are requested, send 100 - *not* 200 because you were unable to whittle the number down.

If we stay with this example a moment longer, it is not a bad idea to start off with twice the number you need and reject all of those which are in any way below standard, repetitive or do not reflect your skill and versatility. The pictures should also work well together when viewed as groups. If transparencies are being assembled in multi-pocket viewing sheets, try to make each sheet cohesive according to subject, colour and composition. If in doubt, seek a second opinion from a colleague whose judgment you trust.

Contracts and agreements

Let us now assume that you have been accepted by the agency and contracts or agreements have been signed. You should be given guidance on the type of material your agent would like to continue to receive from you and this will be based on your specialisations and their needs. Both attributes are necessary.

From time to time new requests will come your way. These will be based on changing requirements, your developments and travel opportunities and even the location where you live. It is worth paying serious attention to these requests. Try very hard to respond to them because they are the all important clues which can lead to a productive relationship with the agency and get you into that 'best-selling' bracket.

I have found dealing with an agency rewarding in more ways than one over the years. My pictures have been used in many markets throughout the world that

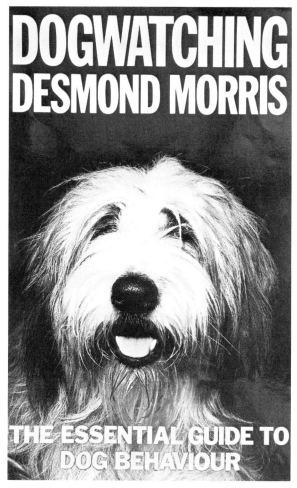

Book publishers, looking for cover pictures, are prime customers for photo agencies.

I would almost certainly never have reached, markets which seldom deal direct with lone freelances. For me, working with an agency is part of my diversification, leaving me free to spend more of my time on writing and photography. But it is very much a personal choice.

CONCLUSIONS

Is it all worthwhile? If you take it seriously, send in material known to be required and regularly, it can be. After a few years you could be earning an annual four-figure supplementary income. However, the wise photographer will monitor his operation and judge after two or three years whether it is worthwhile to him personally from a business point of view.

Weddings

BY RON GREGORY

INITIALLY, I WAS not really interested in undertaking wedding photography. Although having been involved in photography for many years as a keen amateur with the occasional remunerative commissioned job coming my way, the thought of being responsible for photographing a couple's wedding filled me with dread.

However, redundancy from my full time occupation at a fairly late stage in life led me to the not-so-lightly taken decision to go it alone as a self-employed freelance photographer. Having had many successful years as a landscape and portrait photographer, albeit as an amateur, with good positions in local and county run competitions, I decided to earn a living doing something I love to do.

I was also fortunate in that over the years I had chosen my camera equipment wisely and now, on the threshold of turning professional, I owned two Nikon bodies plus lenses from 28mm to 200mm. In medium format I had a tried and trusty Mamiya C330f, 6 x 6cm twin lens reflex, with 55mm, 80mm and 180mm lenses. With redundancy payment I added to my equipment a Bronica SQA 6 x 6cm format single lens reflex plus 50mm, 80mm and 150mm Zenzanon lenses.

Curing the problems

Although the Mamiya was adequate for general medium format photography, problems could be encountered with the parallax on close-up shots and the non-interchangeable back meant delays on a wedding shoot whilst changing films.

My equipment was further enhanced by the addition of a good sturdy tripod and a hammer head type flash gun with guide number of 45. The tripod is used most of the time, in good weather and bad, as it not only prevents the risk of camera shake but also allows freedom of movement to organise individuals and groups.

A small, low-powered flashgun is useful for against-the-light shots of this type.

The flashgun is a must for low level light indoor shots - i.e. bride's home, signing the register and register office, as well as for fill-in flash on bright sunny days when harsh shadows need to be eliminated from across people's faces. A Gossen Lunasix 3 meter completed my outfit. Without exception all my wedding photography is metered by the incident light method.

When you start out, consideration should be given to whether you aim to hire your services to one of the many studios that abound throughout the country or whether you are going to undertake wedding photography on your own behalf.

In the first case, unless you can demonstrate to your chosen studio that you are proficient in wedding photography, or have the ability to become a useful

Group shots are always popular, but make sure you have everyone's attention before you press the shutter.

member of their team, it may prove difficult to be accepted. Some studios will train their photographers in the techniques of creative wedding photography, provided that person has the basic ingredients.

The studio would take care of the administration work involved and deal directly with the engaged couple and/or parents, present the wedding previews from your shoot and deal with the ordering, invoicing and collection of monies from sales.

Your reward is the pre-arranged fee paid by the studio for photographing the wedding, the profit on sales going to the studio.

It is obvious that working on your own behalf is more stimulating and profitable provided you have the motivation and drive to succeed. Rules must be drawn up from the outset and strictly followed in order that nothing is left to chance or overlooked.

You will need to advertise your services via the press, church magazines and local directories. Make friends and relatives aware that you are now available to accept wedding photography assignments. Display your work in local shops, restaurants and anywhere the general public frequent. Personally, I

have found that a few 20 x 16 inch framed prints placed in a florists, an off-licence and restaurants have worked quite well in providing enquiries and subsequent bookings. Initially, difficulties may be encountered in obtaining suitable locations to display your work, but arrangements with the business owners can usually be made, either on payment of a reasonable rent for space or an agreement in sponsoring their business - e.g. recommending the bridal flowers.

Free pictures

A promotion entered into with the local branch of a national jewellers proved reasonably successful. A free engagement portrait was offered to engaged couples on the purchase of a diamond engagement ring. A photo leaflet was presented to them inviting them to call at my home-based studio where an appointment was made for a sitting. Proofs were subsequently shown to the couple who decided on which portrait to be printed to 10 x 8, mounted and presented completely free of charge. The object of the exercise was to advertise my photography and to

have the opportunity of discussing with the engaged couple at an early stage, their wedding photography. The promotion was based on a no obligation understanding, additional prints required over the free offer being purchased at normal rates.

The quality of the studio portraits, together with informal discussion of wedding coverage and price structure, has led to many engaged couples booking their wedding photography.

Selling wedding photography is no different, in essence, to selling any other service. The importance of the customer is paramount - the bride and groom. They are the people to convince that *you* are the photographer they need for their special day.

Customer contact is, therefore, all important. The first tentative phone call from the prospective bride or groom must be met with a positive response. Answer questions clearly, giving detailed coverage of the wedding including the cost involved. An invitation should be extended to the couple to visit you and discuss in more detail their exact requirements, and an opportunity will be made to show them your portfolio. The latter may be limited to begin with, but as you secure assignments more of your selected work can be shown both in album form and framed enlargements.

Get the details

Having secured a booking from the enquirer, at the time of the couple's first visit full details of prices, approximate number of prints required together with sizes, selection of wedding albums and guests' prints can be discussed in detail. It is of considerable help to hand out a printed list to overcome any misunderstandings. When a booking is secured the relevant form should be completed giving all the details of the wedding and a deposit taken which is deductible from the balance, on completion of the assignment.

Never hesitate to visit clients with your portfolio, should they be unable to visit you. This is good public relations and demonstrates to the customer your eagerness to secure the order.

Study other photographers' work and compare their results with your own. Do not copy other people's style but develop your own way of going about wedding assignments and producing work which is recognisably yours. Approximately ten days prior to the wedding, contact the bride or groom and arrange a meeting in order to discuss final arrangements such as time of your arrival at the bride's home for photographs before leaving for the service, a brief

Points to remember

■ **Invest in the right equipment.**

■ **Decide whether to work for a studio or for yourself.**

■ **Publicise your business as much as possible.**

■ **Give every consideration to the client.**

■ **Programme your day's work.**

■ **Work to a variety of picture types and shapes.**

■ **Get the proofs back on time.**

run through of the shots to be taken and note any specials required. Personally, I always check the booking form at this time, bearing in mind that this may have been completed twelve months prior to the wedding date, and consequently changes may have occurred. The completed booking form is helpful in extracting information when submitting the press photograph of the wedding. These details are most important too when getting a calligrapher to prepare the title page of the wedding album.

Make sure you arrive promptly at the agreed time on the day of the wedding. Take the photographs in a logical sequence and be most courteous and attentive to the people who are your subjects. It is a big day for the bride and her attendants and nerves are bound to show. Converse with them, reassuring them all the time. Make sure the bride's veil and train are correct and arrange help where necessary.

On completing the photographs at the bride's home, make haste to the place of ceremony, allowing sufficient time to photograph the bridegroom, best man, ushers and bridesmaids *before* the bride and her father arrive. On arrival of the bride and father,

capture a few moments with them and the brides-maids prior to entering the church.

Try to mix a few informal shots with the more formal photographs along the way. It makes for more interest in the presentation of preview prints and can result in increased sales. I find a most popular candid is the minister greeting the bride and father at the church door or lych gate - you need to be quick in order to capture the spontaneity of the moment. It is not usual for photographs to be allowed in church during the course of the service, but sometimes the rules are relaxed and a word with the minister before commencement of the service will clarify the situation. Telephoto shots taken from an inconspicuous position, without the aid of flash, usually go unnoticed and are generally well received.

Check out the church

The signing of the register and bridal procession at the conclusion are normally required for the wedding album. Should the church not be familiar to you, a visit beforehand will help establish the best location for photographs. Don't wait until the actual day, it is so easy to choose the wrong setting. Additionally, prior arrangements with church officials for possible use of the church for the photographs should the weather be inclement can usually be made.

Once outside the church, the sequence of photographs usually commences with the bride and groom, adding bridesmaids/page boys, best man, parents, family and relatives and friends in a gradual build-up of the groups. Once the main group shots are completed, you may concentrate on further photographs of the bride and her bridesmaids, bride and groom, bringing into use soft focus filters, and lens masks to provide and introduce a different aspect into that particular section. Final shots at the church would be of the bride and groom leaving for the reception. Coverage at the reception would then include a set-up cutting of the wedding cake, couples toasting each other and any other you consider suitable.

My own wedding coverage, developed over the years, now includes a selection of finished prints in square, upright, landscape and oval mounts. This affords a wide choice to the customer and provides interest both in album prints and guest prints by varying the format. In order to achieve this I always shoot my weddings on the 6 x 6 cm square and print to 8 x 8 inches, cropping where necessary at the finishing stage to 8 x 6 inches. Many owners of 6 x 6 cm format cameras use the required accessories to adapt to 6 x 4.5cm. This allows an additional three frames on a roll of 120 film, four extra on a Hasselblad, giving 15 or 16 frames per roll of film.

I consider 12 on 120, 24 on 220 the better deal for the flexibility it affords in choice of rectangular or square prints and not having to worry about tipping the camera on its side when shooting upright with 645. Eventually, as your number of weddings increases, your coverage will follow a pattern. Record the day's events in as creative a way as possible, develop your own style and stamp your own personality on the proceedings. An additional service I offer to the bride and groom is to take separate black and white photographs specifically for the newspaper publicity, develop and print the required number of copies to size 8 x 6 inch, gloss finish, available to press and parents by the Monday following the Saturday wedding. This ensures the photograph of the bride and groom appearing in print as early as possible and whilst the memories of the happy day are still fresh in everyone's mind. A further 8 x 6 inch copy of the press photograph is held for the couple on return from their honeymoon.

Preview prints should be available for presentation within seven to ten days after the wedding unless prior arrangements have been made for proof prints at the evening reception.

CONCLUSIONS

Wedding photography should not be rushed into. It needs careful thought and preparation. But, providing you carry out your assignment in an efficient manner, print orders from bride and groom, parents and guests should be generous, giving you a good financial return and providing further material for future publicity. All of which, of course, adds up to increased business.

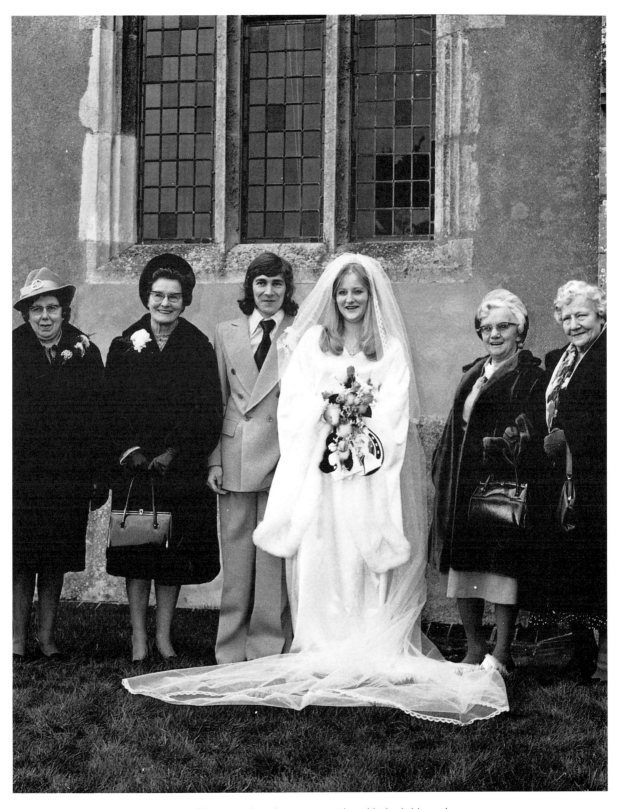

Don't forget the traditional pictures. They are often the most popular with the bride and groom.

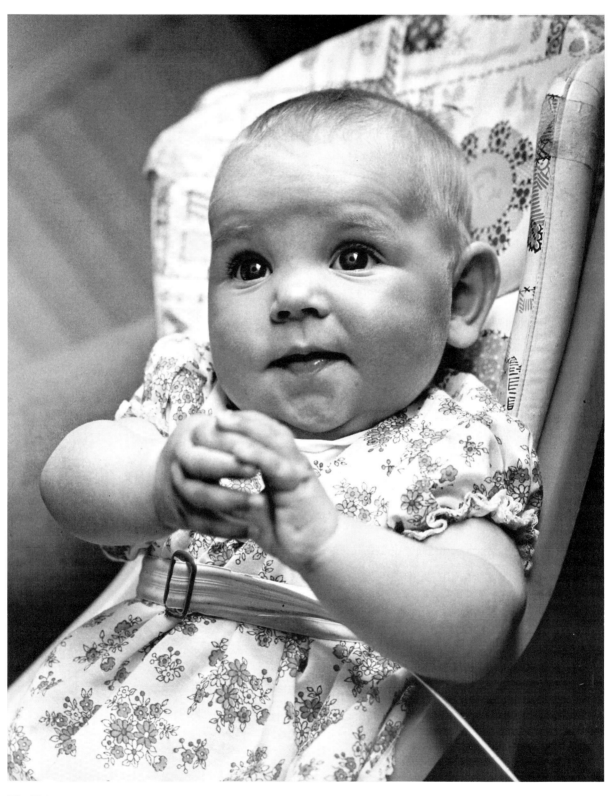

The lifeblood of the high street portrait photographer is pictures of people, children and, of course, babies.

Private sales

BY RON BEARE

I WOULD ASSUME that anyone seriously contemplating taking photographs of the general public and expecting them to part with cash in return for same, has obviously more than a basic knowledge of photography. Having supreme confidence in your own photographic ability is of prime importance for studio work involving the public at large. Remember that each and every client could be a total stranger; they may well be impressed by the photographs you have taken of family and friends, but gaining the confidence of a nervous sitter is an art in itself.

Practice on family and friends until you can expect to get things right ninety-nine per cent of the time. Camera operation should be almost an automatic reflex action, a mechanical function. There is nothing more disconcerting to anyone having their portrait taken than a photographer who continually fiddles with lights or camera. They've come to you as an expert who'll make them look their best in a picture and here you are nervously twiddling various knobs and things, paying more attention to the equipment than to them. They're not likely to be impressed or put at ease are they?

For a successful commercial operation, taking and selling portraits of the general public, the camera itself is of secondary importance, far outweighed by the ability to communicate at all levels and ages. Are you mature enough to create an impression with the manager of a branch of a major chain store; enough to let him allow you to take over a corner of his retail area to run a portrait promotion for a few days? Are you confident enough to act the clown in front of a tearful two-year-old, whilst mum and dad look on, probably thinking you're completely off your trolley, remembering of course to press the shutter release at the right moment when that elusive smile appears?

Still with me? Right, now to the mechanics of running your own portrait operation. Not everyone has, or even needs a high street studio location to successfully run a photography business taking portraits of people or their pets. The rent and rates are a major obstacle to overcome. Better by far is to let someone else pay the rent and rates of a prime retail position and 'borrow' a piece as and when required. Most of the major supermarkets and drugstores not only have a prestigious high street position, they also have an area instore, set aside for special promotion work. This is generally large enough to take a mini studio set-up, of say ten by twelve feet.

Before you make any approaches to the management, thoroughly scrutinise the area, note the positions of power points, facilities for hanging your background and any advertising material you may want to put on display. It is not vitally important to completely screen off the area. You could, for example, use a few artificial potted trees to provide a small amount of cover and prevent too much distraction for your young sitters. Get your studio plan firmly sorted out before going to the next stage.

Background information

What background to use? I personally would stay well away from the paper roll on this occasion. Why not create your own exclusive design? Obtain from your local marquee contractor a length of theatrical backdrop canvas. This is usually available in nine foot wide rolls, a six-foot length should be adequate for our purpose. For painting you will need a fine but not too sunny day and a selection of your chosen colours in vinyl emulsion paint. A floor mop for spreading the paint and lawn large enough to lay the canvas on are the only other requirements.

Dilute your main dark colour fifty-fifty with water and cover the canvas well, getting right into the corners. Then, whilst still wet, apply the chosen light colour by putting a good mopful in the centre and gradually blend it into the darker colour, working outwards from the centre. Use a reasonable amount of water and the two colours should wash into each

The private sales photographer should think about working in the subject's home as much as in a studio.

other, giving an indistinct joining line. Take the mop and just dip the ends of the tassels into your third colour, then spot the area you want and, using the mop well wetted, create little areas of apparently out of focus colour around your central light area.

The remark about the use of a not too sunny day should at this stage become readily apparent, since the longer the paint stays liquid during the operations, the more indistinct will be the blending lines. A light shower won't do any harm and may even give a really exclusive designer finish, but do keep an eye open for next door's moggie: your neighbour might not appreciate a designer finish on her windowsill or kitchen floor.

A length of plastic drainpipe makes an ideal support for the background. Attach the width to the tube, using heavy duty carpet fastening tape, giving a nine-foot drop. For lighting, choose the most powerful studio unit you can afford, a robust stand, the largest available gold brolly and an adjustable reflector board, preferably silver for maximum reflection and mounted on a tripod stand. The more powerful flash unit will of course give us greater depth of field and, if you've got your background blending correctly, it should look out of focus even at minimum apertures.

If you can get hold of a couple of slave flashes and mount them on either side of the background sup-

ports, facing forward, this will give an extra dimension to your photographs, the added hair/kicker light will really separate your subject from the background. Remember though to use a good lens hood to prevent flare. Have a trial set up in the village hall or somewhere and run off a film or two using a variety of apertures. You can then see from the results which aperture will give the best effect. A word of warning, however. Don't try the set up at home in the lounge; the light loss in a large area is quite incredible and there are no light walls to throw the flash output into shadow areas. Light reflected from your lounge walls will considerably reduce the contrast ratio and give a misleading result.

I haven't mentioned a flash meter because although an advantage, it isn't really a necessity as once the set-up is finalised, the results should be pretty well constant.

Regarding the camera equipment, 35mm is preferable, any make is suitable and a 1/125 second synch speed is an advantage in reducing the effect of ambient light during exposure, particularly important in big stores which tend to be well-lit places. A motor drive, whilst not by any means a necessity, is a great advantage. It helps continuity if you don't have to keep breaking off from your handstands or whatever it is that's getting little Willie nearly to smile, to wind the film on.

Move in close

A long pneumatic release will allow you to get in close, essential for coaxing smiles from a really young subject. A medium range zoom, say from 35mm to 135mm will allow you to position the camera, using a firm tripod, and stick to that position at all times, using the zoom to frame each individual client or clients. Use a medium-speed film for maximum depth of field.

Right. We've got the set-up, trial sessions have proved it works, now we can go about the promotion work.

The first approach should not be made directly to the store manager. Instead, look through the local free papers and note which one carries the most advertising from your chosen prospect. Make an appointment to see the advertisement manager of the paper. They always seem to be more impressed if an appointment is made, rather than just calling in on the off chance. Take along a reasonable selection of your best shots of the subject that you want to promote, but not *too* many - the idea is to impress, not bore him - and suggest that you join forces to stage

an instore competition on your mutually chosen theme.

For example: *pretty pets,* if you have a flair for animal photography, *sexy-smiles,* if you fancy having a foray into the glamour market. There are lots of teenagers just dying to have their photographs taken. They wouldn't dream of paying out for a professional studio portrait, but would like something a little more daring to give to their girl or boy friend than the usual school photograph. And don't neglect the male teenager, he's just as proud of his latest hairdo as any young lady these days.

You can, of course, go for the old perennial, the *under fives* and catch them before the school photographer. Whichever you choose, be sure to emphasise to the advertisement manager that it isn't really a photographic competition, it has been known for some mums to want to enter family snaps taken by the old man. No way!

Once the paper show an interest, request that the ad manager finds you some sponsors. He can usually rely on his regular clientele to come forward with a £5 voucher or something similar and of course his paper gets the benefit of some more advertising copy because the sponsor will naturally want to be featured during the run up period to the competition.

You will have to contribute to the prizes. I would suggest a personal chat to the promotions department of your regular processing laboratory. If caught in the right mood, they may be willing to provide you with some big machine prints from the winning shots, especially if they get a reasonable mention in the newspaper feature. Contact your wholesaler. Again for a mention they may allow extra discount on the big frames. Dangle the carrot well and the only thing you could finish up paying for are the films and processing. Perhaps now would be a good time to go over the programme and give you a timetable of events, hopefully filling in any relevant points missed. I've based this programme on my own experience with one of these promotions.

The promotion programme

1. Prepare your portable studio set up.

2. Borrow the village hall or church hall, the neighbour's kids, dog, cat or wife, whichever you intend doing your promotion on and have a really good practice session.

3. Take the prints along to your local paper. Chat up the advertisement manager, explain that you think the paper should run an exciting competition in conjunction with a specific superstore. If he (she) would like to see if the superstore manager would like to play

Points to remember

■ **Practice makes perfect.**

■ **Use other people's facilities.**

■ **Use the best equipment you can afford.**

■ **Set up a joint promotion.**

■ **Be prepared to work hard.**

■ **Take advantage of spin-offs.**

ball, he may allow us to set up a small photo studio in the superstore, we could photograph all the entrants without charge of course and the judges could make their selection from the prints. We will provide the major prizes: three beautiful framed colour photographs, you know how much we normally charge for pictures like these don't you?

4. Select your competition date carefully. Generally January is out, too near to Christmas. February and March aren't bad, you can use Valentine's and Mother's day as themes. Think about a framed photo for an Easter gift, why not supply all finished prints in an oval frame or mount? Summer months tend to be difficult without some sort of theme, but one that goes down well amongst the teenagers (and some glamorous older ones) is the *sexy suntan,* after the fortnight in Majorca. This promotion ties in well with hairdressing salons, who often have a sunbed parlour. Think also about chemists (suntan oil) and the opticians (sunspecs). Autumn is ideal as many people are thinking about Christmas presents for loved ones in far flung corners of the globe, and these often have to be posted in November to guarantee delivery in time for the festivities.

5. Two weeks prior to the competition, the paper should run a quarter-page preliminary article, complete with entry form and competition rules and including if possible some of your photographs of the relevant subject. All entries must be on an official entry form, to guarantee the paper additional copies.

6. One week prior, the paper should run a full page feature about the competition, complete with some more of your pictures, details of the prizes, who the judges are, lots of adverts and editorial from the sponsors and of course the entry form and rules.

7. Competition week, you will naturally have arranged the first photo session to be on the day after the paper's publication, because you'd be surprised how people can forget even in a week. If you are allowed, set up the studio a few days prior to the set date to create interest in advance.

8. Our promotions are always run on two separate days in the same week, allowing a day or two between sessions. Have the first day's work processed, using the local 24 hour service if your normal lab can't give a speedy return of work. Get the prints on display as rapidly as possible to ensure ongoing interest. Don't rely on having a lunch, or even a coffee break during the shooting. Our first promotion was planned to have a couple of two-hour sessions, from 10 a.m. to 12 noon and from 2 p.m. to 4 p.m. No way. The pushchairs were queuing outside our studio at 9.45 a.m. We started early and worked continuously until 5.30 p.m. without a break, photographing an average of one child every six minutes, 156 over the two days. All were printed to 5 x 4 inches and mounted on a board with the reference number underneath.

9. Judging. Again, the newspaper entered into the spirit of the thing. The judges were photographed surrounded by literally hundreds of kiddy photos. I took at least a couple of shots of each sitter, because you could lose a sale if you only take one shot and then find the little darlings have gone and blinked.

10. Orders. Don't give credit! Make everyone pay cash with order, it's so easy to forget to collect the prints when you're so disappointed because little Willie didn't win. Get the money in first, then it doesn't matter about their lapse of memory.

11. The Big Announcement. Done through the pages of the newspaper. When the enlargements of the winners were finished, we posed each of the youngsters alongside their picture, complete with mums and judges and the photograph, along with prints of the winning shots, appears the following week, just two weeks after the competition.

Count the cost

12. Costings. All the original photographs were taken without charge and the pictures retained for reference purposes. There was no obligation whatsoever to purchase, the whole exercise relied entirely upon myself getting a saleable shot of each youngster, the rest depended on the print appealing to the parents. Reprints were simply costed out at print cost from lab (single print prices), plus the cost of the slip-in mount and multiplied by three. Some may say that this is too low, but I don't complain. Money for old rope it certainly isn't, it's hard work for a few hours. The major expenses were ten rolls of 35mm colour film, plus processing, three enlargements for prizes at a very special price plus three frames for same, again at special prices. These costs were more than offset by the fact that we had a minimum of a quarter page advert appearing in the local free paper each week for five weeks, all without any charge. All the legwork after the initial approach, was in our case done by the newspaper advertising department. They certainly enjoyed the exercise as we were requested to do a repeat promotion within a few months.

Spin-offs from this sort of promotion continue long after the end of the photo session. Re-orders of course appear months after, elder brothers and sisters need their likeness recording in the same style so the pictures match on the lounge wall.

CONCLUSIONS

There are millions of people out there, waiting to have their photograph taken by millions of people with cameras. If you want some of them to have you to take their picture, then take better photographs than the other millions with cameras by continually practising and, more important, take every opportunity for self promotion. Make your name known by regularly getting it in local papers, not always necessarily in connection with photography. Get involved with the community, charities like Round Table, Lions, any organisation that gets into print often. Always ensure that the newspaper gets the most important letters after your name - PHOTOGRAPHER.

PART THREE

PART THREE

TIPS FROM
THE TOP

NOTHING SUCCEEDS LIKE SUCCESS: Interviews with working freelances, case studies to inspire your work, ideas, people and books to bring you more information.

THE FREELANCE FILE

Name: John Woodhouse.

Occupation: Self employed credit trader.

Specialist subjects: Adventure sports.

How long have you been interested in photography? 30 years.

What equipment do you use? Olympus 35mm.

Do you work mostly in colour or black and white? 50/50.

What markets do you supply? Magazines, books, advertising, calendars, newspapers, public relations, T.V., audio visual.

How, when and where did you sell your first picture? Postage stamp size, humorous news picture published (on spec) in motor dealer's house journal in 1960 - no fee.

Why does your work succeed more than others? Quality and originality.

What was your most successful picture? Humorous rambling/bull sign picture, sold world wide.

What was your most unusual picture? Picture of insect actually crawling across film inside camera when exposure was made.

Three tips for successful freelancing? Provide the goods! Maintain your service and standard. Guard your good reputation.

Any other tips? Be genuinely interested and *care* about what you photograph. Be business-like yet friendly and helpful. Be determined, and remember that there is no substitute for quality. Retain your sense of humour!

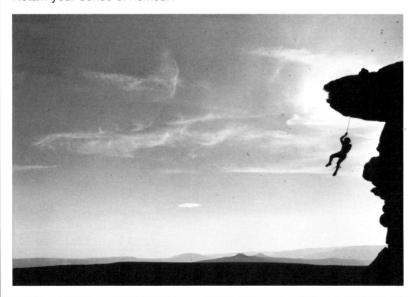

The kind of picture that has made John Woodhouse a well-known and popular freelance. His style of photography always combines pictorial composition with genuine information about his subject.

THE FREELANCE FILE

Name: Hugh Graham

Occupation: Full-time writer and photographer. I was a writer first and became a photographer in self defence, because I was depressed by the pictures taken by others after I had written the words.

Specialist Subjects: Christianity, alcoholics/alcoholism, family life, writing and photography, countryside/country ways/rural crafts, DIY, commercial fishing, farming/growing/gardening, architectural, archaeology, travel.

How long have you been interested in photography? About six years.

What equipment do you use? Two Minolta AF bodies, one for colour, the other for monochrome. Two lenses - 28mm f/2, my standard lens - 70 per cent of my pix are shot on this - and a 100mm f/2, my portrait lens. I hire a 50mm macro for close ups, and copying, with ringflash, also a 100-300mm zoom for outside fieldwork.

Do you work mostly in colour or black and white? 30% colour, 70% monochrome.

What markets do you supply? National dailies and Sundays, and sometimes the colour magazines. I also work for a carefully selected portfolio of leading monthlies as well as Trade and professional publications.

Why does your work succeed more than others? I take the trouble to work only on timeless photo-features, which have a potential of at least 12 sales to non-competing markets, so that I can work at my own speed without the pressure of trying to beat the rest of the ratpack. There are hundreds of ideas and since I consider myself to be Mr Average I think it's fair to say that if I'm interested in the material, so will many others.

What was your most successful picture? A series of pictures, rather than just one, of Ashley Courtenay, publisher of the leading Hotel Guide. He was 97 when I shot the series and still at work every day. So, quite obviously, he was Britain's oldest working man, and who, because of his work, had stayed in more hotel beds, eaten in more restaurants, and drunk in more bars than any man alive. That series of pictures has sold 117 times so far - and, three years after his death, they are still selling.

Three tips for successful freelancing? Work only on material that can sell and sell without serious competition. Choose the ideal camera system which suits your style of working, and then stick with it. Choose a single colour transparency film and a single monochrome film/developer combination and learn how to get the very best out of them.

Any other tips? Remember that words and pictures are better than either words or pictures on their own. So all photographers should and can learn to write saleable material. Believe that what interests you, will interest others. It's much easier and far more profitable to sell and sell material you already have, than to work up a new idea.

THE FREELANCE FILE

Name: Nigel Harper.

Occupation: Full-time freelance photographer.

Specialist subjects: Landscapes, weddings, portraits, videography.

How long have you been interested in photography? 22 years, but seven months full-time.

What equipment do you use? 35mm Canon with 17mm, 24mm, 35-70mm, 50mm, 55mm macro, 80-210mm zoom lenses. 35mm is used for all subjects and particularly for duplicating. Bronica ETRS system with 75mm lens, used for weddings and PR work. Mamiya RB67 system with 50mm, 90mm, 180mm lenses, used for landscapes, portraits and commercial work.

Do you work mostly in colour or black and white? Mostly colour slide film, Fujichrome 50 and Kodachrome 64; Kodak VPS for weddings; B/W Ilford FP4, XP1 and Kodak T-MAX, Tech Pan.

What markets do you supply? Photographic press and a picture library for which I shoot stock pictures.

How, when and where did you sell your first picture? In a photo competition a slide won £25 in the Zenith Photo Awards of yesteryear - some 10 years ago. This encouraged me to enter more competitions and I gradually became more successful.

Why does your work succeed more than others? Hopefully, it's because I try to adopt an unusual approach or slant to my subjects whenever possible and supply the pictures clients need on time.

What was your most successful picture? A portrait of my son under a poolside shower won 2nd prize in a national 'Child Photographer' competition. The prize included a holiday, cash and camera worth over £2,600 and the picture is still being published.

What was your most unusual picture? A slide sandwich of my son apparently looking out of the top of his own head.

Three tips for successful freelancing? Study your intended market(s) and supply exactly what the editor needs with a little originality and lots of impact. Ensure the quality of your work is of the highest order. When working to deadlines (which is most of the time) ensure they are met, be punctual when meeting clients and well turned out.

Any other tips? Look at successful photographers' work for ideas and inspiration. Use hobbies as a source for pictures and specialist knowledge. When on assignment, shoot plenty of film, bracketing if necessary. Re-shoots are expensive, not always possible and very bad for your reputation. Enter as many competitions as time permits. If funds allow, invest in medium format - the quality is just so much better.

THE FREELANCE FILE

Name: Lupe Cunha.

Occupation: Full-time freelance.

Specialist subjects: Photo-library pictures, babies and children from pregnancy to school age.

How long have you been interested in photography? I've been studying or working in photography since 1973, when I took up photography in my art degree course. Since then I have worked for a couple of years on a small newspaper, then doing various types of photography in a minor way until my current area of specialisation.

What equipment do you use? A Nikon body and three lenses - 28mm, 50mm and 105mm. In the studio, I use a Mamiya RB67 with standard and portrait lenses.

Do you work mostly in colour or black and white? Predominantly colour.

What markets do you supply? I started supplying the mother and baby magazines, now I supply several of the women's interest magazines, nursing and health publications and even the photo press.

How, when and where did you sell your first picture? My first sale was to a newly launched quarterly called *Baby - The Magazine,* for which I received £75. I have continued to supply them with pictures and now provide on average 12-15 pictures per issue (more than half the photos used).

Why does your work succeed more than others? I set up my shots. Even on location work, I don't do grab shots. If I need pictures of a mother shopping, I don't photograph a random mother shopping but set up a posed shot.

What was your most successful picture? Always my latest, newest work. Which means I'm constantly improving.

Three tips for successful freelancing? Choose a single market, study it well, and then shoot specifically for it. Don't go for the big well established glossies to start with. Never send rubbish.

Any other tips? Never mind how artistic your work is, when dealing with editors a photographer is a businessperson, and you should show this by your appearance and punctuality, both of your person and of your work.

Lupe Cunha's philosophy of choosing a single market and then studying all aspects of that market are ably demonstrated with these two pictures.

THE FREELANCE FILE

Name: Carol Gould

Occupation: ITV drama executive

Specialist subject: Tennis.

How long have you been interested in photography? 20 years.

What equipment do you use? Leica plus Canon autofocus SLR with 70-210mm and 100-300mm zooms.

Do you work mostly in colour or black and white? Colour.

What markets do you supply? Tennis magazines and tennis fan clubs.

How, when and where did you sell your first picture? I advertised tennis photos in 1985 in a tennis magazine and now have a fans mailing list of 1,500.

What was your most successful picture? Pat Cash practising at Wimbledon - on cover of a June '87 tennis magazine - the only one to have the Wimbledon champion on its cover that month!

What was your most unusual picture? Red tulips in foreground, black hearse in background by churchyard.

Three tips for successful freelancing? Don't do it 'part-time' - try to do it full time if you can afford not having a 9 to 5 job.

Any other tips? The tennis and sports photography scene is *very* tough. There are two top photographers in the field at the moment, and their pictures are used 90% of the time. So, it's a tough nut to crack. Also, the 'atmosphere' at tournaments is fierce, grim, humourless, and ruthlessly competitive. There's very little time for being chatty, thoughtful or artistic when attempting to talk shop with other photographers - particularly grim for a lady in a man's world.

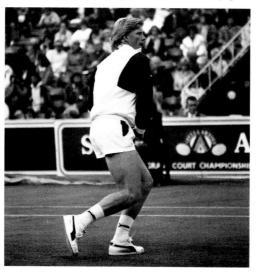

Carol Gould's picture of tennis champ Boris Becker sums up her determination to remain a part of the sports scene, even though the life is tough for a photographer who doesn't work the circuit full-time.

THE FREELANCE FILE

Name: Peter Gibson

Occupation: Full time teacher and lecturer in Adult Education (photography).

Specialist subjects: Although I tend to cover all aspects of photography from aerial to caving I do veer towards natural history, originally in 35mm but increasingly in 6 x 7 medium format.

How long have you been interested in photography? Since I was 18 when some fool let me look at a plant through an SLR with close-up attachments - I was hooked!

What equipment do you use? Two 35mm Olympus SLRs - which I consider the most useful and versatile camera type yet invented - latterly a Pentax 6 x 7 merely because the larger size of slide makes it more attractive to purchasers.

Do you work mostly in colour or black and white? 40% monochrome, 60% colour slide.

What markets do you supply? From picture libraries to religious publications, but 70% of my pictures go to illustrate articles which I write for a variety of magazines nationwide.

How, when and where did you sell your first picture? Using a black and white picture to illustrate the first article I ever wrote about a local smuggler to a fairly local magazine which covered the Welsh community.

Why does your work succeed more than others? Due to persistence and not being put off when the rejects rain back through the letter box. To send what is wanted, to diversify as much as possible and to be prompt, efficient and courteous.

What was your most successful picture? Probably a black and white seascape of Wormshead, an island just off The Gower Peninsula, Britain's number one area of outstanding natural beauty.

What was your most unusual picture? A photograph of a red-dead-nettle taken on a misty day by flash. The flash actually went off accidentally and created a most weird and unusual image of the flower, rimmed with light and backed by a mysterious and interesting halo.

Three tips for successful freelancing? Be prepared to work hard for no rewards for a long time. Send the market what it asks for. If you think you can take pictures, never give up.

Any other tips? Don't fall into the trap of taking the same old pictures over and over. Travel a bit to new landscapes. Words sell pictures: if you can write, write, and use your pictures to illustrate your words.

THE FREELANCE FILE

Name: Martin Edge.

Occupation: Police Officer.

Specialist subjects: Underwater photography.

How long have you been interested in photography? Eight years.

What equipment do you use? Nikon underwater cameras, Oceanic 2003 flash, Oceanic 2000 flash and 2000 slave, 15mm wide angle lens, extension tubes, close-up lens and framer, 28mm lens and recently purchased Nikon F2 with 55mm Micro-Nikkor in an underwater housing.

Do you work mostly in colour or black and white? Exclusively colour.

What markets do you supply? Scuba-diving magazines, photography and underwater photography magazines. Archaeology books and the occasional fishing magazine. Picture galleries for outlets of popular prints.

How, when and where did you sell your first picture? Initially, to local divers, depicting scenes, for home decoration. My first published picture sold to a magazine, to illustrate a photo/story of a project when we successfully tamed, hand-fed and fed by mouth, a conger eel in waters off the Dorset coast.

Why does your work sell more than others? Within the environment I have chosen to work, it has been the ability to obtain high quality shots in water off the UK. Researching the market, finding out what's popular, what is currently being published and, most important, what is not being published but could prove popular.

What was your most successful picture? A black and white print of a jelly fish, taken originally on colour slide film, in the waters off Cornwall. It has graced the cover of a diving magazine and won two national competitions and has also proved very popular as a framed photograph.

Three tips for successful freelancing? Research - you have to know the market, what's published and what is being published. Enthusiasm - every freelance needs it. Professional presentation - be professional in all aspects of your work.

Any other tips? Advice given to me by some of the best underwater photo-journalists in the world I can only reiterate. To sense stories and get them together. It's the ability to get close to the subject, a picture in which the personality and character of the fish, animal or person jumps right out of the piece of Kodachrome and onto the printed page. It's not enough to photograph the fish or person. They have to be doing something or illustrating something. The shots have got to tell a story.

THE FREELANCE FILE

Name: Elizabeth Wiggins.

Specialist subject: Vans. Personality profiles. Commercial advertising.

How long have you been interested in photography? Since the age of nine when I took my first photo with a Kodak Brownie.

What equipment do you use? Pentax LX & ME Super bodies. Pentax lenses: 50mm, 2.8mm, 24mm, 100mm, 28-80mm zoom, 35-70mm.

Do you work mostly in colour or black and white? 50/50. Colour transparencies for magazines, black and white for newspapers.

What markets do you supply? Specialist magazines. The local newspaper. Local businesses.

How, when and where did you sell your first picture? I was approached by a magazine editor to photograph a pick-up van he was testing. The picture was published in *Van Buyer*.

Why does your work succeed more than others? I can offer a complete package of words and pictures.

What was your most successful picture? An Autosheen van. It led to an editorial feature with colour photos, another magazine feature with black and white photos and then a subsequent approach to do an advertising feature.

What was your most unusual picture? A sewage works in Bournemouth.

Three tips for successful freelancing? Take plenty of shots for maximum choice later. Study house style very carefully before submitting work. Explore every avenue for possible follow-ups from the same item.

Any other tips? Take pride in your work. Be businesslike. Keep a keen sense of achievement alive. Don't be disheartened by rejection.

Not the sort of pictures that win photographic competitions, but the kind of thing that a commercial photographer lives from. Once people came to know that Elizabeth Wiggins was making regular sales to magazines and local newspapers, commercial commissions began to roll in.

THE FREELANCE FILE

Names: Maurice and Marion Teal.

Occupation: Both now enjoying early retirement. Marion formerly a computer operator and Maurice a design engineer.

Specialist subjects: The outdoor scene. Landscapes and pictures illustrating cycle-touring, camping and rambling. Oddities in the countryside, etc.

How long have you been interested in photography? Maurice about 40 years. Marion about 30 years.

What equipment do you use? Olympus cameras for 35mm work. Yashica twin lens reflex for medium format.

Do you work mostly in colour or black and white? Both in 35mm.

What markets do you supply? Magazines and books dealing with outdoor activities, particularly cycling, camping and walking. Country and county magazines.

How, when and where did you sell your first picture? In 1969 we had our first article published in *Cycling,* illustrated by three black and white pictures.

Why does your work succeed more than others? We endeavour to provide as big a choice of pictures as practical.

What was your most successful picture? Kinder Downfall on Kinder Scout. (Waterfall being blown upwards by a high wind). Published ten times.

What was your most unusual picture? The one above. (Used in *Countryman, Country Life, Field, This England* and three books.)

Three tips for successful freelancing? Research prospective markets. Provide good quality, contrasty black and white prints or transparencies with good colour saturation. Keep comprehensive records of what you've sent and where you've sent it.

Any other tips? Don't be discouraged when your work is rejected. Send out straight away to an alternative market, having checked that you are satisfied with it.

Maurice and Marion Teal have won a well-deserved reputation for providing good, competent black and white pictures on all aspects of the outdoor life.

LOCAL PICTURE THAT SOLD ROUND THE WORLD

By Stephen Huntley

FREELANCE PHOTOGRAPHY FOR me is mostly concerned with publicity and press work. There are five local papers in my area and it was through these that I covered our local carnival. I was only booked for the main procession and went off to cover something else in the afternoon. But I came back to cover a motorcycle stunt later in the afternoon.

Nothing much was going on, just one of the riders splashing petrol on the hoops, and everyone was looking away. I used the time to set up my camera - exposure set to manual and the Canon SLR in stopped down mode to get maximum frames per second.

I'd just checked I still had enough frames left for the stunt and was pre-focusing on the hoops when there was a big explosion. I saw the first flash and just kept my finger on the shutter. At first I thought it was one of those fire acts, but when I saw the man on the ground with his chest alight I knew it wasn't a stunt.

It happened so quick everyone missed it. I would have if I hadn't been looking through the lens at the time.

Contact the nationals

This happened about 4.30 pm. Frankly I was a bit shocked and did nothing about it at first. It was a couple of hours later when I developed the film to see what I'd got. It was a friend who phoned me and told me to contact the nationals.

At 7.15 pm on a Saturday night, it was too late for the Sundays, but they suggested ringing the *Mirror* the next morning. I couldn't believe how interested they were. They sent a photographer down to check out the pictures and later phoned me for an exclusive. Then the *Sun* phoned me to use them as well.

The right place, the right time and quick wits produced a picture that went round the world.

On average I was used to about £50 for a picture in the nationals, but I was amazed how much they wanted to pay me. I negotiated an even higher rate to keep it exclusive in the *Mirror* and they used the set right across the centre pages.

The very next day the *Mirror* picture library asked to borrow the negatives and since then they have sold throughout the world: Japan, Holland, Spain, America, pretty well everywhere. As with most news pictures, they mostly sold over the first couple of months, but I'm still picking up cheques a year later.

I also sold the shots to my local papers to keep them happy, and to the *Illustrated London News*. *Amateur Photographer* picked up on them in their Presswatch section, and then used them again in a sports supplement.

Sometimes I think there's someone else out there with the same pictures, but they've still got the film in their camera!

CREATING YOUR OWN MARKET FOR PICTURES

By David Hugill

A LOT OF people say I'm lucky to find so many different places to sell my pictures. But I don't believe in luck, only in hard work - and that will often generate the kind of luck that you make for yourself.

I was walking through a market one day when I saw an old photo album, full of local views. I bought it, took it home and made copies of some of the people in the album. Then I rang the editor of my local newspaper.

'How about some pictures from the past that you can run with a caption asking, where are they now, or some such idea?' I suggested.

'Great,' he replied and the pictures appeared in print that weekend.

That was an example, not so much of finding a good picture to sell, but of creating the market for it in the first place. But the story doesn't end there.

A week later I had a call from a lady who had seen the pictures in the paper and recognised herself. She wanted to see the rest of the album. So I invited her round to my house, showed her the album and asked if I could take a few pictures of her looking at it.

The picture from the past that started a string of sales.

Second sale

The same local newspaper ran that picture a week later with a Local Woman Reunited with Lost Family Album story. That made a second sale with the same market. And, when a photo magazine heard how I had produced two sales literally out of thin air, they asked me for a copy of one of the pictures, running it with a story on freelancing and making a third sale.

That's how I came to be contributing to this book - and how I've now made a fourth sale from that morning's walk through the local market.

DISASTER TURNED INTO PROFIT

By Helene Rogers

The picture sold - but if it hadn't been for an apparent disaster at the start, it might never have been taken.

EXPERIENCE IS IMPORTANT to the travel photographer. Experience not only of the types of pictures which sell well, but also in how to get the best out of tricky situations as well as coping with problems which occur whilst travelling in strange and unfamiliar countries.

Frequently, the best made travel arrangements go wrong; but the ability to be flexible often pays dividends in the end. A few years ago on a trip to the Sudan, I had planned to photograph the tribes in the Southern region around the towns of Juba, Wau and Malakel. I arranged a plane ticket which would give me a round trip stopping off in the three different areas. The day before departure, skirmishes broke out in Southern Sudan and it became clear that the trip would have to be postponed. I was left with ten days in Khartoum or the choice of returning home early without any photographs.

Having spent the money to get there in the first place, returning home without pictures would have created a loss that I could not afford. I therefore studied the map closely and decided to travel the Red Sea coast to Port Sudan and on to the town of Suakin.

The need for pictures

I had, before I left, discovered a need for pictures of Port Sudan and contacted a firm of construction engineers working on the redevelopment of the Port. I promised them that if there was time I would visit the Port and take any pictures they required. The pictures taken in the Port were used by the contractor and six other magazines on my return.

Whilst working at the Port, I was shown a ship beached on a sand bank that had been scuttled by its owners after a small fire. I took a distant shot with a long telephoto lens and the picture was not only subsequently published twice, but led directly to an introduction to the Maritime Bureau in London who investigate maritime fraud worldwide, and a series of articles on maritime fraud.

Suakin was an added bonus. When I finished my work at Port Sudan, the Port Director loaned me his car to travel 50km northwards to the site of a new proposed port development at Suakin. En route I took pictures of nomads and, on arrival, I discovered a ruined city of Ottoman architecture. All the pictures have sold extremely well. The whole trip relied on intuition and knowing my markets. Instead of being a disaster, my trip to the Sudan was one of my most successful to date.

THE STORY THAT KEEPS ON SELLING

By John Wade

SOMETIMES YOU COME by a story that you know is going to be extra-profitable, not just for the freelance who finds it, but for everyone concerned. Such a story came from a man called Mike Carrie who I found running a company called Cloud-9. Mike's speciality was aerial photography without an aeroplane. What he used instead, was a specially-constructed mast that could be towed behind a car and which extended to 100ft. On top of that, he put a remote-controlled camera.

As soon as I contacted him, I knew this was going to be a good one. On arrival at his home in Nottinghamshire, I produced my portable tape recorder and spent about an hour asking him all about the business, how it had started and where he was aiming to go next.

It transpired that he was not only running this rather unusual business for himself, he was also designing the equipment and renting it out to other professional photographers who wanted to set up their own Cloud-9 operation.

When we went out to take some pictures with this highly unusual equipment it soon became clear that the only way he could get an accurate idea of the kind of picture that was going to result from shooting 100ft up in the air, was to take a Polaroid instant print with his Mamiya RZ67 camera in place at the top of the mast, before commitment to conventional film.

As Mike went about the operation - not nearly as complicated as it might at first sound - I took pictures from all angles, asked if I could have one of the original Polaroid prints, made sure I got a picture of him checking details on the instant print and asked if I could have the film from the aerial picture that he subsequently took. I used two camera bodies, one loaded with colour slide film, the other with black and white, duplicating every shot as I went along.

Since he was so reliant on Polaroid for the final picture, that company was my first port of call. The publicity department eagerly bought a feature and four pictures from me, which they used in their house magazine *Instant Record.* They also had the feature and two of the pictures made up into a case study on a single sheet of A4 to send out to customers who wanted information about their products, making a second sale.

Next call was *Practical Photography.* At that time, I was writing a regular column for the magazine, so it was a natural to incorporate Mike's story here, playing up the funny side of the business, rather than the serious aspects of using Polaroid. Naturally, not everyone has a regular column in a national photographic magazine, but this story was so unusual and so good that most of the amateur photo press would have bought it anyway. So a third sale was made.

Press release

Meanwhile Mike himself contacted me and asked me to print fifty copies each of two of the pictures I had taken that day to send out with a press release, this time in black and white, because few press releases find their way onto colour pages in magazines. Sale number four.

Yet there was still another angle that hadn't been exploited: the fact that Mike was setting up a national network of photographers who were renting the equipment from him. So *Professional Photographer* magazine was my next target. Result: sale number five.

All this took place literally within a few weeks of first hearing about Cloud-9. Future possibilities, still in the offing at the time of writing, include the county magazine for Mike's area, a woman's magazine that uses off-beat pictures (the man with his camera up a 100ft pole), security magazines (the equipment can just as easily be used for surveillance), the importers of Mamiya cameras, the people who make the mast that he uses... the possibilities are enormous.

THE RIGHT PLACE, THE RIGHT TIME

By David Cundy

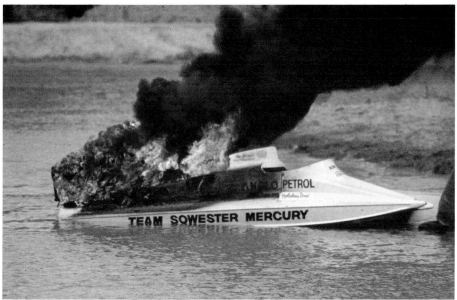

David Cundy's best sales of all time - not so much because they were the best pictures around, but because he had the initiative to set out to sell them to as many markets as possible.

DURING THE DAY I work in a camera shop, but days off and weekends are devoted to cameras and cars. I first started watching racing in 1959 and I bought my first camera in 1965, so my motor racing library as such, goes back to 1966.

I have to admit I'm nuts about the subject - I've spent as much as £5,000 on Leica gear in the last year or so and I've got to make it pay for itself. My feeling is that if you try to sell yourself half-heartedly you might as well give up.

The motor sports photography has paid off. I sold some work to the photo press, and a letter printed in *Amateur Photographer* about the coverage it gave me did the world of good, as a photo book publisher saw it and asked me to do a sports book for them.

I've now been the chief photographer on two motor sports books, and have shot the jacket for Sports International's Le Mans video.

But my best selling pictures of all time were taken at a power boat meeting in 1985. One of the drivers was taking the managing director of the sponsoring company for a ride and the boat suddenly caught fire! I got several shots of the boat disintegrating. They had to bail out and the MD wasn't too happy about it!

Funnily enough, I've seen a friend's photos of the same scene and, frankly, they're better than mine, but he didn't try to sell them. I sold them to the *Power Boat Racing Annual,* Southampton University Marine Technology Department (in return for a sailing course!), to *Fire Prevention and Post Magazine,* and *The Insurance Weekly.* The last two came out of *The Freelance Photographer's Market Handbook,* published by BFP Books.

For successful sports photography you've got to be in the right place at the right time, or be very, very lucky. Translating the scene onto film doesn't always work the way you want it to. If you get five frames out of 36 you're doing well.

COMMISSIONS OUT OF EXHIBITIONS

By Stewart Seale

The kind of picture that Stewart Seale now gets commissions to take. The picture, he points out, has all the ingredients for a successful sale: human interest, prominent symbol of the activity, appropriate but non-competing background and implied expertise of the subject.

THE DREAM OF every aspiring freelance is to have editors and others commissioning their work. No more rejected manuscripts and photographs, no more expensive speculative trips, no more disappointments and frustrations.

But how do you begin to get commissions? Here's how it happened for me.

My speciality is angling and fishing photography and it all started with an unexpected breakthrough coming my way when a skilled rodmaker, whose work I had photographed and written about, telephoned. 'How would you like to help me at the Floors Castle Game Fair this summer, assisting on my stall?' he asked. I checked the diary and agreed, promising to phone back to confirm.

I thought carefully about how this opportunity could be put to best use. Living in South Queensferry, near Edinburgh, makes meeting the editors and staff of United Kingdom newspapers and magazines difficult, so I decided that the priority of the weekend would be to make firm contacts. I phoned back, explained to my contact what I wanted to achieve and suggested an exhibition of my photographs at the stall.

In every field, not least angling, the freelance needs an expert knowledge, preferably coupled with practical skills. For an editorial staff, the annual fair or conference is an opportunity to meet business acquaintances and friends, make fresh contacts, and keep up to date with new developments. So the staff of every angling and country magazine saw my work, I met a number of editors for the first time, and I also made several unexpected and valuable new contacts.

Since the Game Fair, which I followed up with new speculative material, my dealings with the editors have been on an entirely new footing. They have suggested to me what to submit, requested new work, and commissioned photography from me for the first time.

Apart from making me feel good, this has had the following results: A commissioned photograph was immediately published; I now have many stock photographs in the files of several magazines; I was paid for the work, aside from publication fees; a national daily paper is holding angling photographs; featured anglers are asking to pay for prints of themselves in action, and angling portraits. Interestingly, producing strong newsy images on demand has also encouraged some editors to consider my more off-beat photographs for publication - in other words, the photographs I like to take.

Further information

ANYONE WHO IS at all serious about freelancing should consider membership of the Bureau of Freelance Photographers. The BFP is Britain's foremost organisation devoted to the needs of freelance photographers, from the rawest beginner through to the seasoned expert.

Apart from the Bureau itself, there are two other divisions of the BFP organisation - The BFP School of Photography and BFP Books. Here are further details of what the different BFP divisions can do for you, together with suggestions of BFP books for further reading.

BFP MEMBERSHIP

All members of the BFP receive the monthly *Market Newsletter* and the annual *Freelance Photographer's Market Handbook,* as well as having access to the Bureau's expert advice and assistance services.

Market Newsletter

The *Newsletter* is an essential guide for the serious freelance, keeping you ahead of other photographers with advance information about new picture outlets and important changes in the marketplace. Each issue carries news of potential markets for your photographs or articles, telling you exactly what magazine editors and other picture buyers are currently looking for. It also contains much other news and comment of interest to the freelance, plus frequent in-depth interviews with leading editors and picture buyers. A lively letters column provides a forum for members to exchange views, tips and personal experiences.

The BFP's unique Market Newsletter brings monthly news of markets for your pictures.

The Freelance Photographer's Market Handbook

Whereas the monthly *Newsletter* keeps members up to date with current picture requirements, the annual BFP *Handbook* provides a unique overview of the freelance market. It lists over 600 markets that are in constant need of freelance material, including magazines, picture agencies, and card and calendar publishers.

Each entry gives detailed information on the type of pictures and articles being sought, exactly where to send your contribution and to whom it should be addressed. The *Handbook* is completely revised and updated every year and all the information checked with the picture buyers concerned to ensure optimum accuracy.

Also included is useful advice on presentation and how to approach different markets.

Advisory Service

If you have any specific problems concerned with aspects of freelancing, the Bureau can offer advice based on many years of experience and research in the freelance market. The sort of advice covered

includes copyright and other legal matters, marketing information, publishing rights and fees. In addition the Bureau is often successful in assisting members to obtain unpaid fees and compensation for lost or damaged transparencies.

THE BFP COURSE

The BFP School offers the BFP Course in Freelance Photography and Photojournalism, a unique postal course that is designed to show the student how to produce saleable work and how to market it most effectively.

The course material consists of two volumes containing nineteen lessons covering all you need to know to become a 'selling' photographer. However, the most valuable part of the course is the personal tuition facility, which offers unlimited access to one of the School's expert tutors. The student is encouraged to submit photographs for detailed appraisal. The tutor examines the photographs carefully and then writes a friendly personal reply containing helpful advice and constructive criticism. The BFP course is designed to be flexible enough to be helpful both to those who simply want to make their hobby pay for itself, and to those whose ultimate ambition is to become a professional freelance.

Up to two years is allowed to complete the full course, although most students find that they are able to complete it in less time.

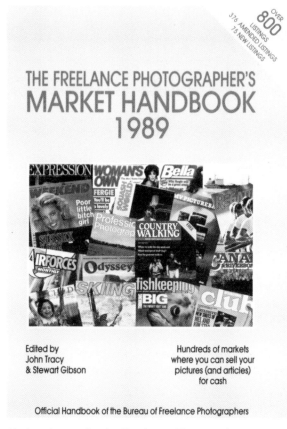

Updated annually, the Freelance Photographer's Market Handbook lists hundreds of markets for your pictures.

The BFP Course in Freelance Photography and Photojournalism takes you through the basics and the more advanced fundamentals of freelance photography, all under the guidance of your own personal tutor.

BFP BOOKS

This is the book publishing arm of the BFP, producing books that cover all aspects of freelancing and related topics. Whether you require detailed and comprehensive advice on legal matters or setting up your own business, or just a good, inspiring read about the exploits of established freelances, there is a BFP book for you.

The Freelance Photographer's Market Handbook

As well as being included as part of membership of the BFP, the *Market Handbook* is also available on its own to non-members. For details see above.

Freelance Photographers' Britain
By Kevin MacDonnell

A highly informative book that shows you how to seek out interesting and saleable subjects all around

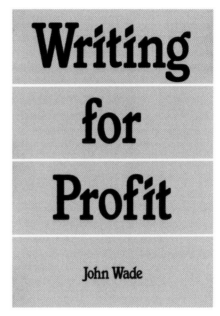

Helping you add words to your pictures and make extra sales in the bargain.

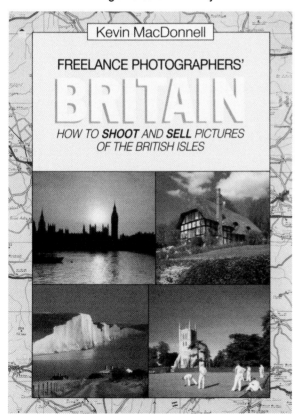

How to take and sell better pictures of Britain.

you. It will show you which subjects have the most potential and how to photograph them to their best advantage. It will also show you how to approach the many potential markets for such work.

There can be no better guide to photographing Britain than Kevin MacDonnell. Widely know for his experience and expertise in searching out the many interesting people and places that can so easily be overlooked by the casual observer, his photographs of the British scene have been widely published. In addition he has written and illustrated a number of guidebooks to different parts of the country - another profitable area that is covered in *Freelance Photographers' Britain*.

Writing For Profit
By John Wade

It's a fact: you'll sell more pictures if you can write. Indeed, the freelance who can produce articles as well as pictures is highly prized by editors. The book starts you right at the beginning and shows you how to produce the kind of work that editors will buy. It shows you how to find ideas for articles, how to research them, how to conduct interviews, and how to write the final piece. Along the way it discusses the tools of the trade, shows you how to analyse markets, and gives advice on fiction writing, newspaper writing, and writing a book. The book even shows how to make your photos more saleable with the right kind of caption. All you need to know to earn money from words as well as pictures!

The Photographer and the Law
By Don Cassell

What is copyright? Who owns copyright in a photograph, and how can this right be protected? What can be done if copyright is infringed? What are the dangers of candid photography, and can anyone legally object to being photographed? Where and when is it against the law to take photographs, and how much legal force do such prohibitions carry? What is legally required when setting up a photographic business?

These are just a few of the many questions that are dealt with in this authoritative guide. Written in plain language for the layman, *The Photographer and The Law* is an indispensable guide through the legal minefields that can surround the practice of photography.

Freelance Travel Photography
By Helene Rogers

In this book, the author recounts her many exploits and adventures in obtaining photographs in many parts of the world - Africa, the Middle East, the Far East, USA and Europe. It is profusely illustrated with many of her best-known and best-selling pictures, from the refugee camps of Sudan and the ancient culture of North Yemen, to assignments in the ultra-modern cities of New York and Hong Kong.

Combined with this autobiography of a working photojournalist is a wealth of practical advice and information for anyone who aspires to this most exciting and rewarding branch of photography. The author gives the benefit of her experience and expertise on a range of topics, from picture composition and choice of equipment, to methods of dealing with awkward customs officers and local wildlife!

The Business of Freelancing
By Graham Jones

If you're serious about freelancing, - whether on a part-time or full-time basis - this book will set you right on the business side. It shows how to adopt a professional business approach and how to maximise your profits.

Make Your Pictures Win
By John Wade

Hundreds of thousands of pounds worth of prizes are given away every year as prizes in photo competitions. This book brings you advice and information from winners and judges alike, designed to lead you straight to the winning spot in any photo contest.

The Business
of
Freelancing

A comprehensive guide
to the business side
of freelance writing and photography

The
Photographer
& the Law

Don Cassell

Two books to cover two important aspects of freelancing - the business side and how the law affects you.

And finally... leave 'em laughing. It's worth remembering that a picture containing an element of humour will be welcomed by nearly every magazine or newspaper published. The photographer with an eye for the funny or the absurd will find markets galore waiting with open arms.

Picture credits

Cover: Main picture taken on Polaroid Professional Chrome film by Duncan Roe and Ashley Smith of Plymouth College of Art and Design. Pictures below, left to right, by Graham Betts, Peter Phelan and Nigel Harper.

6, Peter Trievnor
18, Michael Tedder
25, David Hugill
26, David Hugill
28, David Hugill
31, Reginald Francis
32, Dennis Mansell
35, Brian Sutton
38, Brian Sutton
40, David Hugill
41, Raymond Lea
42, Raymond Lea
43, Raymond Lea
44, Raymond Lea
46, John Wade
48, Bruce Pocklington
50, Bruce Pocklington
51, Bruce Pocklington
53, Michael Tedder
54, Top Martin Lillicrap Bottom Trevor Crone
55, Frank Peeters
56, Frank Peeters
57, Maurice & Marion Teal
59, Val Bissland
60, Raymond Lea
62, Raymond Lea
64, Raymond Lea
64, Top Val Bissland Bottom Michael Tedder
65, David Hugill
66, David Hugill
67, David Hugill
68, Ken Ayres
71, Michael Edwards
72, Kevin Macdonnell
73, John Capes
74, Chris Cole
75, David Hugill
76, Raymond Lea
77, David Hugill
78, Mike Foote
79, Maurice Rowe
80, Peter Kirby
81, Peter Kirby
82, Peter Phelan
83, Peter Phelan
85, Peter Phelan
86, Graham Betts

87, Graham Betts
88 Nigel Holmes
90, Graham Betts
91, Tony Boxall
92, Tony Boxall
93, David Hugill
94, Val Bissland
99, David Hugill
100, Monte Fresco
101, Mervyn Rees
103, Ian Weightman
104, Raymond Lea
105, Raymond Lea
107, Bill Wilkinson
108, Raymond Rimell
110, Raymond Rimell
111, Raymond Rimell
112, Doug Chalk
114, Martin Lillicrap
116, Peter Phelan
117, John Wade
118, John Wade
121, JohnWade
123, John Wade
124, John Claridge
126, Ian Giles
127, Graham Hughes
130, Peter Phelan
131, Brian Sutton
132, Mervyn Rees
133, Mervyn Rees
134, Michael Edwards
135, Brian Sutton
136, Helene Rogers
138, David Askham
139, Nigel Harper
140, Nigel Harper
143, Tony Boxall
144, Val Bissland
146, Nigel Harper
150, John Woodhouse
153, Lupe Cunha
154, Carol Gould
157, Elizabeth Wiggins
158, Maurice & Marion Teal
159, Stephen Huntley
160, David Hugill
161, Helene Rogers
163, David Cundy
164, Stewart Seale
169, Tony Boxall

Index